WOMEN

SEEING

WOMEN

Authorized American edition of the work published by Schirmer/Mosel Verlag, Munich
Copyright © 2001 by Schirmer/Mosel Verlag GmbH, Munich
Copyright © for the American edition 2003 by W. W. Norton & Company, Inc., New York
A Schirmer/Mosel Production

Printed in Germany

Manufactured in Germany
Book design by Nova Concept, Berlin
Production manager: Jim Mairs

Library of Congress Cataloging-in-Publication Data

Frauen sehen Frauen. English.
 Women seeing women : a pictorial history of women's photography from Julia
Margaret Cameron to Annie Leibovitz/ selected and edited by Lothar Schirmer; introduc-
tion by Naomi Rosenblum.
 p. cm.
ISBN 0-393-05778-X
 1. Photography of women. 2. Women photographers. I. Schirmer, Lothar, 1943– II. Title.

TR681.W6 F73713 2003
779'.24—dc21 2002043229

W. W. Norton & Company, Inc., 500 Fifth Avenue, New York, N.Y. 10110
www.wwnorton.com

W. W. Norton & Company Ltd., Castle House, 75/76 Wells Street, London W1T 3QT

1 2 3 4 5 6 7 8 9 0

WOMEN

A Pictorial History
of Women's Photography

SEEING

from *Julia Margaret Cameron*
to *Annie Leibovitz*

WOMEN

159 photographs
Edited by
Lothar Schirmer

Introduction by
Naomi Rosenblum

W.W. Norton & Company

New York • London

CONTENTS

WITH PHOTOGRAPHS BY

Berenice Abbott
Lola Alvarez Bravo
Rogi André
Diane Arbus
Eve Arnold
Atelier Elvira
Ellen Auerbach
Vanessa Beecroft
Ruth Bernhard
Aenne Biermann
Lillian Birnbaum
Margaret Bourke-White
Steffi Brandl
Marianne Breslauer
Claude Cahun
Julia Margaret Cameron
Elisabetta Catalano
Yvonne Chevalier
Imogen Cunningham
Louise Dahl-Wolfe
Minya Diez-Dührkoop
Rineke Dijkstra
Zoë Dominic
Jayne Fincher
Trude Fleischmann
Martine Franck
Gisèle Freund
Trude Geiringer
Jitka Hanzlová
Clementina, Lady Hawarden
Florence Henri

Hannah Höch
Dora Horovitz
Vera Isler
Dominique Issermann
Lotte Jacobi
Sarah Jones
Gertrude Käsebier
Ursula Kaufmann
Barbara Klemm
Ute Klophaus
Annelise Kretschmer
Germaine Krull
Brigitte Lacombe
Inez van Lamsweerde
Ergy Landau
Dorothea Lange
Annie Leibovitz
Helen Levitt
Ruth Harriet Louise
Ingeborg Ludowici
Dora Maar
Linda McCartney
Frances McLaughlin-Gill
Madame d'Ora
Madame Yevonde
Sally Mann
Mary Ellen Mark
Margrethe Mather
Susan Meiselas
Lee Miller
Lisette Model

Tina Modotti
Lucia Moholy
Sarah Moon
Inge Morath
Barbara Morgan
Nelly
Isolde Ohlbaum
Meret Oppenheim
Bettina Rheims
Sophy Rickett
Leni Riefenstahl
ringl + pit
Charlotte Rudolph
Lise Sarfati
Nina Schmitz
Eva Sereny
Marilyn Silverstone
Vanina Sorrenti
Liselotte Strelow
Karin Székessy
Joyce Tenneson
Deborah Turbeville
Ellen von Unwerth
Donata Wenders
Dorothy Wilding
Francesca Woodman
Wanda Wulz

WOMEN PHOTOGRAPHERS SEE THE WORLD

Naomi Rosenblum

"Photography is so adapted to women's abilities," declared an article in an 1890s magazine, "that it seems strange that they did not adopt it from the beginning." But as we now know, women actually had been making photographs since 1839, when the discovery of how to produce pictures by the action of light was first announced. In the medium's earliest years, a few well-to-do British women found in the calotype medium (a paper negative and paper positive) an interesting pastime—one that allowed them to become involved in otherwise off-limits scientific activities. Other nineteenth-century women were drawn to daguerreotyping as a way to earn a living, usually by making portraits. A handful of women recognized that photography afforded them an opportunity for artistic expression. Toward the end of the century, greater numbers of women looked to photography as a life-enhancing experience. In the following century, women began to prove themselves as documentarians and photojournalists as well as pictorial artists. Currently, women photographers are involved in all aspects of the medium—artistic expression, documentation, photojournalism, and commercial and scientific applications.

In today's cultural climate, we take for granted that women photographers have arrived permanently at artistic and professional parity with men, but this was not always the case. The achievements of those who gained fame and fortune in the past often were forgotten or neglected, while the manner in which women looked at those of their own gender also was overlooked. This compendium of camera work by and about women suggests the diverse aesthetic and emotional approaches embraced by women when dealing with images of other women. Since the images are chronologically arranged, the viewer can also gain a sense of the medium's stylistic developments through time.

So to begin at the beginning: Women became interested in the medium in its earliest days. One, Friederike Wilhelmine von Wunsch, actually claimed to have invented a photographic process, although we have only her word for it. Constance Talbot, the wife of William Henry Fox Talbot, inventor of the negative-positive process, played around with the medium, although neither she nor several of her female relatives who were likewise engaged were greatly successful. In the mid-1840s, Anna Atkins produced two scientific compendia consisting of cyanotype prints of algae and ferns (made by exposing the actual matter, placed on paper sensitized with iron salts, to light). Her endeavor appears to have been the first extended scientific project to employ a photographic method of illustration.

Portraiture, however, was the first application of photography in which women figured more prominently. The making of daguerreotypes—unique images formed on silver plates—provided both men and women with a means of livelihood that did not require great investments of money and time and that could be abandoned easily when no longer economically feasible. Throughout northern

Europe and in the United States, women worked either on their own (as did Marie Chambefort in France) or with a relative or spouse (as did Berthe Wehnert Beckmann in Germany and the United States), maintaining studios or traveling as itinerants. After the 1850s, when a new technology involving glass plates, collodion silver sensitizing, and albumen printing paper was introduced, greater numbers of women owned or became part of the studios that turned out thousands upon thousands of portraits. With a few notable exceptions, commercial portrait images by women were not noticeably different from the vast run of those made by male practitioners; one must examine the logo or name to determine the gender of the maker.

Women were active behind the scenes as well. The industries that grew up to supply photographic materials employed women to produce the albumen papers so greatly in demand at the time. On both sides of the Atlantic, they worked at developing and printing glass plates in studios and commercial photo-printing establishments. According to some, women's inborn artistry made them better as retouchers, removing wrinkles or adding color to daguerreotypes and paper prints; more likely it was their willingness to be paid less than men that recommended them for this role.

In contrast to the useful, if unexceptional, general run of mid-nineteenth-century portraits, those made by Julia Margaret Cameron were unique. Her work demonstrated that the medium might attain an unusual level of artistry through the management of pose and lighting and the investment of a considerable quantity of ardent feeling. For the most part, Cameron's work reflected prevailing Victorian attitudes about women's characters and roles, tempered by her own experiences and personality. The portrait of her niece Julia Jackson combines strength and diffidence, while Alice Liddell, mythologized as Pomona, is presented as a determined, almost fierce, protector of fertility. In England, Cameron's work was hailed for its aesthetic qualities by the traditional male art establishment and criticized by photographic groups (also male) as being sloppily executed.

Images of women by Clementina, Lady Hawarden are not portraits in the strict sense. Made at about the same time as Cameron's, and also frequently involved with costumes and make-believe, Lady Hawarden's images of her daughters and their friends demonstrate her interest in creating mood through pose, clothing, and decor. One suspects, also, that the languid poses assumed by her sitters— they are often leaning or recumbent—helped stabilize them and prevented the appearance of movement or blur, which was not appreciated by nineteenth-century photographers or viewers.

As photography developed, a movement known as Pictorialism emerged to counter what was thought to be the mechanical aspects of the photographic medium—its too-great clarity, its harsh gray coloration, and the fact that a negative could be endlessly and almost exactly duplicated. Unfolding in the latter part of the nineteenth century, it promoted an aesthetic approach to the medium in general and to portraiture in particular. It took root as a counter to both the popularity of snapshot photography, made possible by the appearance of handheld cameras, and the growing use of camera illustration for commercial and industrial purposes. Distinctive images were achieved by handwork, colored pigments, and unusual papers, presented in specially designed mats enhanced with a maker's monogram. Portraiture in the Pictorialist style became especially attractive in large metropolitan centers in the United States where affluent sitters desired images of themselves that enhanced their status and revealed their special attributes.

In the late nineteenth century, American women especially began to play a more prominent role in photography. Advertising by the George Eastman Company invited them to use the Kodak camera to become keepers of family memories, but many discovered more than an engaging hobby. Spurning this simple mechanism, they turned to larger equipment and learned the techniques of developing and printing. As a writer in *Godey's Magazine* noted, the woman who started by using a Kodak "is seldom satisfied until she is mistress of larger boxes and expensive lenses."

Technological changes in the medium were not the only factors in women's entry into the photographic profession. With the availability of factory-produced food and clothing and the importation of immigrant help, middle-class women found themselves less tied to household duties.

With more leisure time, they heeded invocations by suffragists to become more aware of their own needs. A number looked to photography as either a means of personal expression or a professional occupation or both. Photography, it was noted by several writers, would still allow women to fulfill their expected roles as family guardians because its tasks could be divided up and it was less demanding than painting or sculpture. Women aided other women to follow this path. Among the most notable, the affluent Catharine Weed Barnes (later Ward) lectured and wrote widely, urging women to take the medium seriously. Toward the same end, Frances Benjamin Johnston gathered the work of twenty-eight women for exhibition at the 1900 Exposition Universelle in Paris.

Women portraitists were welcomed for the artistry they brought to the representation as well for practical reasons having to do with the state of the profession. Following a downturn in commercial studio portraiture in the early 1900s, portraits were now being made in the home, where it was deemed more prudent to invite a woman than a man into one's private quarters. Contemporary attitudes about children also played a part in this transition, as enlightened middle-class families sought photographs that would reflect up-to-date attitudes about child rearing. Camera images often showed them playing genteel games or being read to by their mothers. Women were thought to be more empathetic than men, and thus better able to convey the bond between mothers and their children.

Gertrude Käsebier in New York was among the highly paid and well-regarded Pictorialists whose work embodied these ideas. Male sitters are portrayed in a direct and unemotional manner, while affection and interaction are palpable features of her many images of women and children. Discussing In the Manger by Käsebier, one critic held that "no man, howsoever gifted" could have made this image; only a woman would be capable of capturing the love that passes between mother and child.

It was claimed, also, that women's artistic natures were responsible for the aesthetic quality of the new portraiture, but their art training surely played a significant role. Many middle-class women who had aspired to become artists had been to art school, but they were prevented by conventional strictures from pursuing serious professional careers as painters or sculptors. Käsebier, who turned to photography in her forties while an art student at Pratt Institute, was extremely knowledgeable about historical and contemporary styles in painting and drew upon this knowledge when she costumed and posed sitters.

The social climate in Europe in the early years of the twentieth century was less hospitable to women in the professions, but in England a number of them owned their own photographic businesses. Younger women who gained experience as trainees in these studios eventually were able to make a distinctive mark as portraitists. One, Yevonde Cumbers, known as Madame Yevonde, was an advocate of women's rights as well as an astute businesswoman. She endeavored to put her own stamp on portraiture by transforming her sitters into mythological figures, recalling the concept if not the style of Cameron and forecasting the much later work of Cindy Sherman. Another, Dorothy Wilding, started as an apprentice retoucher and eventually became portraitist to the royal family. Both she and Yevonde were among the first women to find a niche in portraying rich and famous celebrities.

Following the upheavals of the First World War on the continent, women's entrance into the profession—often in family portrait studios—also became more common. Even before the war, Minya Diez-Dührkoop had added an artistic touch to work emanating from her father's famed studio in Hamburg, Germany; after his death in 1918, she took over the business. Wanda Wulz became part of the family firm in Trieste, turning out highly competent if unexceptional images in contrast to the eye-catching self-portrait that has come to represent her vision. By the 1930s, European women were working in all the major cities, usually earning precarious livings as portraitists, product photographers, and, toward the end of the decade photojournalists. Although a number faced economic problems, and were discriminated against by male photographers in Paris, their careers reflected a

greater acceptance of women in the profession—a change wrought by both feminist campaigns and the social dislocations occasioned by the war.

In central Europe and France, women photographers could not help but be aware of the distinctive style that engaged nearly all visual artists of the time. Called, variously, the new realism, *neue sachlichkeit, art moderne,* or art deco, it attracted portraitists as well as industrial and commercial photographers. Portraits by Aenne Biermann, Florence Henri, and Lucia Moholy made during the 1930s, and by Liselotte Strelow made as late as the 1950s, usually present the sitter in extreme close-up, excised from any recognizable background or environment. Attention to pattern, outline, and texture rather than to mood and inner expression creates the image's allure. Of course, different individuals handled this style differently; Annelise Kretschmer and Dora Maar, for example, managed to endow their close-ups of an unknown young woman and of Nusch Eluard, respectively, with a mysterious aura.

A number of European women concentrated on photographing the early proponents of modern dance movement, a form of artistic expression through which women could express a feeling of liberation. German dance photographer Charlotte Rudolph made use of the blurs and ghost images of movement when she portrayed well-known modern dance artists of the time. Nelly (Elly Seraidari), who was to become a recognized photojournalist in her native Greece, studied in Germany and was similarly engaged by the freedom embodied in dance movement. Her attempts to realize the connection between women's bodies and unabashed yet controlled movement were met with resistance when she returned home, and she scandalized her compatriots with an image of a nude dancer at the Parthenon.

Dance movements, in particular those of female members of the troupe, continued to engage women photographers. Barbara Morgan, a painter turned photographer, probably became aware of trends in modernist photography from her close study of European photographic periodicals, in particular those from Germany. A commission from the Martha Graham Dance Company enabled her to put these ideas into practice on this side of the Atlantic. Besides her classically conceived portrait of Graham in mid-motion, she made many double exposures and montages in order to capture the sense of continuing movement in space that dance involves.

In a similar fashion, women derived a sense of freedom from their newfound ability to photograph the nude body—usually that of another woman. Traditionally, men had been dissuaded from engaging with this subject matter, unless they were providing artists' studies or very discreet images that might appeal to an elevated artistic taste. Soon after the turn of the century, the American Pictorialist Anne Brigman, a free spirit living on the West Coast, posed friends in the nude as they communed with nature. A member of the Photo-Secession, Brigman had work exhibited and reproduced in *Camera Work*, but had few emulators on this side of the Atlantic. In the interwar years, however, the nude female body became a subject of much interest to women photographers. Although their engagement was due in no small measure to the recognition that they, instead of men, could control how the female body was represented, it also allowed them free play with the formal elements that were of great interest in the arts of the time. Imogen Cunningham in the United States (another West Coast free spirit), and Ergy Landau, Lee Miller, and Dorothy Wilding in Europe were among those attracted in the 1920s and 1930s to the more formal aspects of representation. That the nude female figure might express more than formalist concerns also inspired the work of Ruth Bernhard. Her mastery of a variety of photographic means, including montage, allowed her to express deep-seated if somewhat inchoate feelings about womanhood and femininity.

Several of those trained abroad brought the modernist vision to portraiture and other genres when they came to the United States. Lotte Jacobi, who started in the family business in Berlin, adapted the starkness visible in her portraits of the dancer Nuraya and Lotte Lenya to the less-sophisticated taste of Americans when she settled in New York. She made a living as a portraitist, but Berenice Abbott,

who had assisted Man Ray in Paris before setting up a portrait studio on her own, was less successful in this genre after her return to the States. Shortly afterward, she turned to making documents of New York architecture and street activities. These are only two of the numbers of women who, attempting to make a living from portraiture, moved from city to city in Europe before the turmoil of war sent them across the Atlantic.

Aside from description and aesthetic enhancement, portraiture has always had ancillary purposes, which women as well as men understood. Käsebier's depictions of Native American Indians, made around 1900, represented her effort to counter stereotypes about this group of people by presenting them in an ennobling manner, as in images of Zitkala-Sa, a young Sioux teacher and musician. Working some thirty years later, Consuelo Kanaga sought through portraiture to counter racist ideas at a time when blacks and whites in the United States were strictly segregated.

Dorothea Lange is the best known of a number of American women photographers who used the portrait (of both men and women) to reveal the trauma of being displaced, poor, and considered worthless by those higher on the economic ladder. Possessed with both empathy and patience, she was able to distill the meaning of the social crisis by her astute organization of pictorial form. Her well-known image of a destitute woman with two children became the icon of the project organized by the Farm Security Administration, on which she was one of three women employed. Portraits of Appalachian mountain folk and blacks living in the South, made in the late 1920s and early 1930s by Doris Ulmann and Louise Dahl-Wolf, also were meant to show that those living in poverty were nevertheless worthy of attention. Margaret Bourke-White, a highly paid celebrant of industrial enterprise on the staff of *Fortune* magazine, joined those using the portrait to reveal the ravages of the Great Depression in the South. *You Have Seen Their Faces*, her depiction of Southern poverty with text by playwright Erskine Caldwell, was one of the first visual documents to deal with social issues in an affordable paperback format. Below the border in Mexico, Tina Modotti was engaged with a similar theme. Having learned the techniques of photography from Edward Weston, she showed herself to be more interested than her mentor in the role of poor women in Mexican society. All these women, along with a small number of urban street photographers who were members or friends of the Photo League in New York City, were attempting, through portraiture, to present ordinary Americans of whatever color or ethnic background in a dignified way at a time when racism was rampant in the United States.

Portraiture has also served as a way to make a statement about women's position in society. Around the turn of the century, Frances Benjamin Johnston somewhat playfully portrayed herself as a liberated woman—cigarette and beer mug in each hand, ankle and leg exposed. Johnson did not depict her camera, but did include a row of her own photographs on the mantel. Lotte Jacobi shows her face alongside the camera, but more frequently women substituted the mechanism for their own features. Working in the 1920s, Alma Lavenson, a remarkably handsome Californian, chose to portray herself as a professional person rather than as a great beauty; one sees only hands and lens. The "I am a Camera" type of self-portrait, in which the apparatus acclaims the maker's professionalism, attracted Ilse Bing and Germaine Krull as a way to assert professionalism rather than gender, although it sometimes is possible to see the maker's face reflected in the lens.

Besides making an unambiguous statement about the importance of one's profession, women have used the self-portrait to examine private fantasies and nightmares. French photographer Claude Cahun, a lesbian member of a Surrealist artists' group in the 1930s, made endless images of herself—both straight photographs and montages—ostensibly to discover her true identity. Some forty years later, psychologically troubled Francesca Woodman portrayed herself as perpetually disturbed and alone.

The invention of handheld fast-action cameras that could record under low light, typified by the Leica, changed the nature of portraiture by enabling photographers to "capture" expression and

gesture whether or not the subject was aware of being photographed. (Previously, photographers using large-format equipment had sometimes used right-angle prisms in the lenses to deflect attention.) Lisette Model started her career by making sardonic street portraits of idle gamblers on the boulevard in Cannes. She continued in the same vein after arriving in the United States in 1938, seeking out individuals who might be portrayed in the midst of an exaggerated stance or expression. Helen Levitt's approach to street life was considerably less ascerbic. Photographing with a Leica in working-class neighborhoods, this photographer sought out moments of inspired fun and quixotic behavior, which she viewed with a generous spirit.

Model's mordant vision, which seemed in accord with new attitudes emerging in the United States during the early postwar period, influenced a number of young photographers, including Diane Arbus. Arbus's scathing depictions of middle-class men, women, and children, along with her more sympathetic portrayal of those on the fringes of bourgeois society, owe something as well to the sensationalism of Weegee's work as a news photographer in the 1940s.

Since the beginning of the twentieth century, photographs had slowly been taking the place of hand-drawn graphic works as illustrations in print media. With the flowering of picture magazines in the 1930s, first in Europe and then in the United States, the work of many European and American social commentators often reached the public as reproductions in magazines. In fact, by the 1950s, previous distinctions between documentation, street photography, and photojournalism had become blurred. Women began to work more frequently as photojournalists, and, given the perception held by women as well as men that women tended to be more empathetic, women were often assigned or chose to depict others of their gender. Eve Arnold, Martine Franck, Barbara Klemm, Mary Ellen Mark, and Marilyn Silverstone are among those whose commissioned magazine work as well as their self-imposed projects frequently dealt with the activities and predicaments of women in various societies throughout the world.

After the mid-century, women also made gains in fashion and celebrity portraiture. In Europe, Sarah Moon, Bettina Rheims, and Ellen von Unwerth were following in the path opened much earlier by Madame d'Ora and Madame Yevonde. Similarly, in the United States, Wynn Richards in the 1920s, Toni Frisell in the 1930s, and Louise Dahl-Wolfe in the 1940s made careers for themselves in fashion photography. As a woman making celebrity shots for MGM Studios in Hollywood in the 1920s, Ruth Harriet Louise had been unique; by the 1970s many more women were engaged in portraying the famous, the most notable being Annie Leibowitz.

The earlier feminist movement that had gained force in the late 1800s had been one of the factors inspiring women to become photographers; the resurgent feminism of the 1970s influenced both their approaches and their themes. Portraiture became a way for the female sitter to express her own desires and dreams through choice of costume and pose rather than by following the directives of the photographer. Other photographers were drawn to subjects formerly considered unappealing—among them women who had undergone radical surgeries such as face lifts or mastectomies, or the very elderly, who might be candidly depicted with their warts and wrinkles, as in Barbara Klemm's portrait of photographer Leni Riefenstahl. Fashion work in particular displayed the effects of this transformation in approach. Rheims and von Unwerth, for instance, felt free to portray their subjects in the kind of sexually provocative manner that formerly had been the exclusive preserve of male photographers.

Any selection of images by women inspires queries about the way that women see and whether, when their camera lenses are focused on other women, the resulting images are noticeably different from those produced by male photographers. Is there a woman's vision? This question has been debated for at least thirty years, but the answers must be equivocal. Many of the photographs produced by women

over time—even those in which they merely figure as a subject—might be difficult to categorize by the maker's gender. But indeed there were times when women fulfilled society's expectations that they would produce images of greater artistry and empathy than their male counterparts, especially if they focused on other women and/or children. Certainly, women engaged by later feminist ideals sought out themes that were of particular interest to their gender, and did render them in ways that might not have occurred to male photographers. In the past, many women had been upset by inequities of opportunities and pay between male and female photographers, but most, I expect, would agree that all photographs should be judged on how well they convey the individual maker's ideas and feelings. Lange felt that for a photograph to be satisfying it should be "full of the world," including, of course, the world of women's feelings and thoughts. The selections in this book will grant the viewer an opportunity to make this judgment regarding images of women by women.

A PICTORIAL HISTORY

OF WOMEN'S PHOTOGRAPHY

PROLOGUE: IN THE 19TH CENTURY

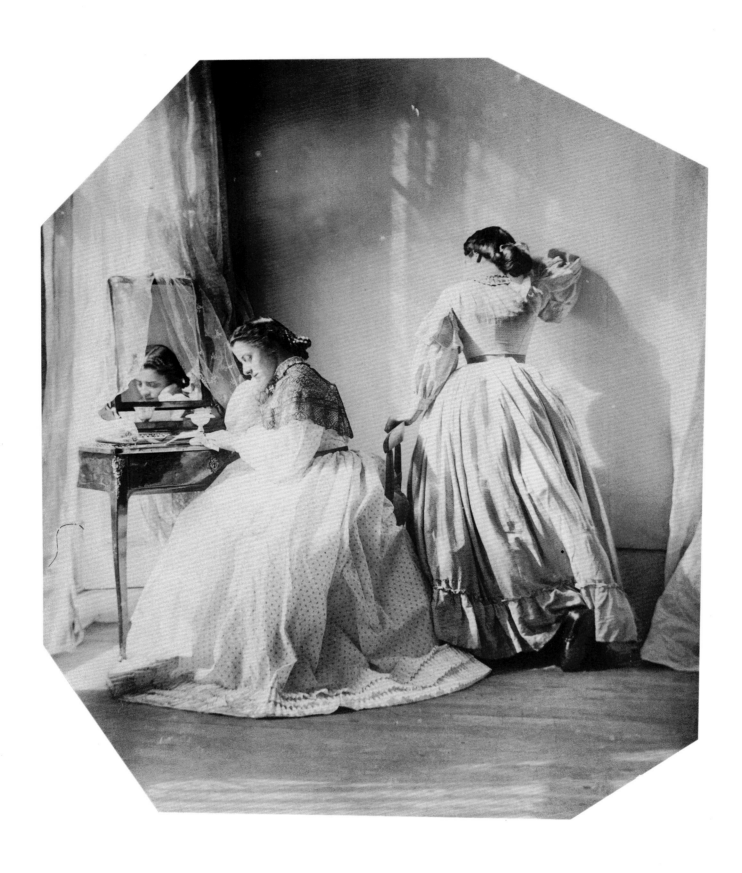

1 | Clementina, Lady Hawarden
Study from Life (Portrait of Isabella Grace and Clementina Maude), c. 1860

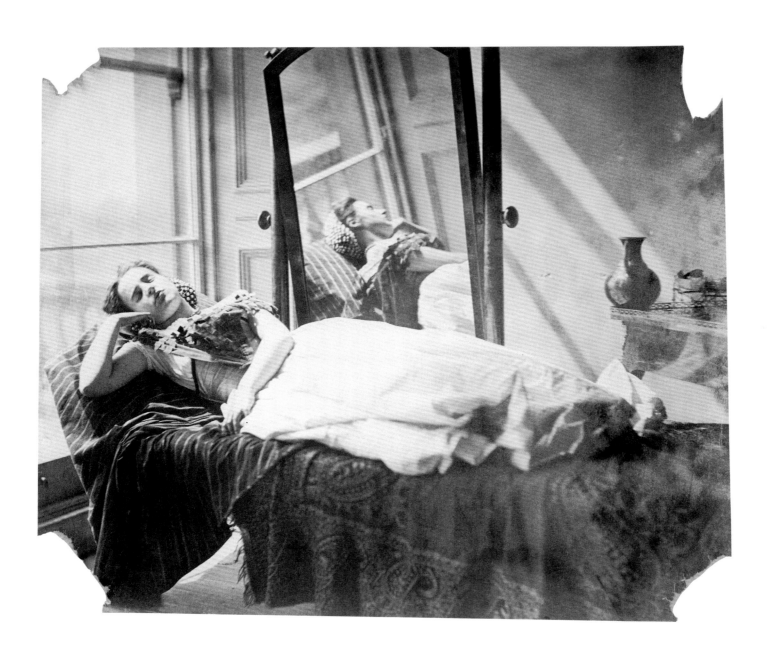

2 | Clementina, Lady Hawarden
Portrait of Clementina Maude, c. 1863-64

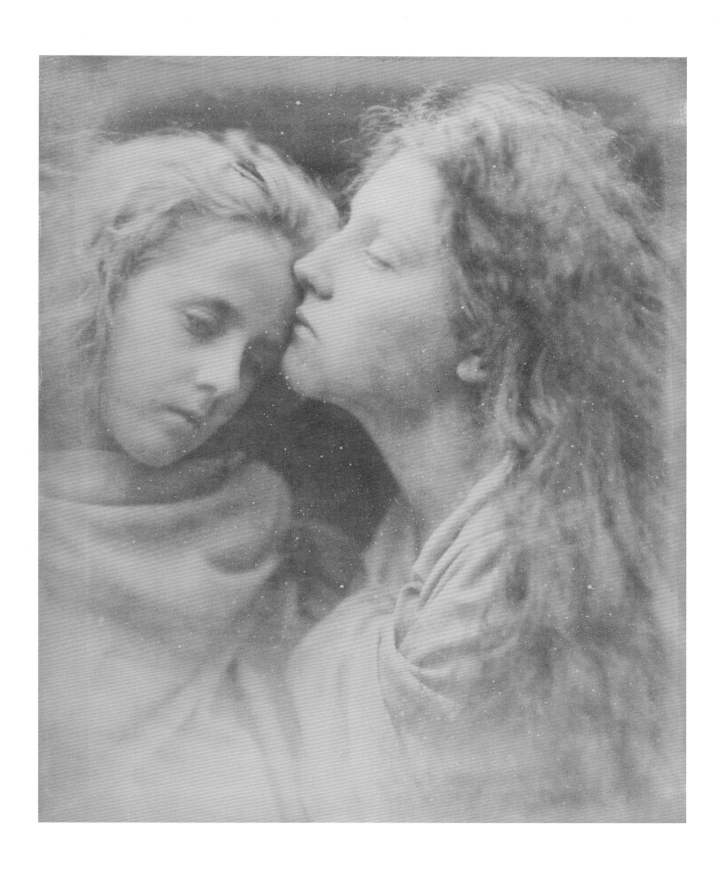

3 | Julia Margaret Cameron
"The Kiss of Peace", 1869

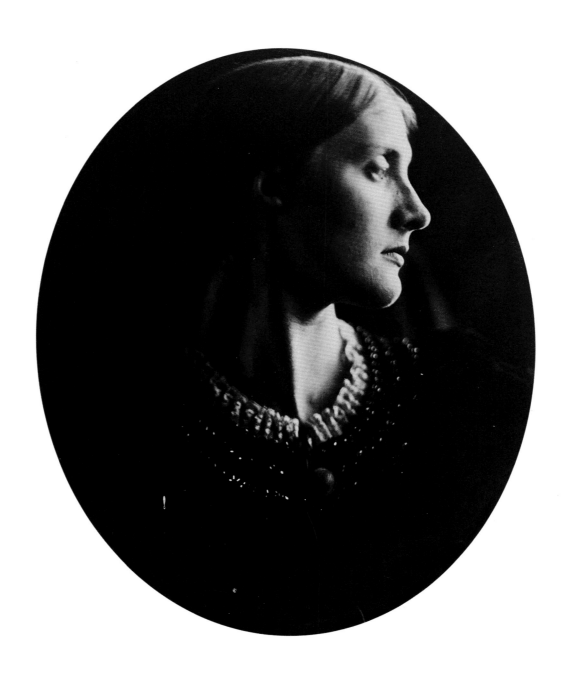

4 | Julia Margaret Cameron
Mrs. Herbert Duckworth (Julia Jackson), c. 1867

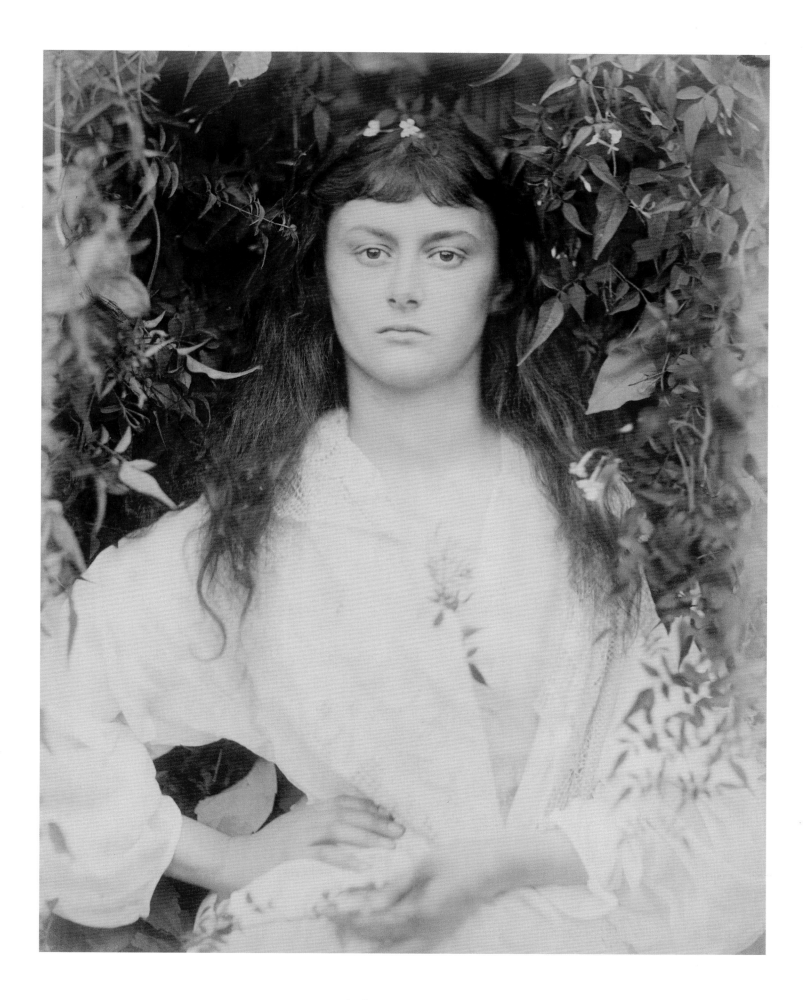

5 | Julia Margaret Cameron
"Pomona" (Alice Liddell), 1872

THE BEGINNING OF THE 20TH CENTURY

6 | Gertrude Käsebier
"Blessed Art Thou Among Women", c. 1900

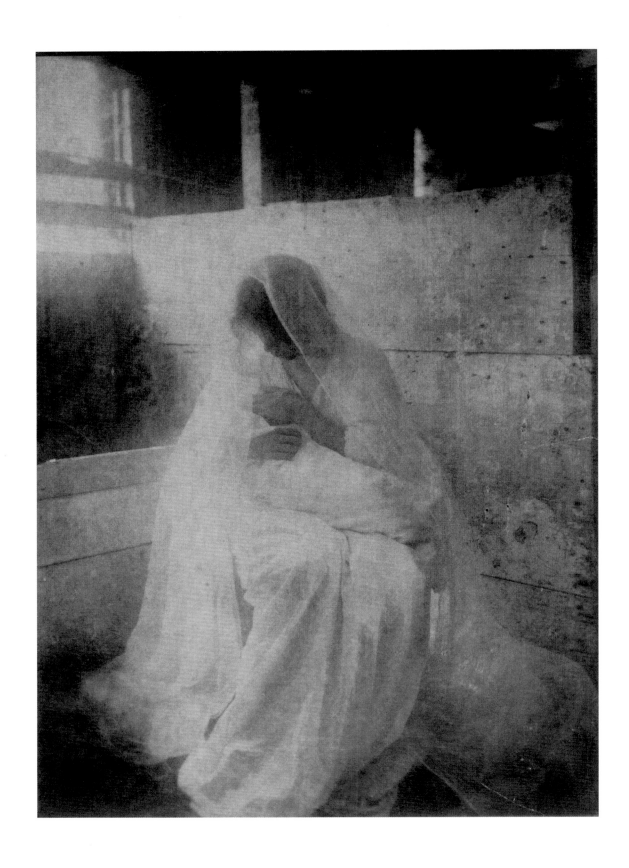

7 | Gertrude Käsebier
"*The Manger*", 1899

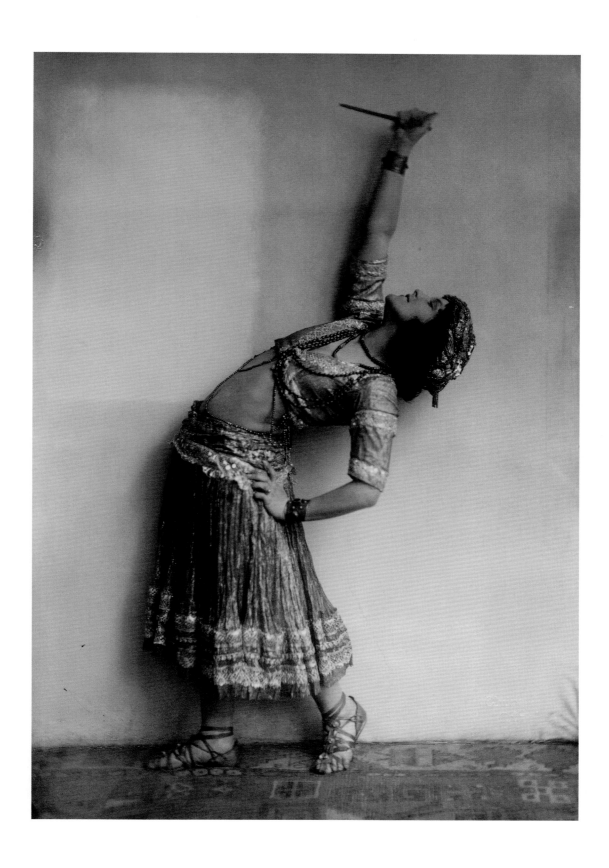

8 | Atelier Elvira
Dancer, Munich, c. 1910

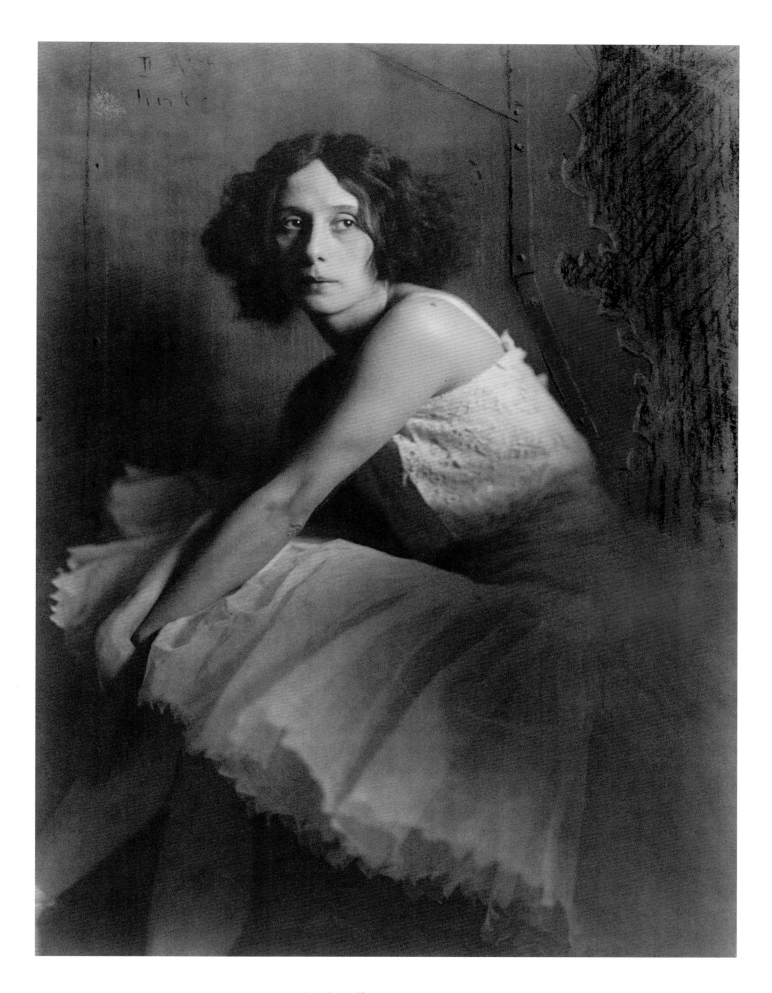

9| Madame d'Ora, i.e. Dora Kallmus
Anna Pawlowa, Vienna, 1913

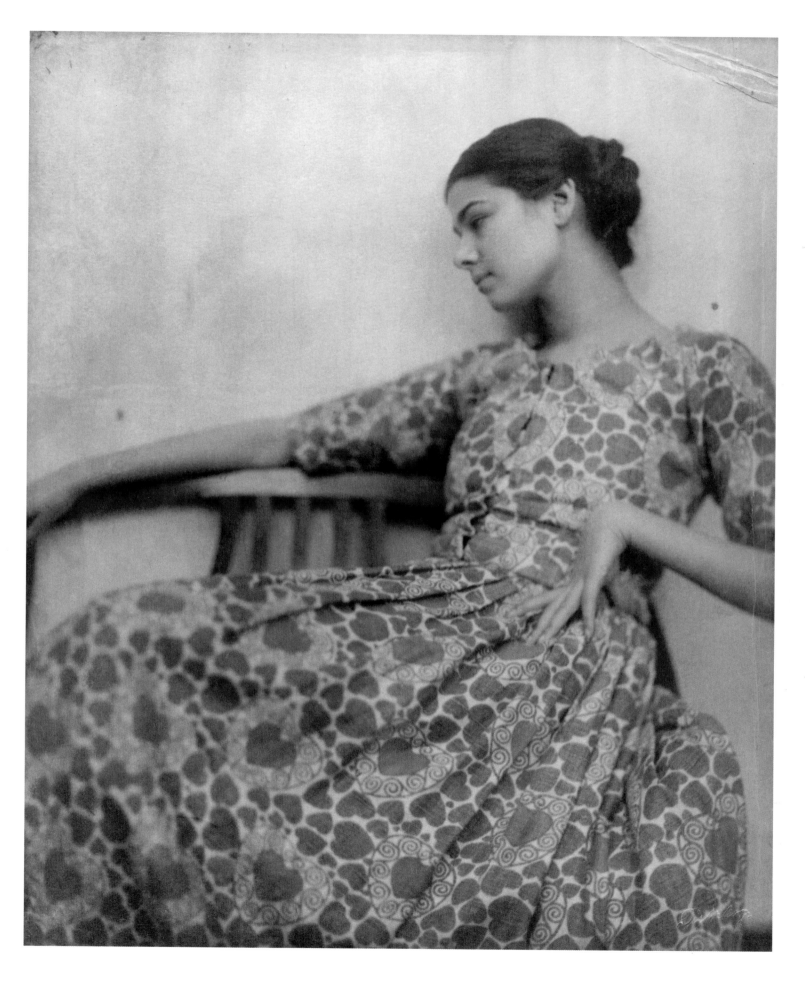

10| Minya Diez-Dührkoop
Portrait of a Young Woman (Clotilde Derp-Sacharoff), c. 1915

THE TWENTIES

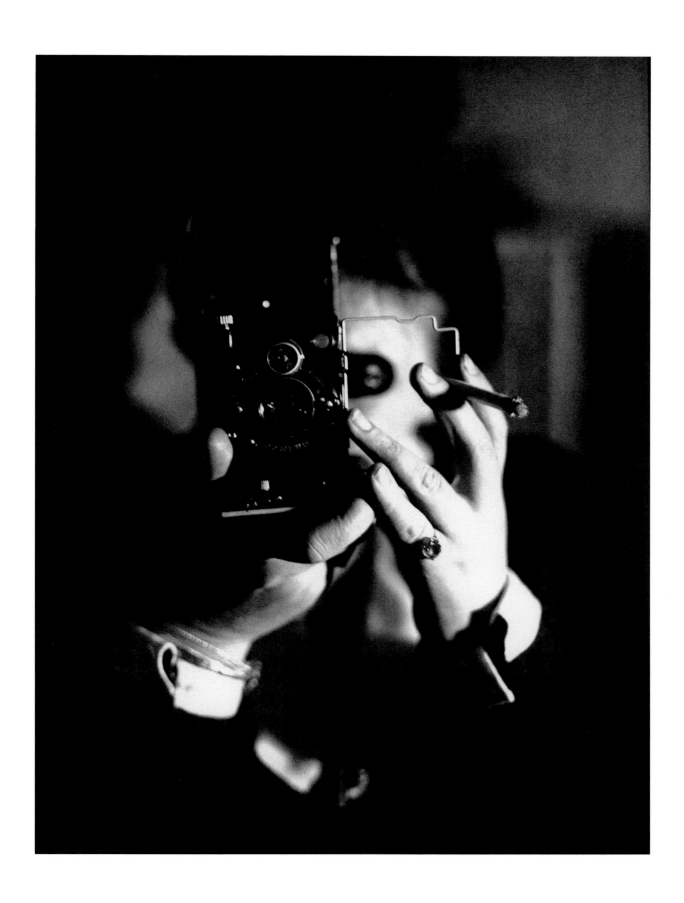

11 | Germaine Krull
Self-portrait with Ikarette, 1925

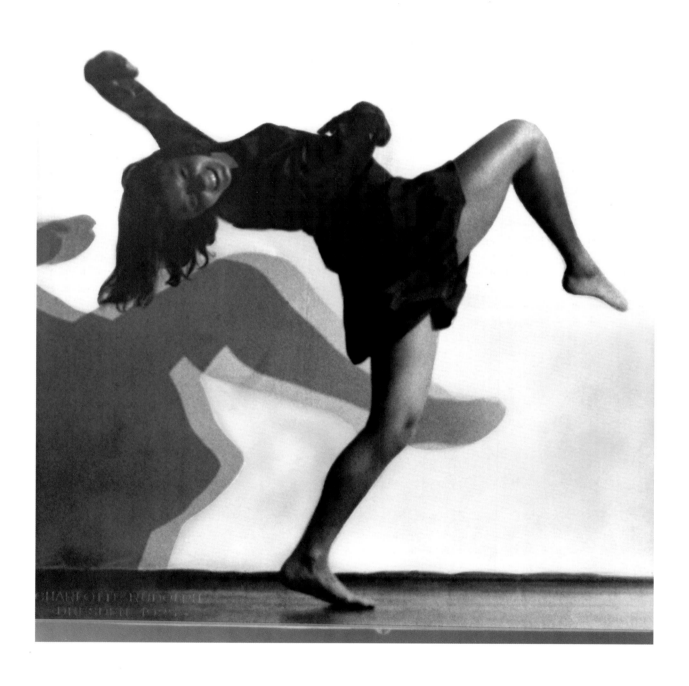

12 | Charlotte Rudolph
Gret Palucca with Double Shadow, 1925

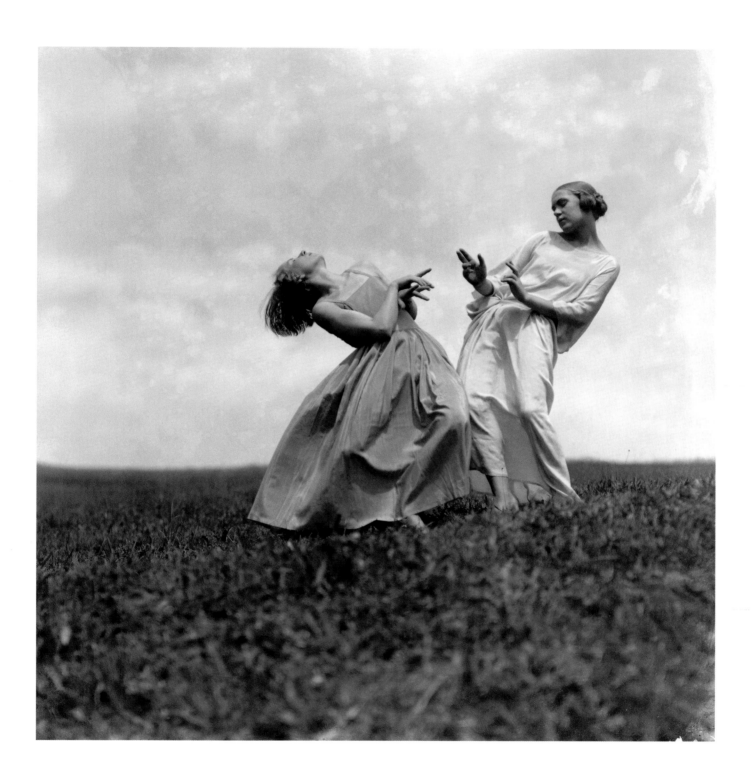

13 | Nelly, i.e. Elli Seraidari
Dancers of Mary Wigman's School, Saxe Switzerland, 1923

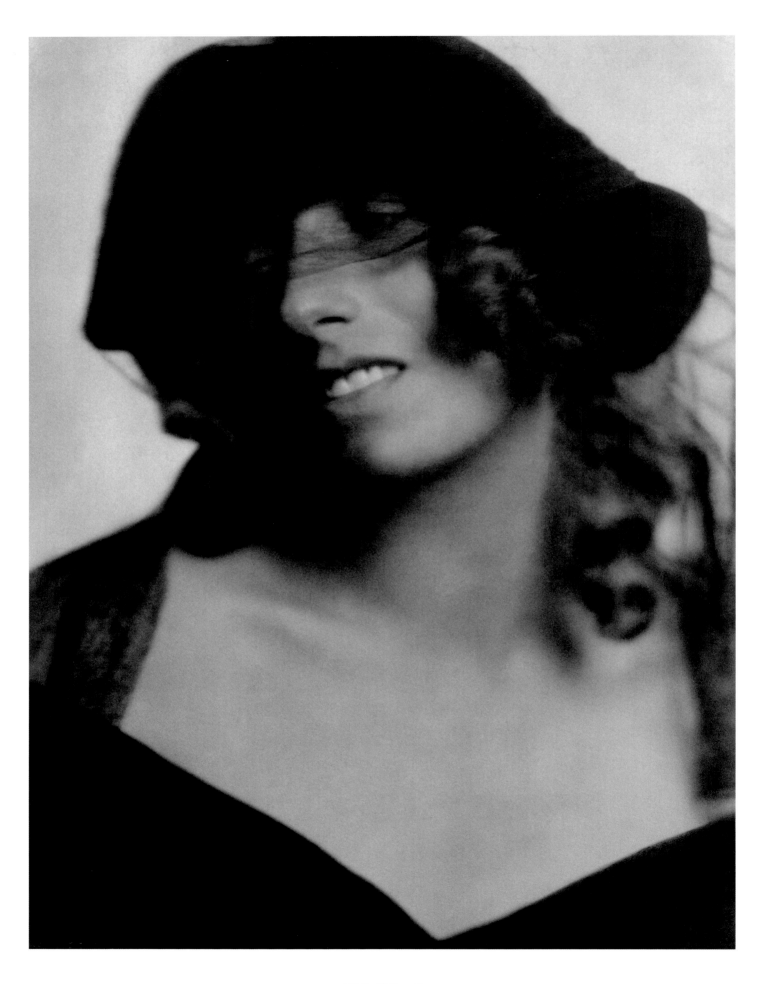

14 | Steffi Brandl
Portrait of Trude Fleischmann, C. 1925

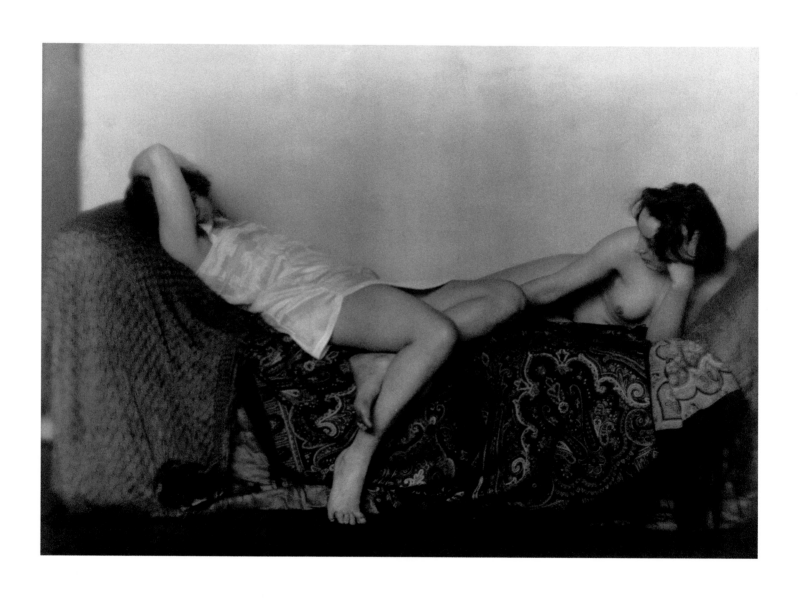

15 | Germaine Krull
Nudes, 1924

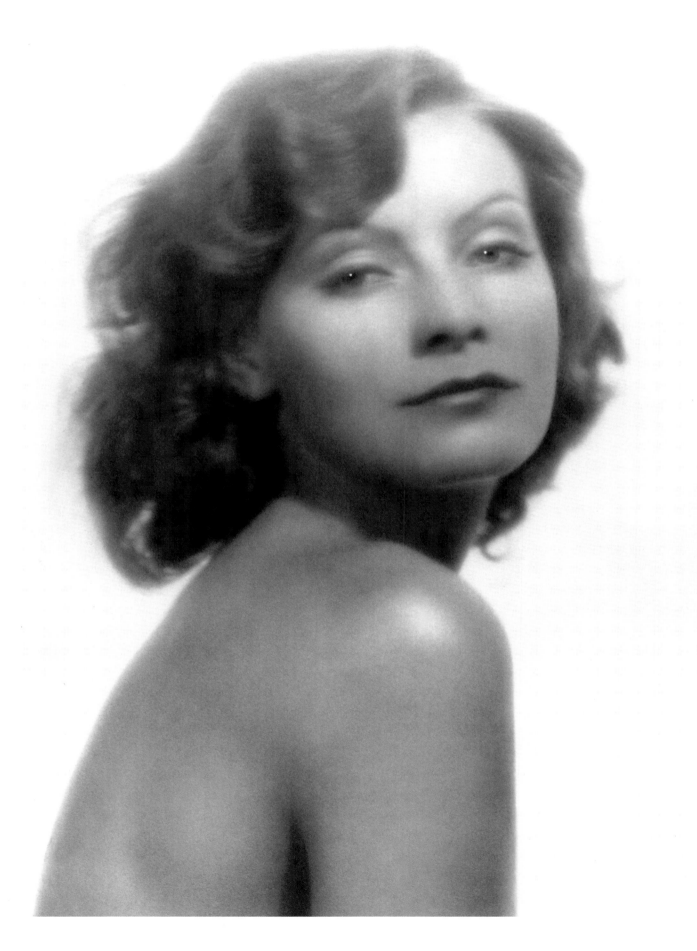

16 | Ruth Harriet Louise
Greta Garbo, Hollywood, c. 1926

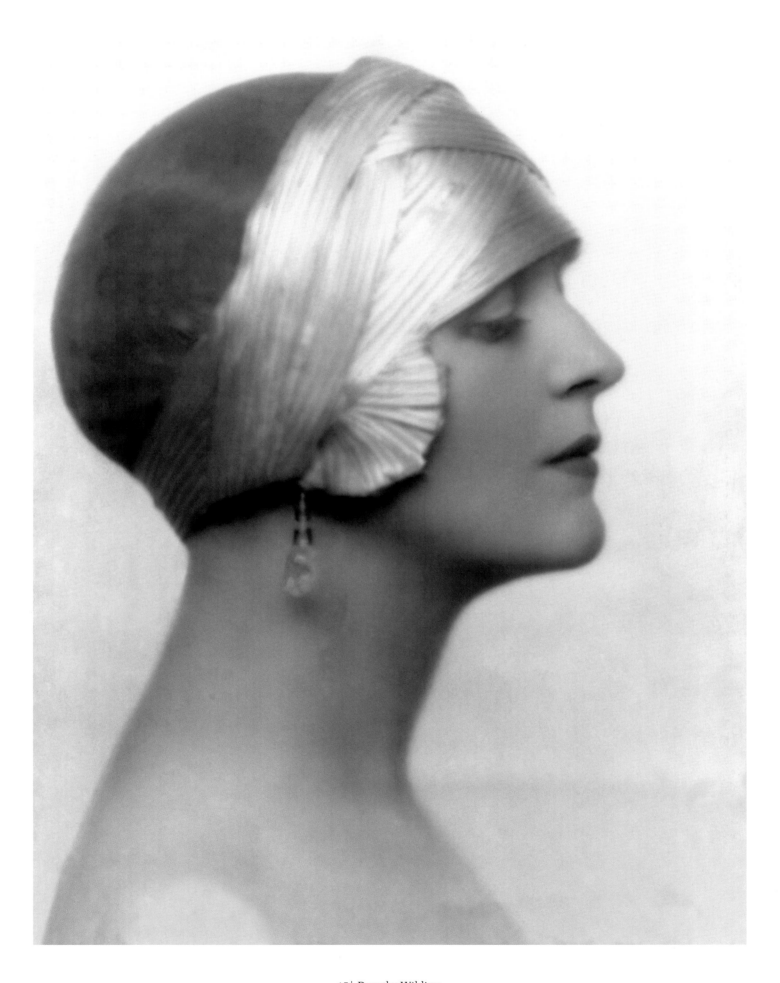

17 | Dorothy Wilding
Margaret Bannerman, London 1925

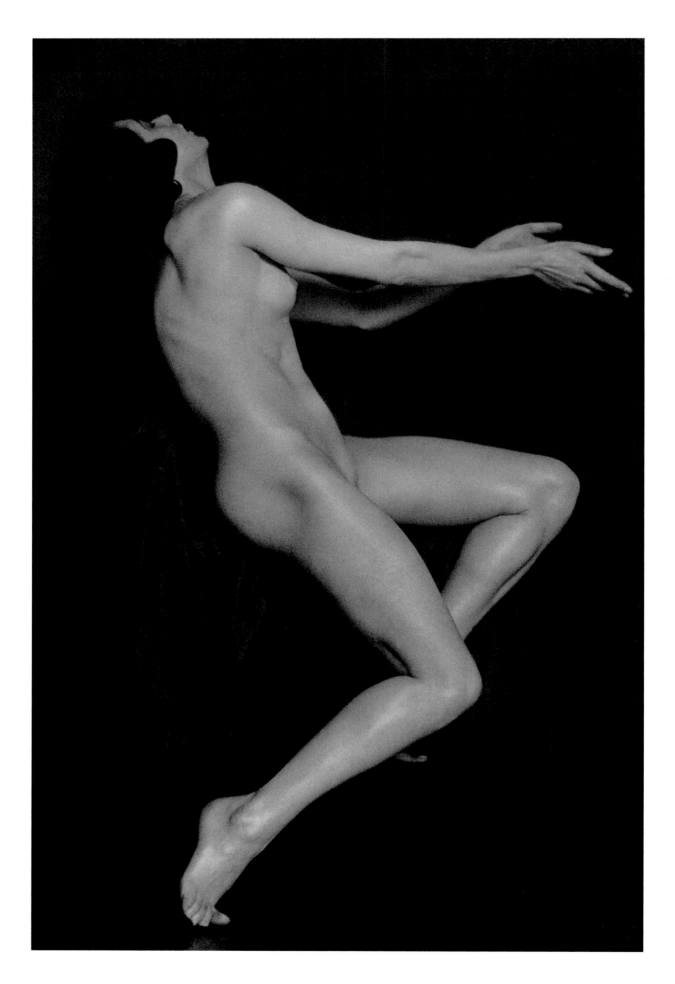

18| Trude Fleischmann
Claire Bauroff, Vienna 1925

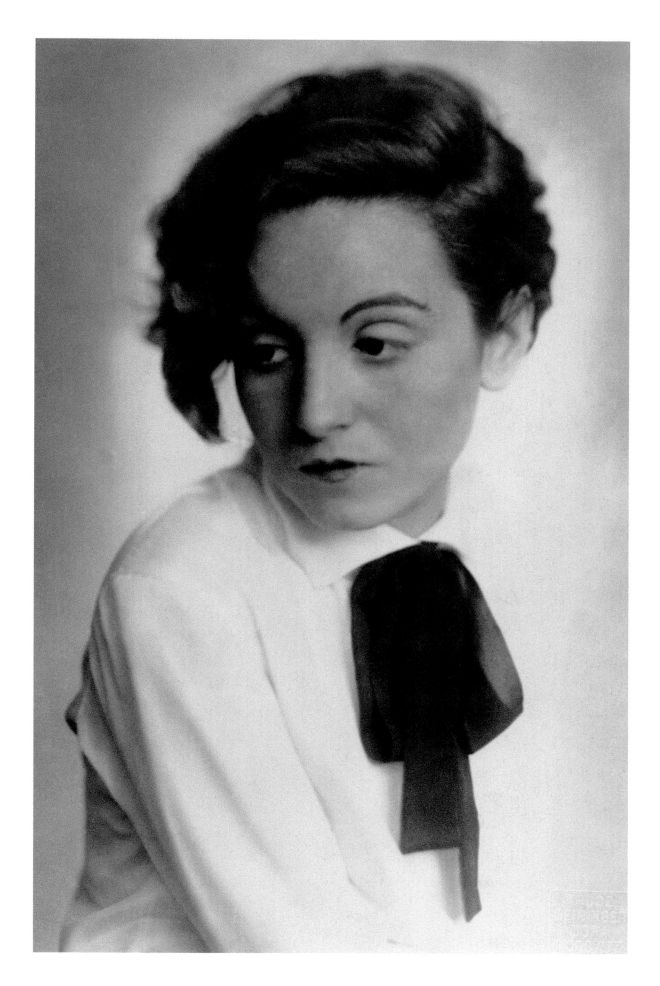

19 | Geiringer & Horovitz Studio
Elisabeth Bergner, Vienna 1929

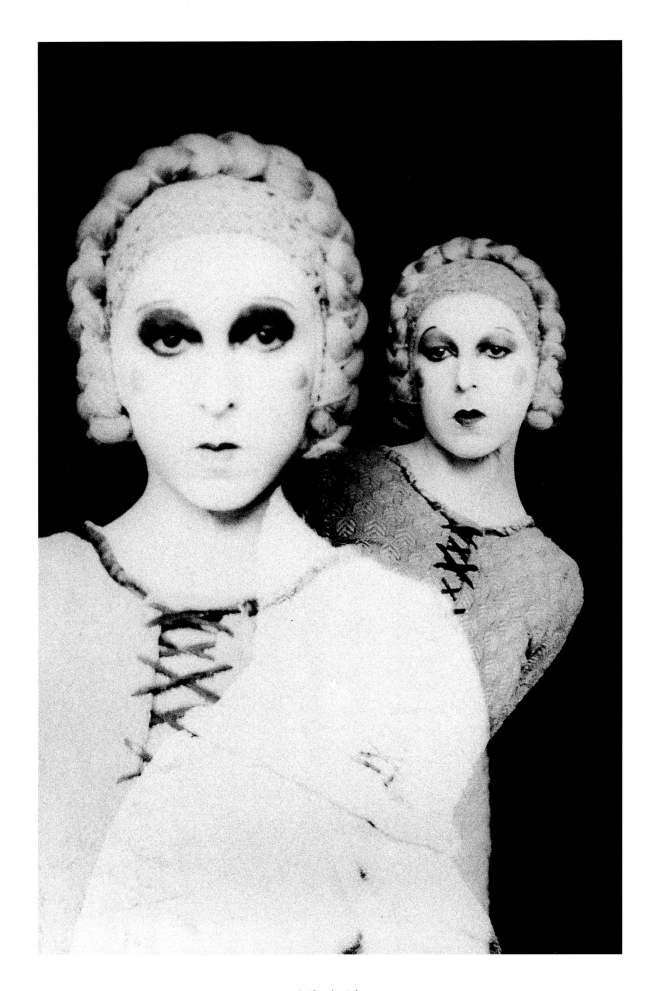

20 | Claude Cahun
Self-portrait, 1929

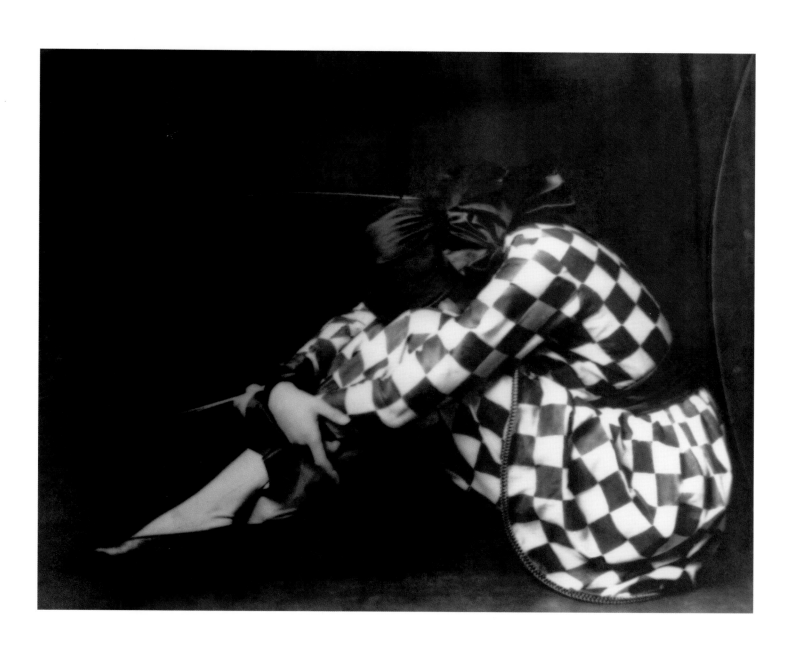

21 | Madame Yevonde
Self-portrait as Harlequin, 1925

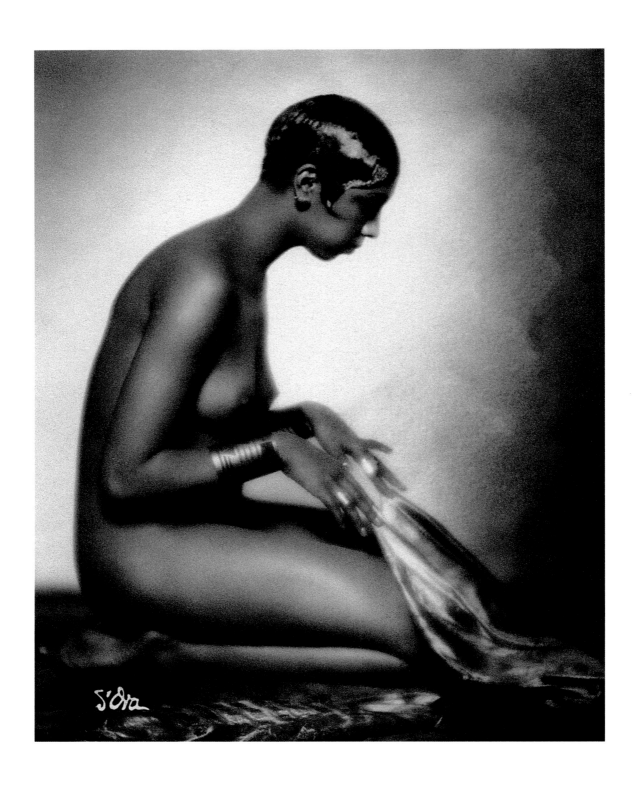

22 | Madame d'Ora, i.e. Dora Kallmus
Josephine Baker, Paris, late 1920s

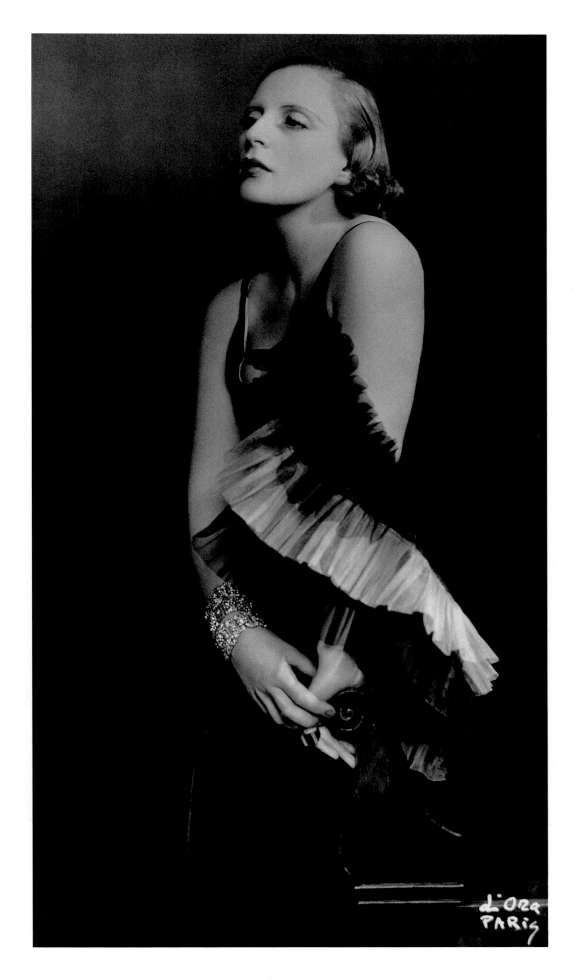

23 | Madame d'Ora, i.e. Dora Kallmus
Tamara de Lempicka, Paris, c. 1927

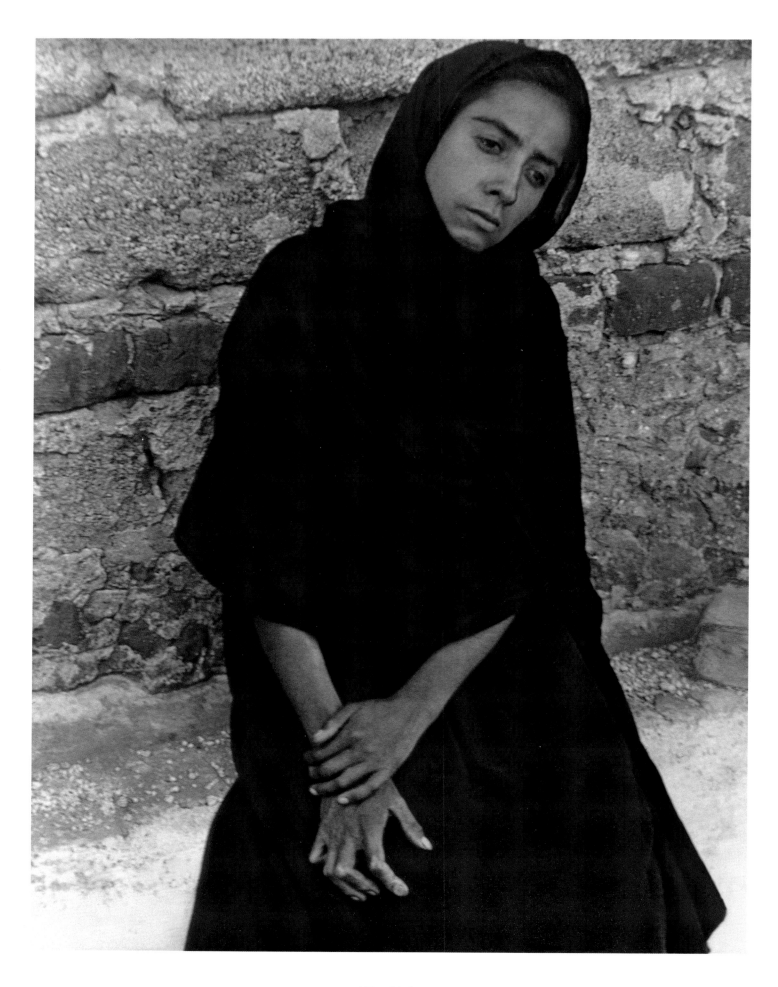

24 | Tina Modotti
Elisa, 1924

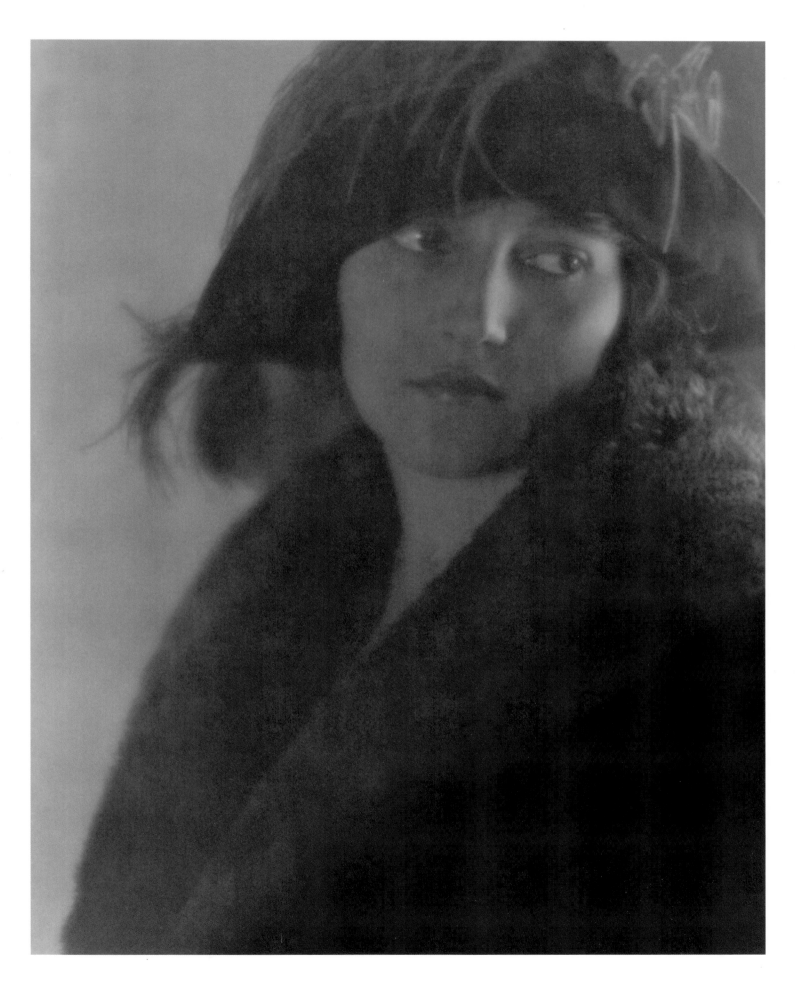

25 | Margrethe Mather
Florence Deshon, c. 1920

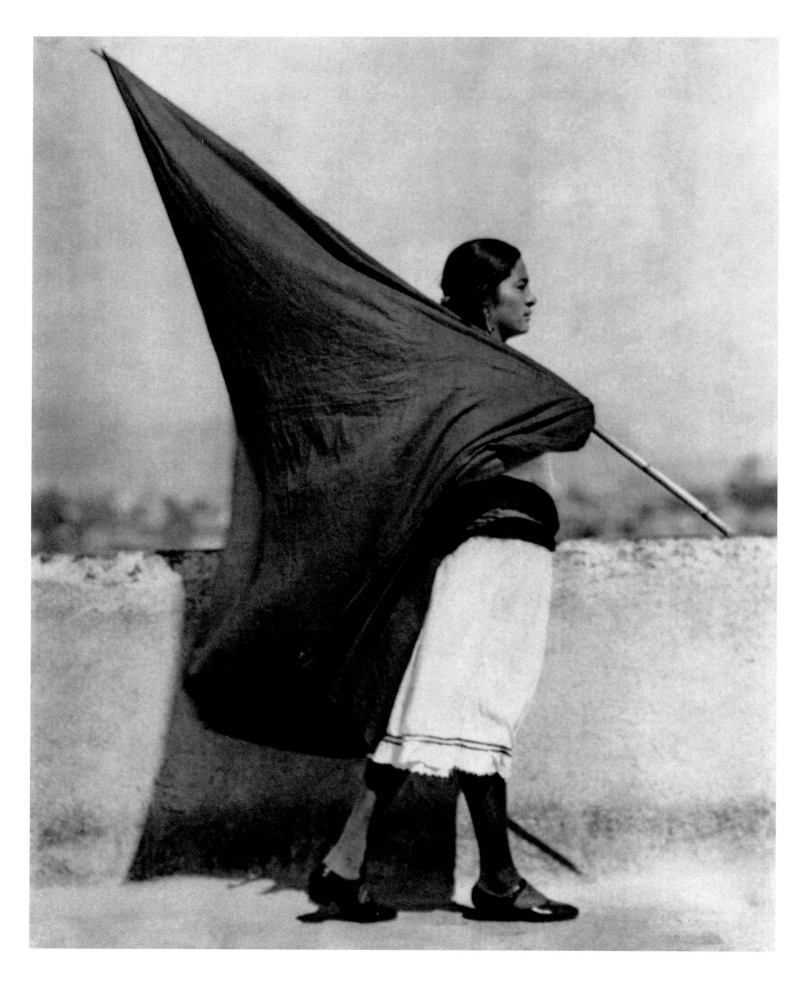

26 | Tina Modotti
Woman with Flag, c. 1928

27 | Berenice Abbott
Nora Joyce, c. 1927

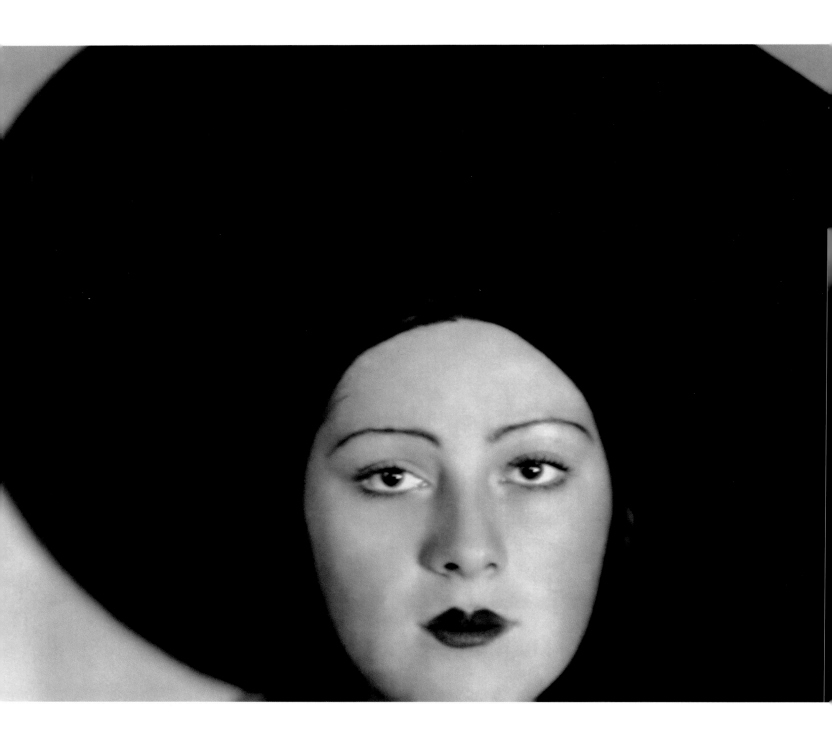

28 | Lotte Jacobi
Head of a Dancer, Berlin, c. 1929

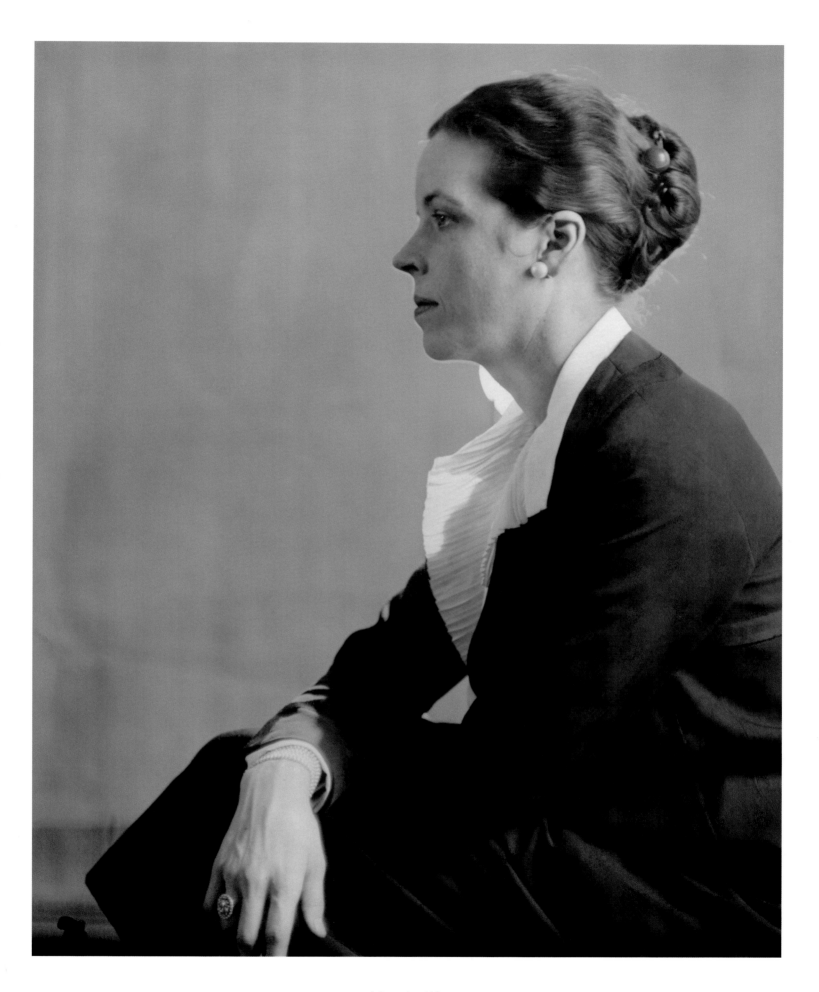

29 | Berenice Abbott
Djuna Barnes, 1926

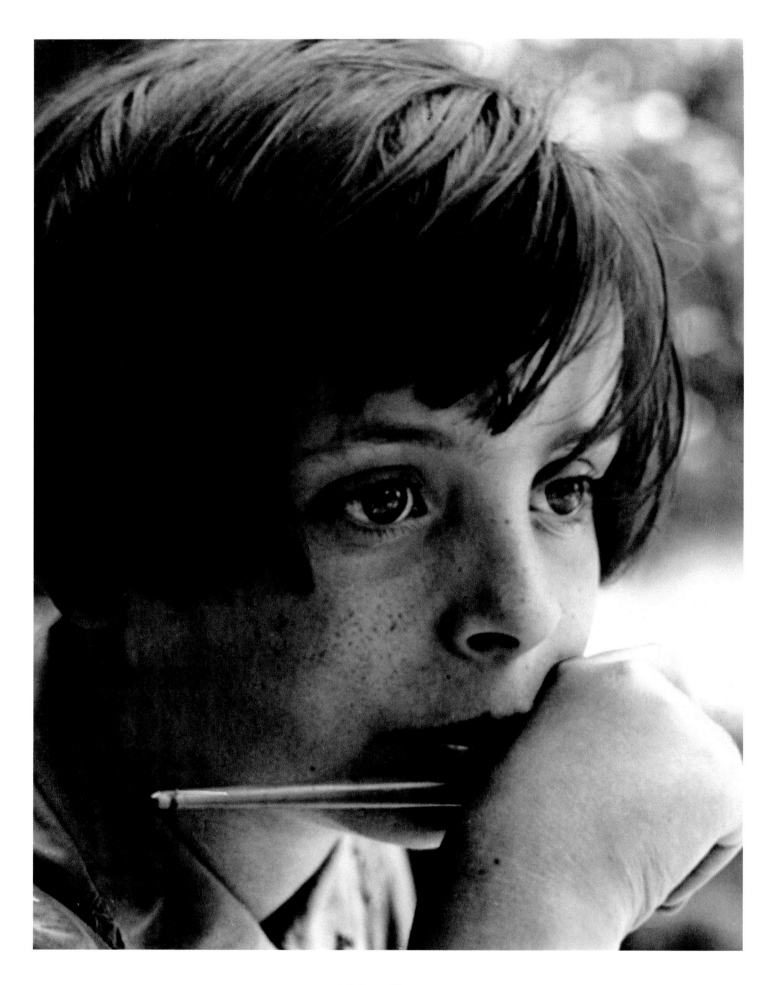

30 | Aenne Biermann
"Contemplation", c. 1929

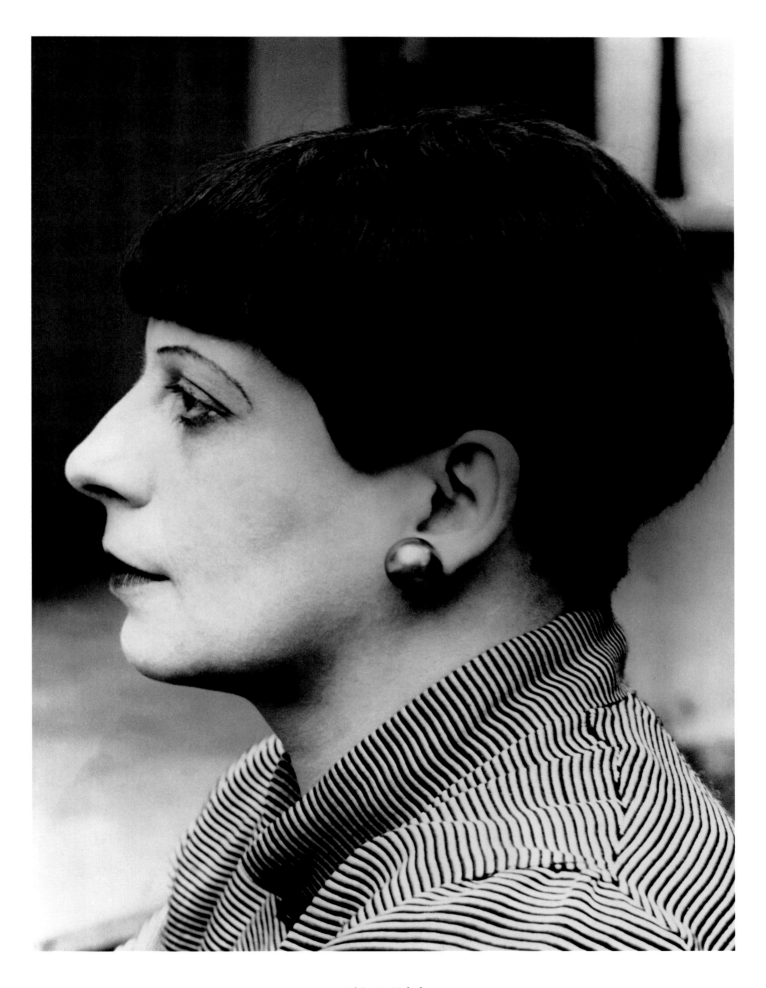

31 | Lucia Moholy
Portrait of Florence Henri, 1927

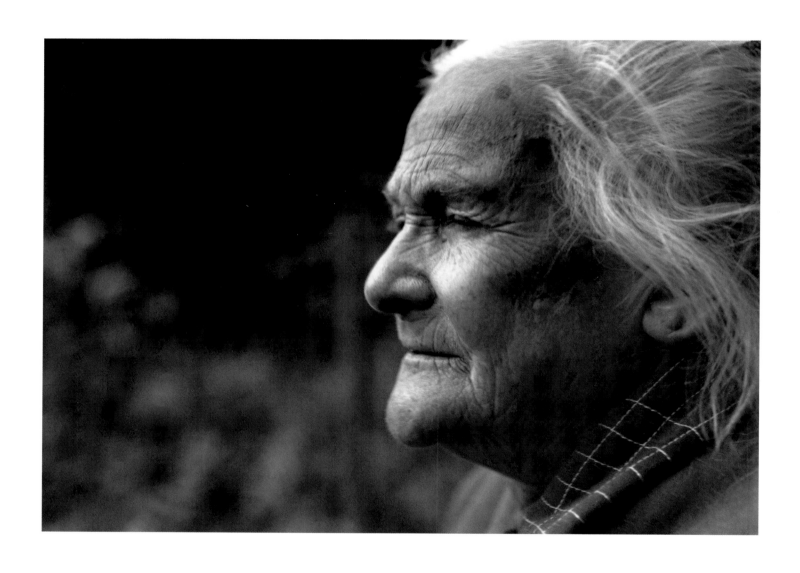

32 | Lucia Moholy
Portrait of Clara Zetkin, c. 1929/1930

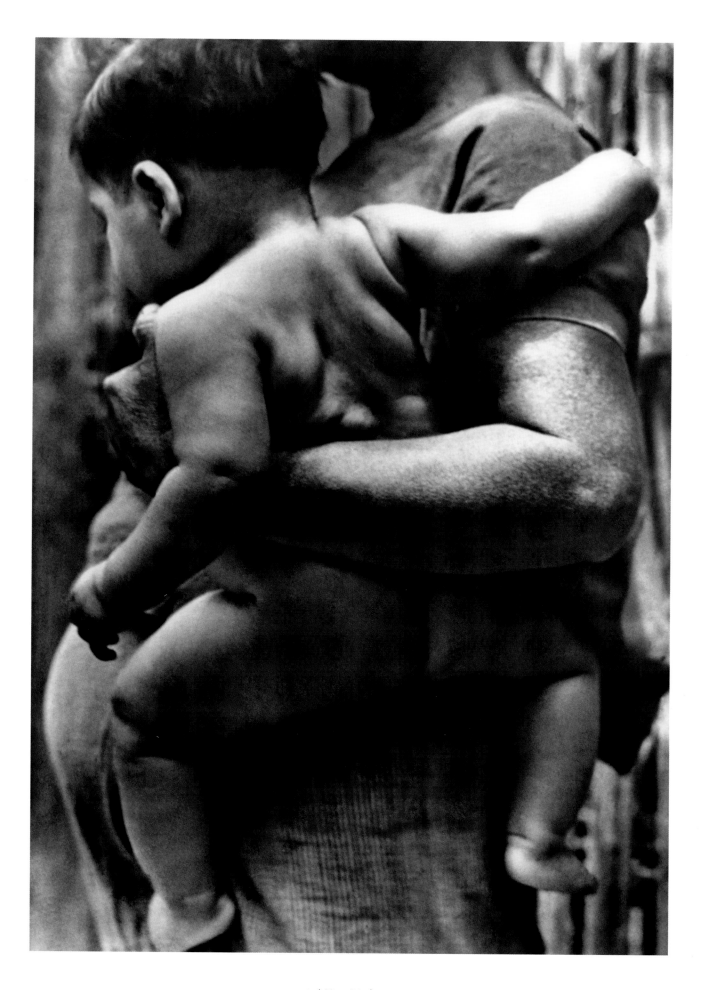

33 | Tina Modotti
Mother with Baby, Tehuantepec, 1929

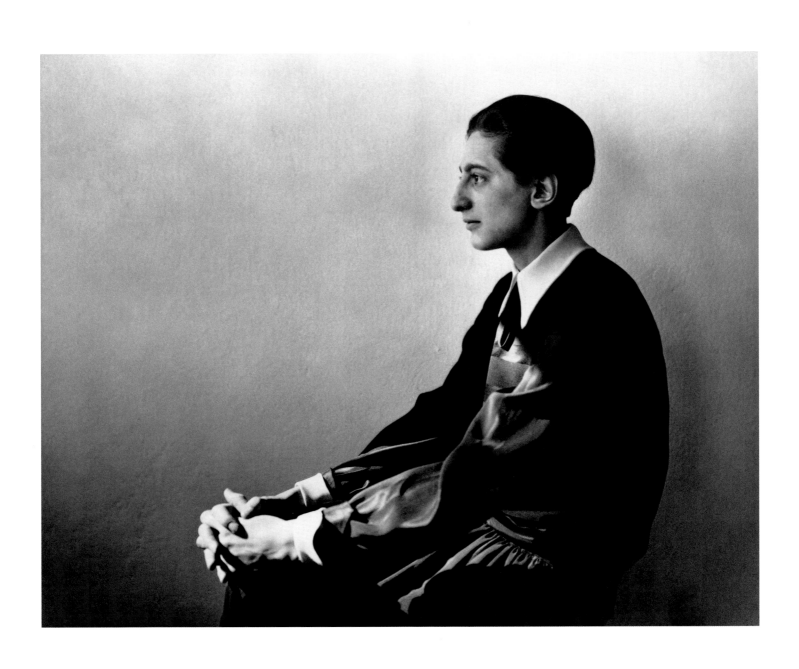

34 | Lucia Moholy
Portrait of Anni Albers, 1927

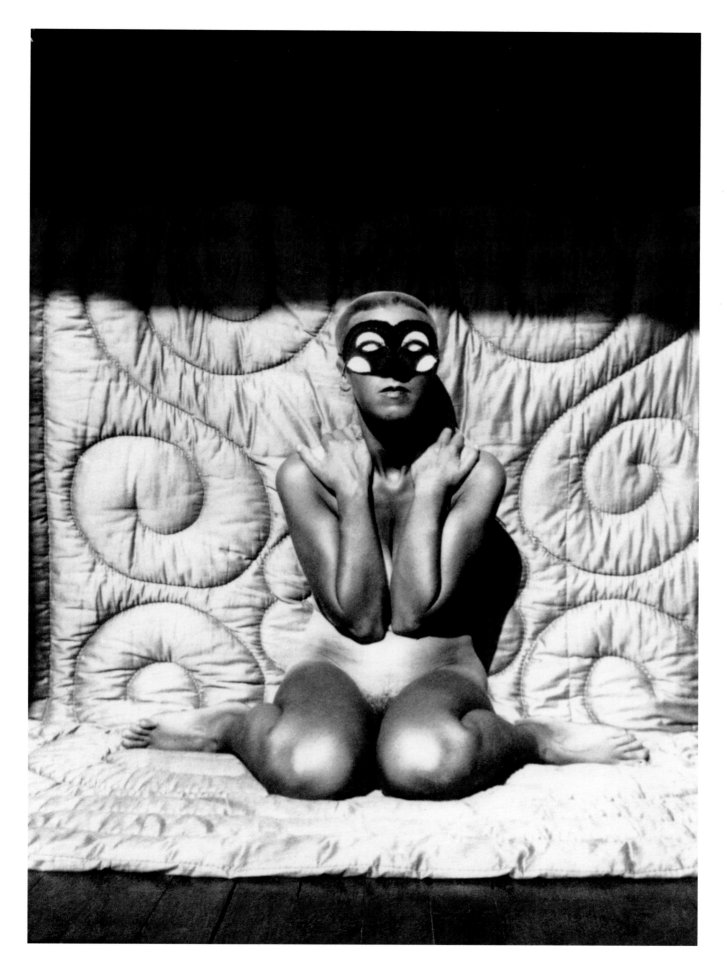

35 | Claude Cahun
Self-portrait, c. 1928

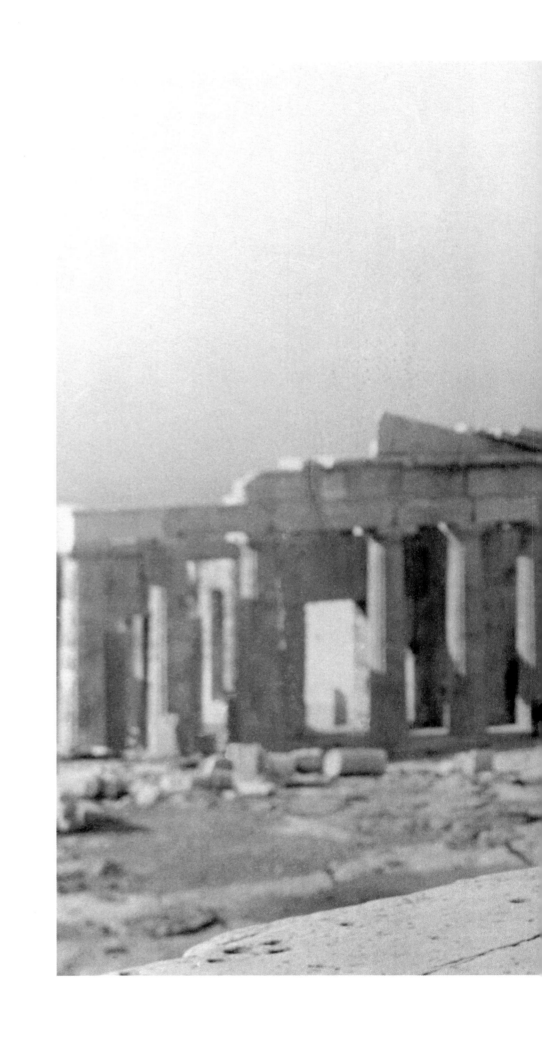

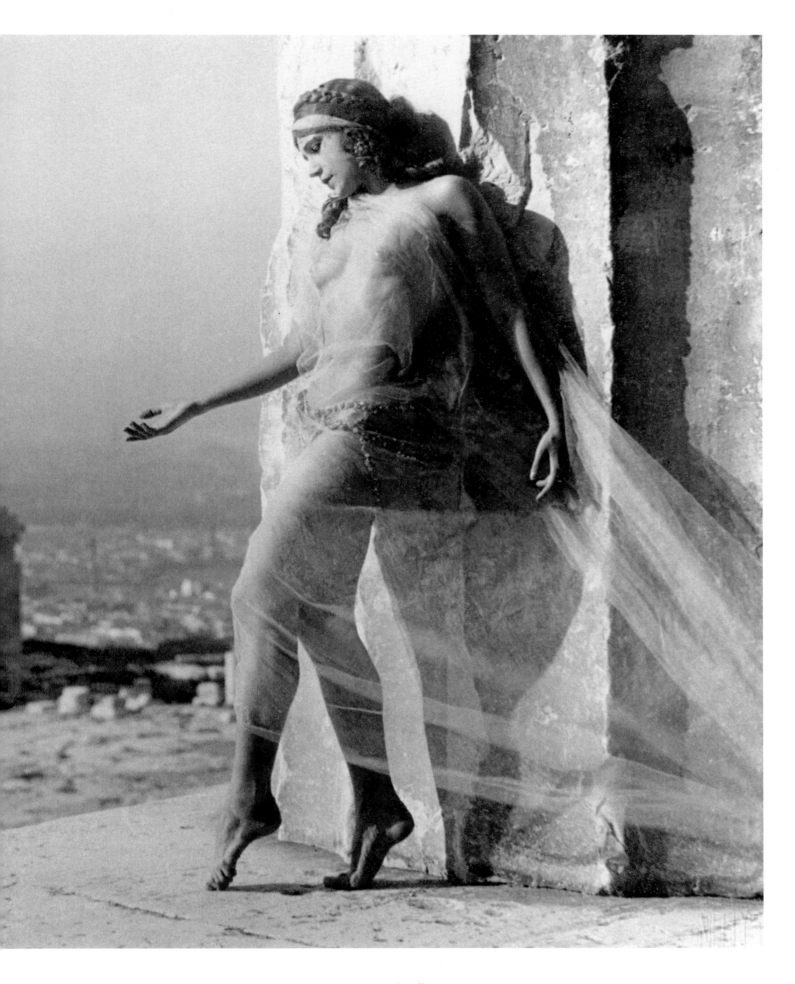

36 | Nelly
The Dancer Nikolska at the Parthenon, Athens, 1929

THE THIRTIES

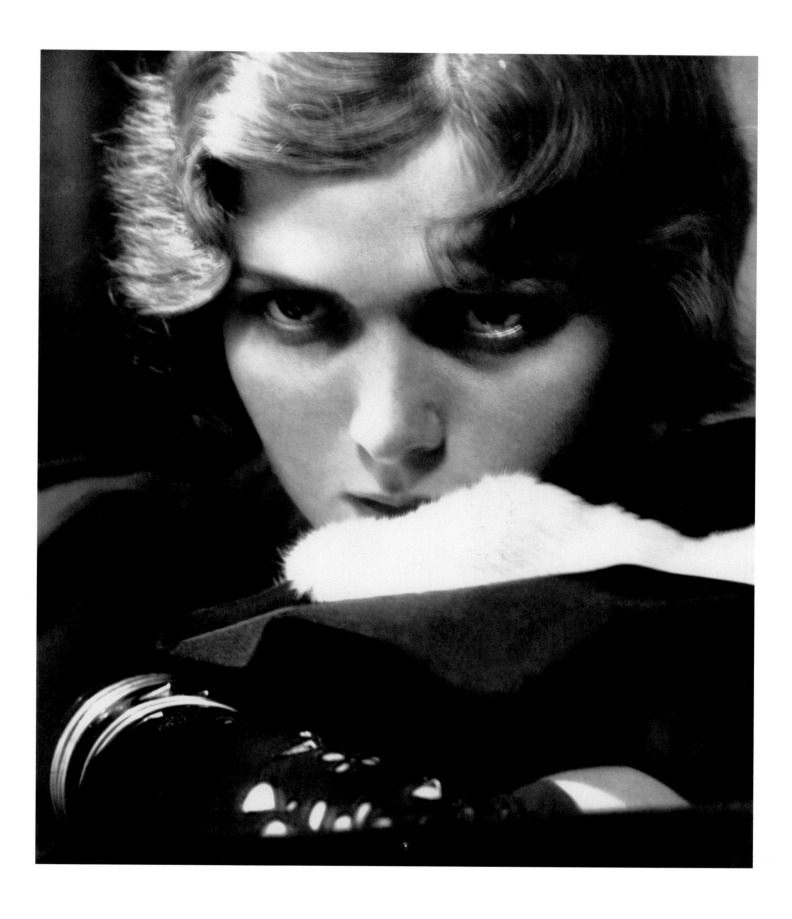

37 | Annelise Kretschmer
Head of a Young Woman, c. 1930

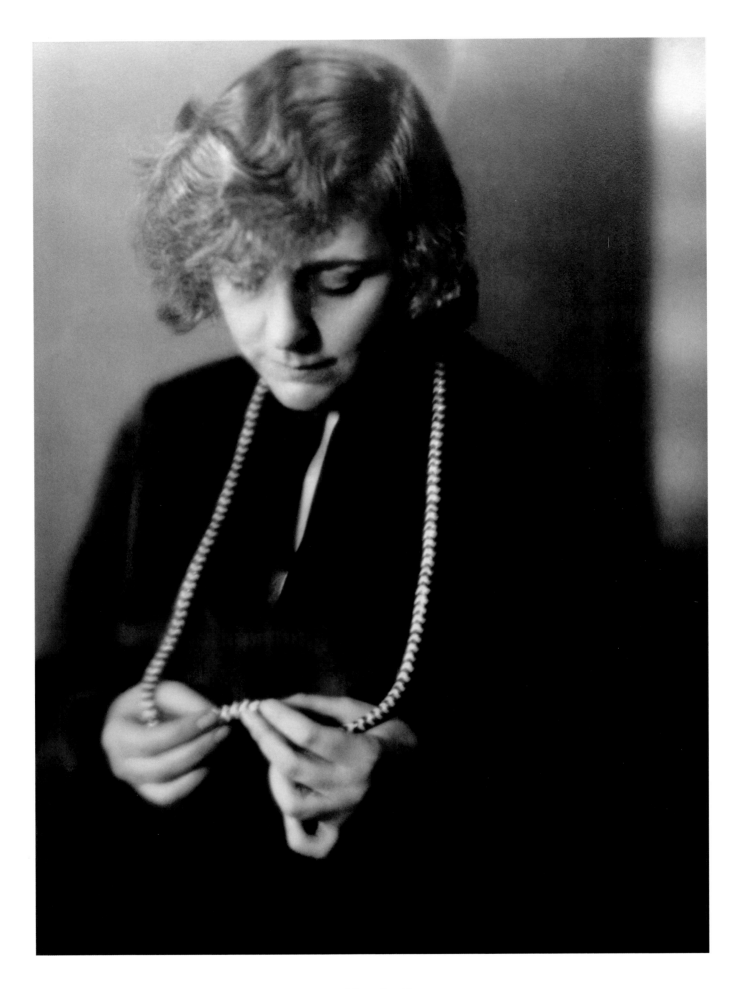

38 | Lotte Jacobi
Vicki Baum, Berlin, 1930

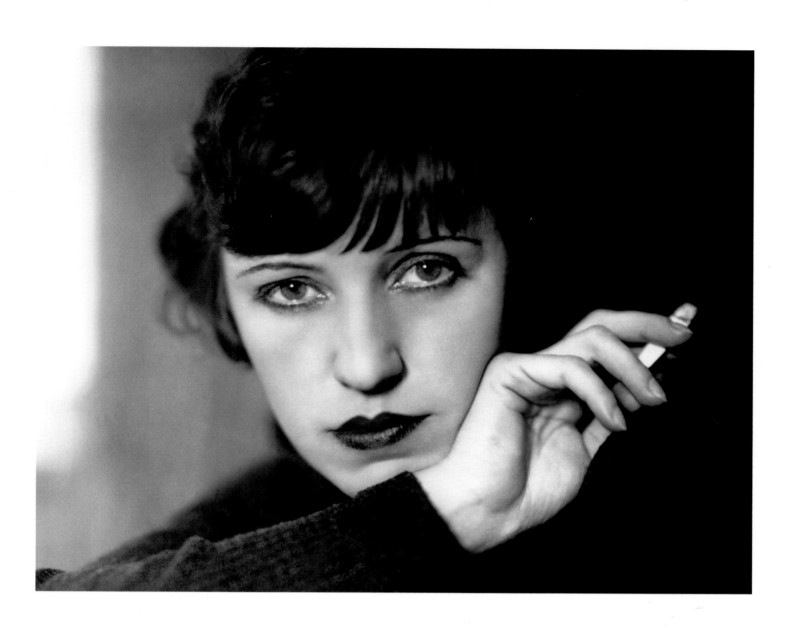

39| Lotte Jacobi
Lotte Lenya, Berlin, c. 1930

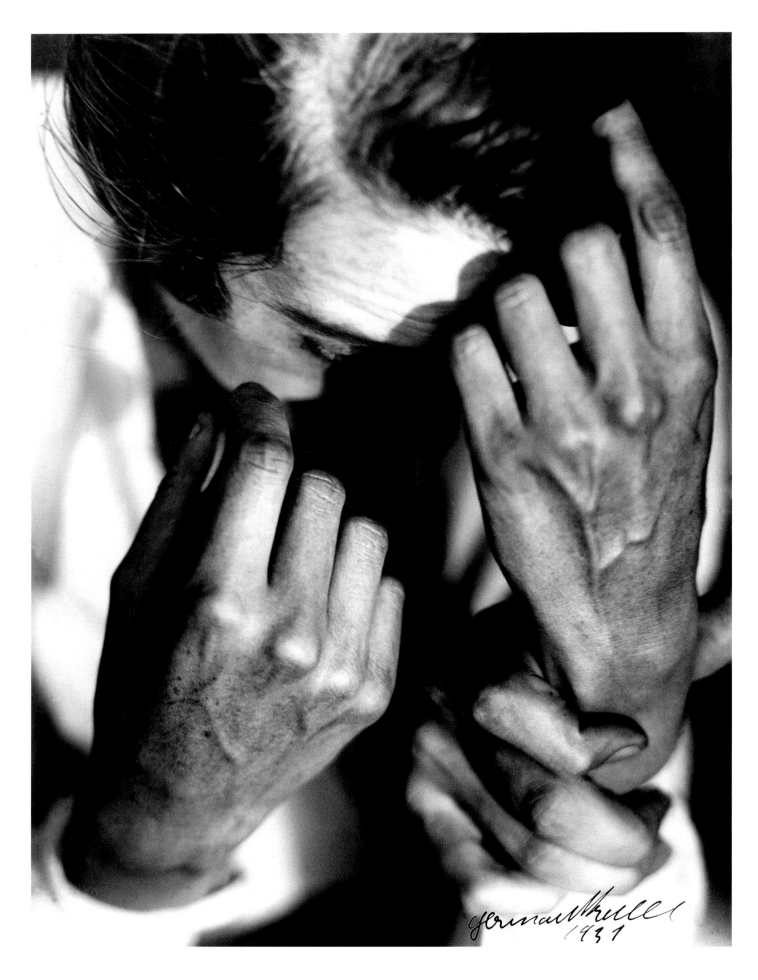

40 | Germaine Krull
Face and Hands, 1931

41 | Yvonne Chevalier
Colette, 1932

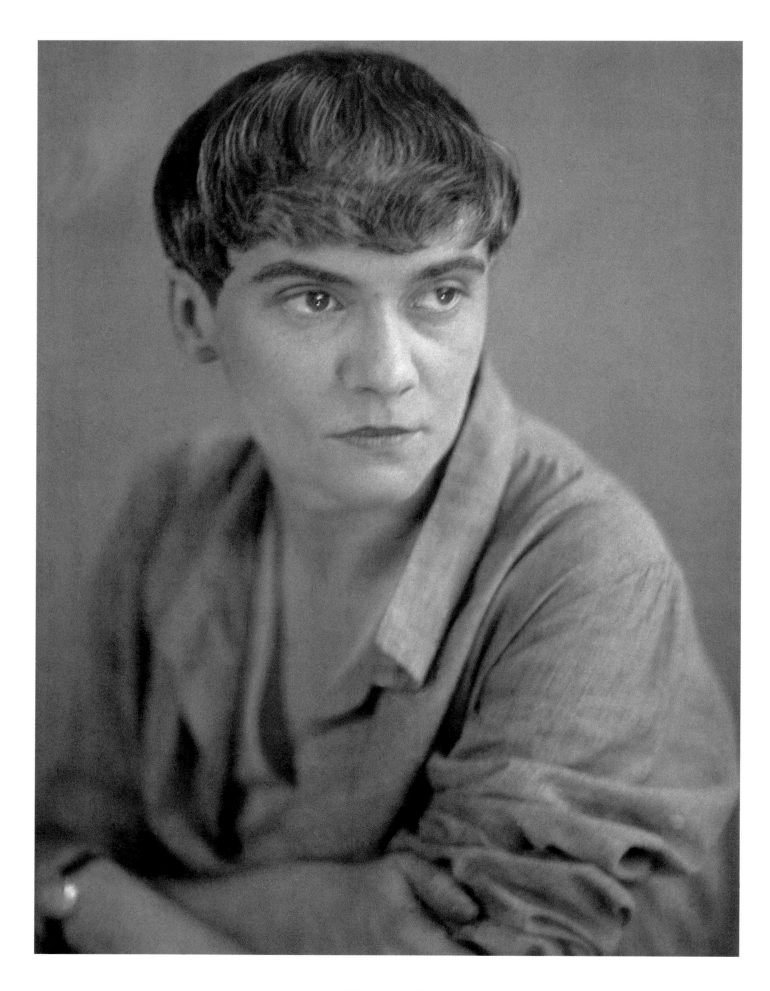

42 | Marianne Breslauer
Portrait of Yvonne Chevalier, 1932

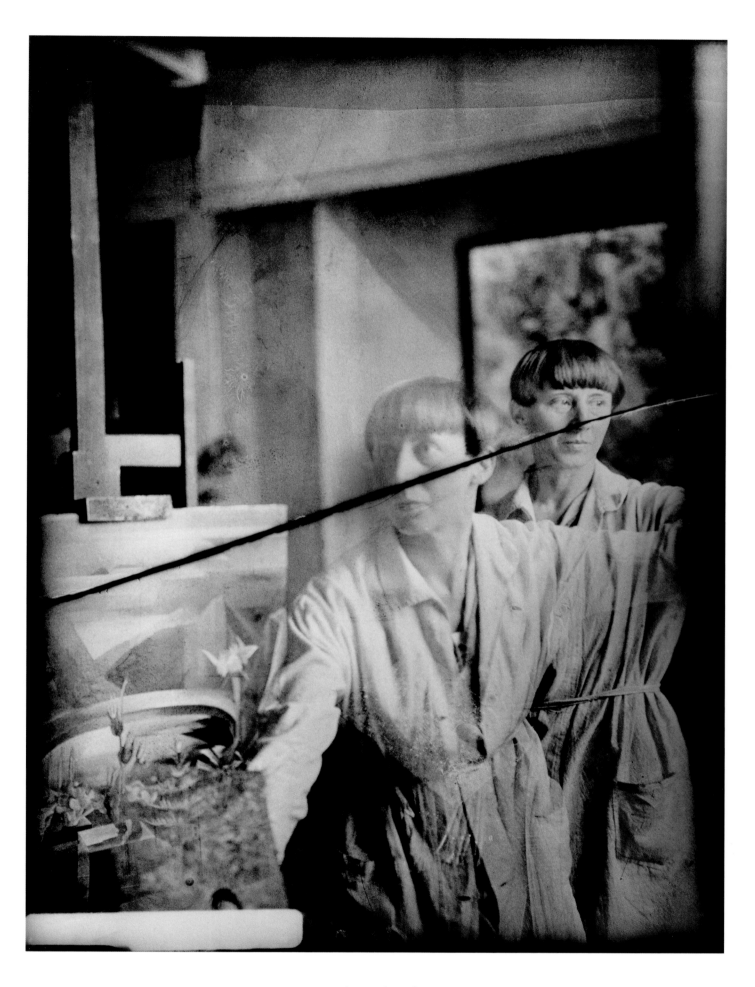

43 | Hannah Höch
Self-portrait with Crack, c. 1930

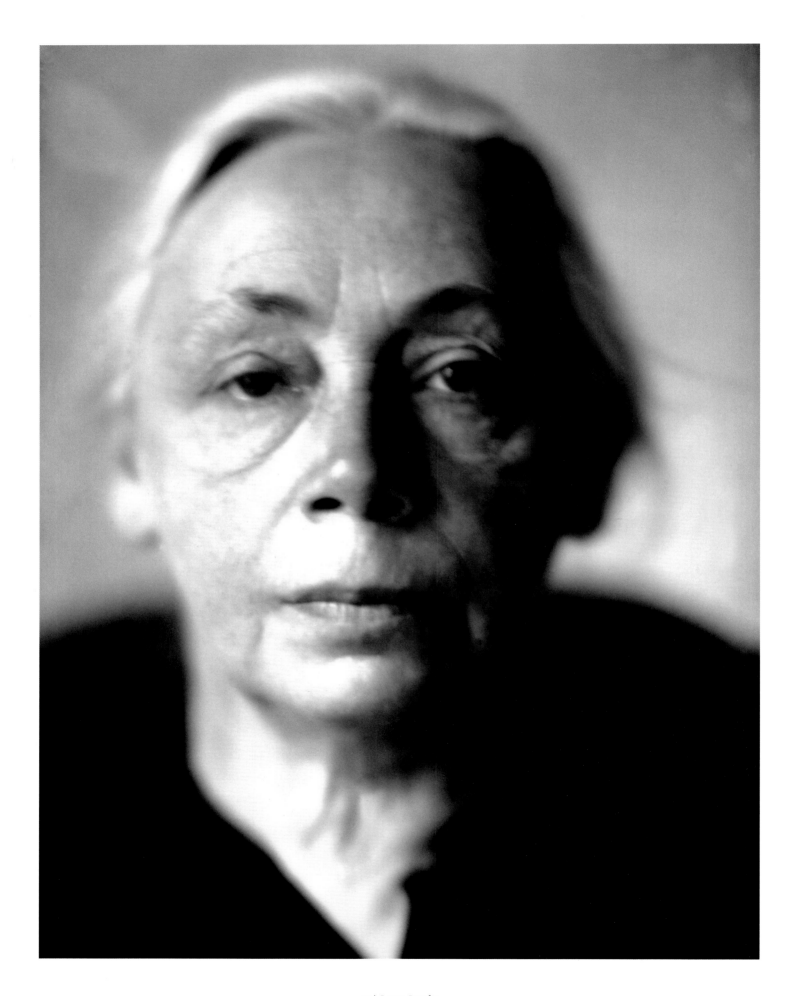

44 | Lotte Jacobi
Portrait of Käthe Kollwitz, 1930s

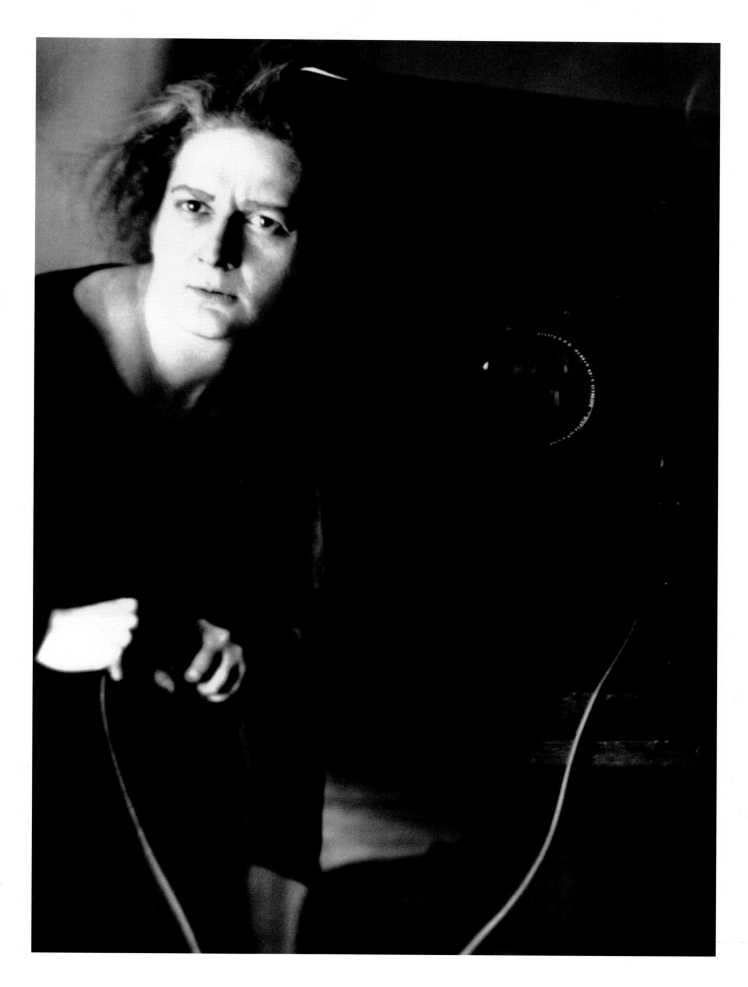

45 | Lotte Jacobi
Self-portrait, Berlin, c. 1930

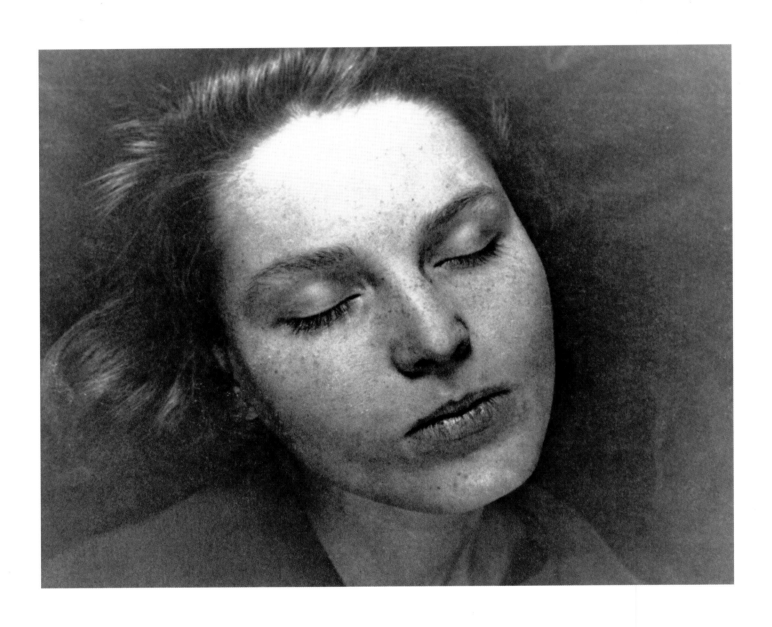

46| ringl + pit (Ellen Rosenberg and Grete Stern)
Klärchen, Berlin, 1931

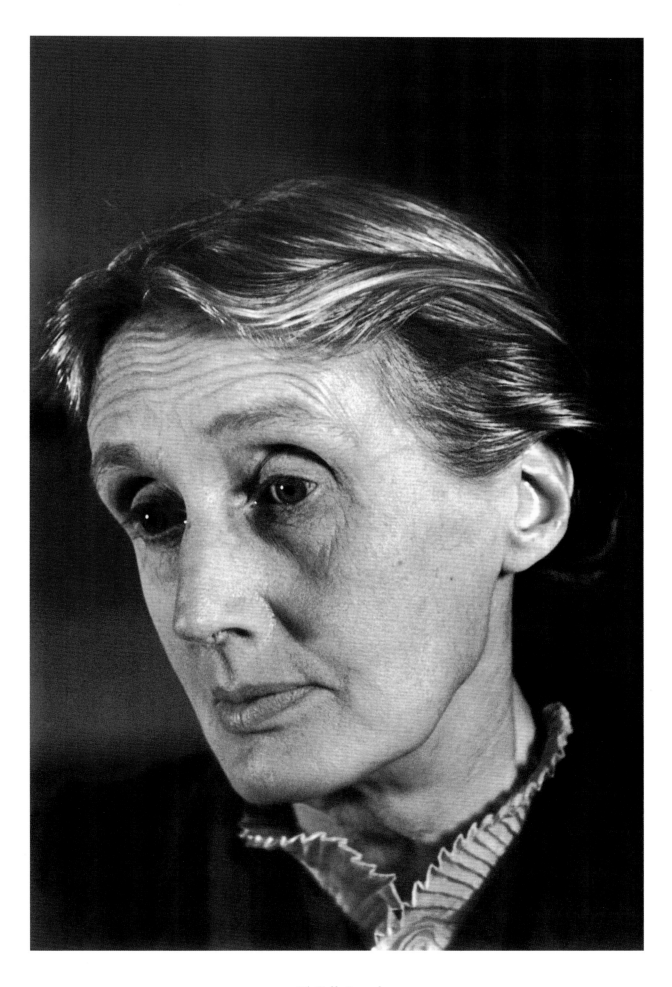

47 | Gisèle Freund
Virginia Woolf, London, 1939

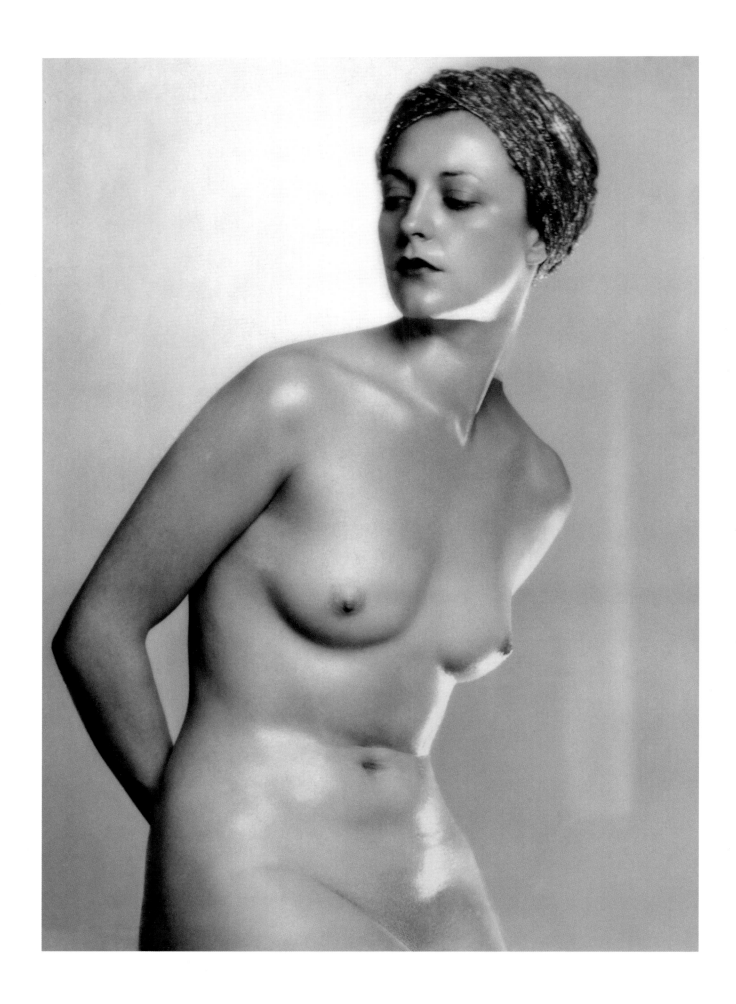

48 | Dorothy Wilding
"Hauteur" (Rhoda Beasley), London, 1935

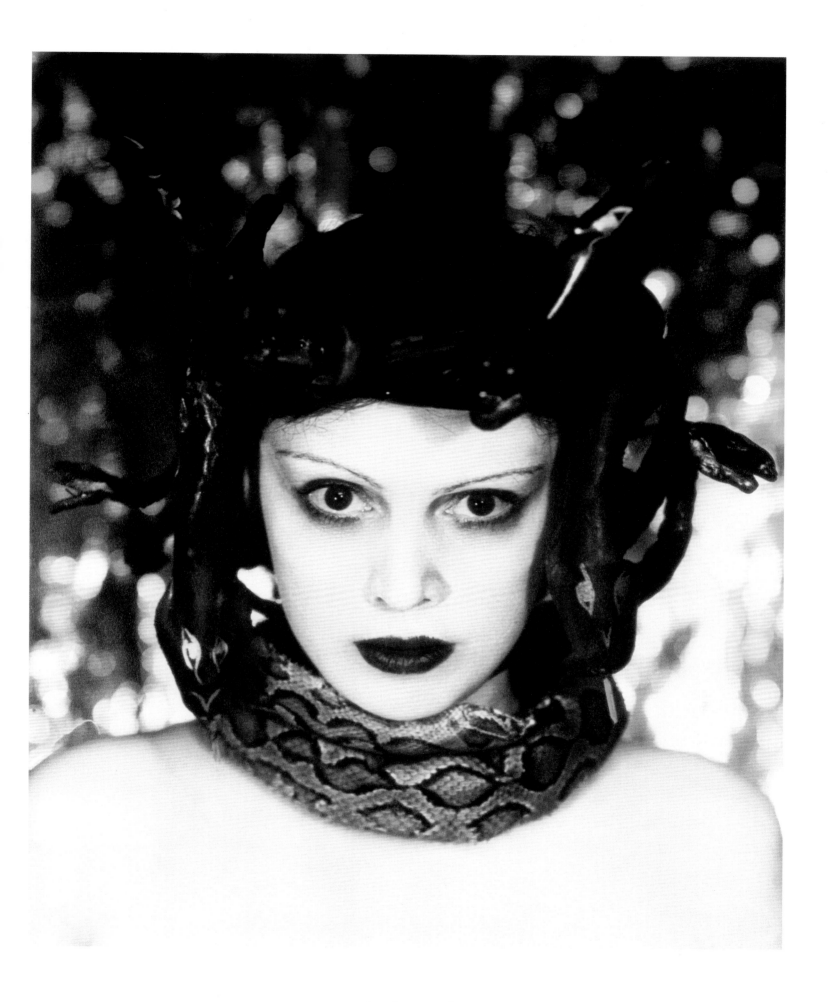

49 | Madame Yevonde
Mrs. Edward Mayer as Medusa, 1935

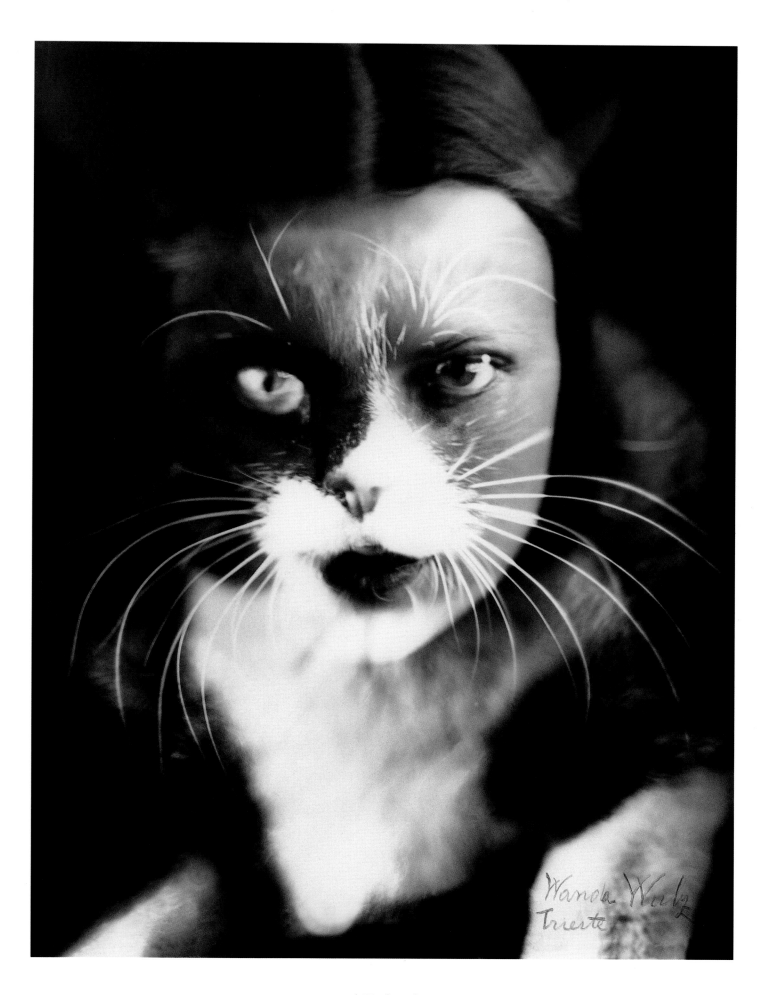

50 | Wanda Wulz
"Io + gatto", 1932

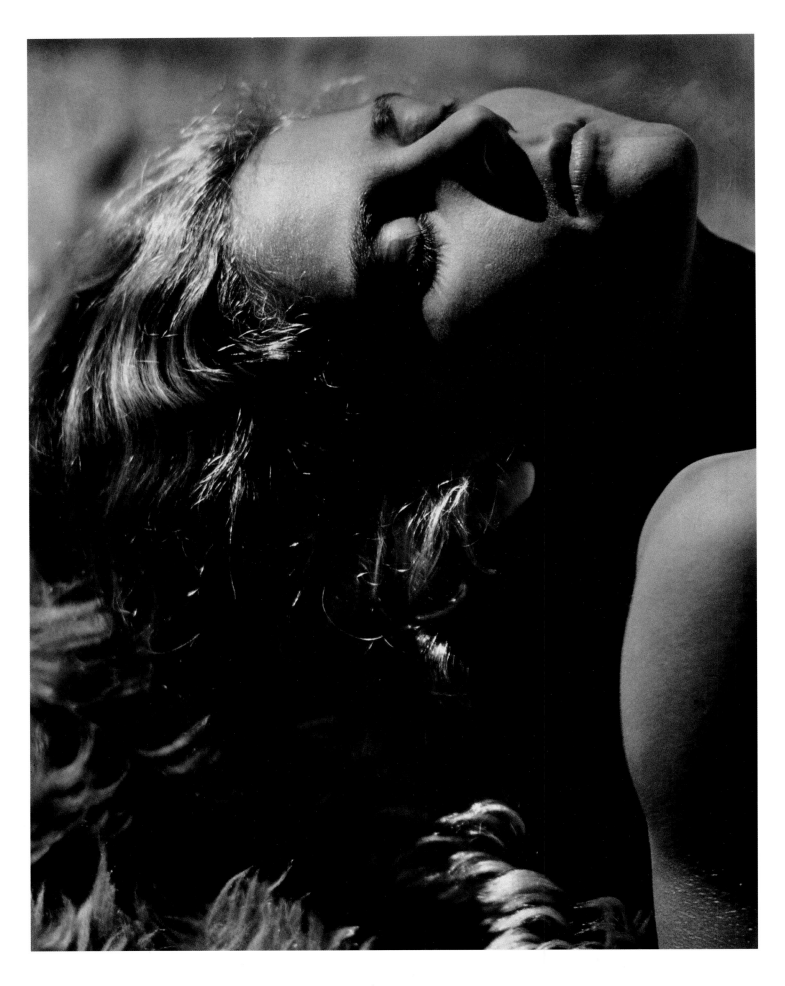

51 | Dora Maar
Portrait of Assia, 1934

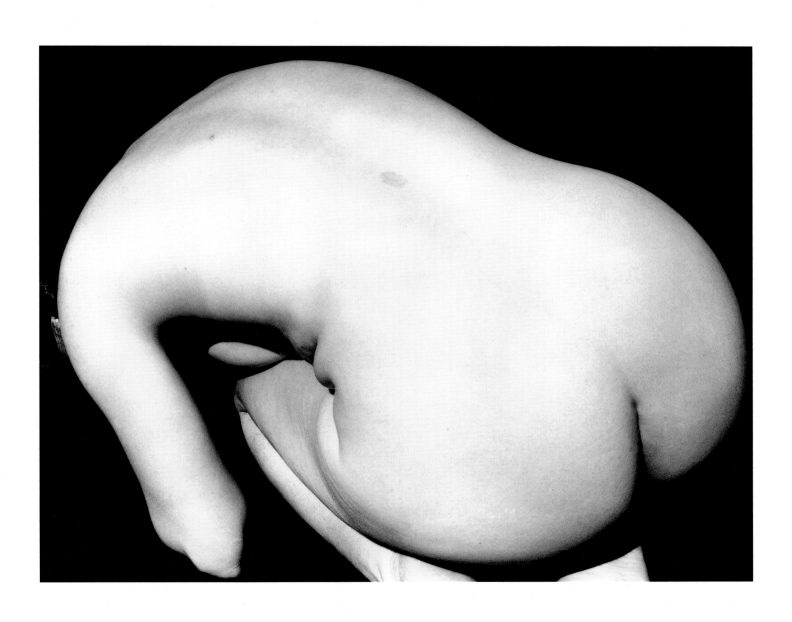

52 | Imogen Cunningham
Nude, 1932

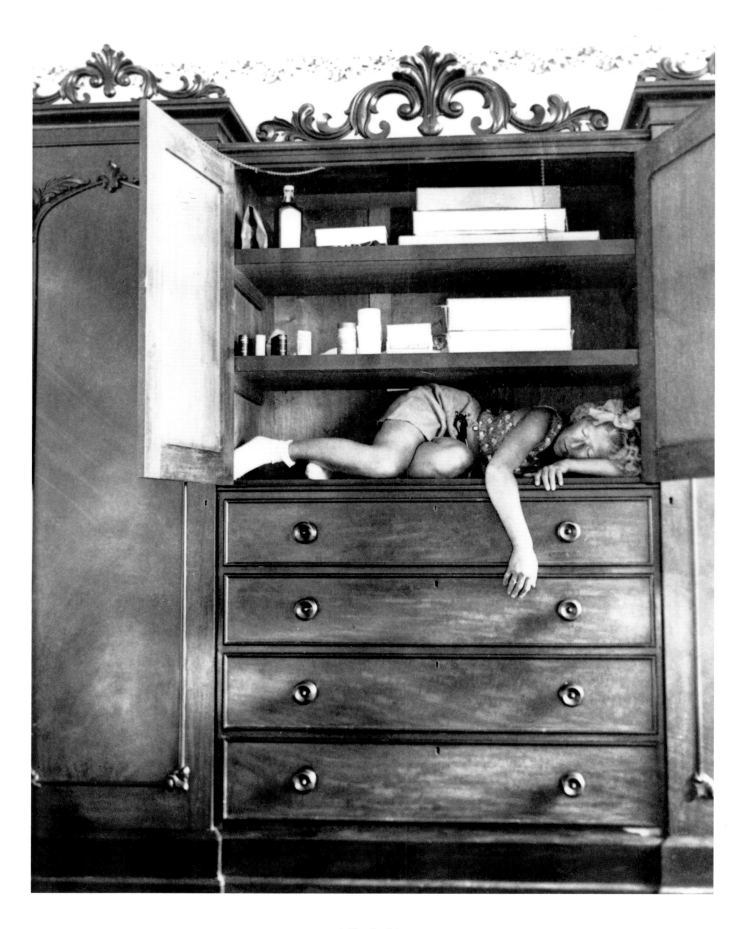

53 | Claude Cahun
Self-portrait, c. 1932

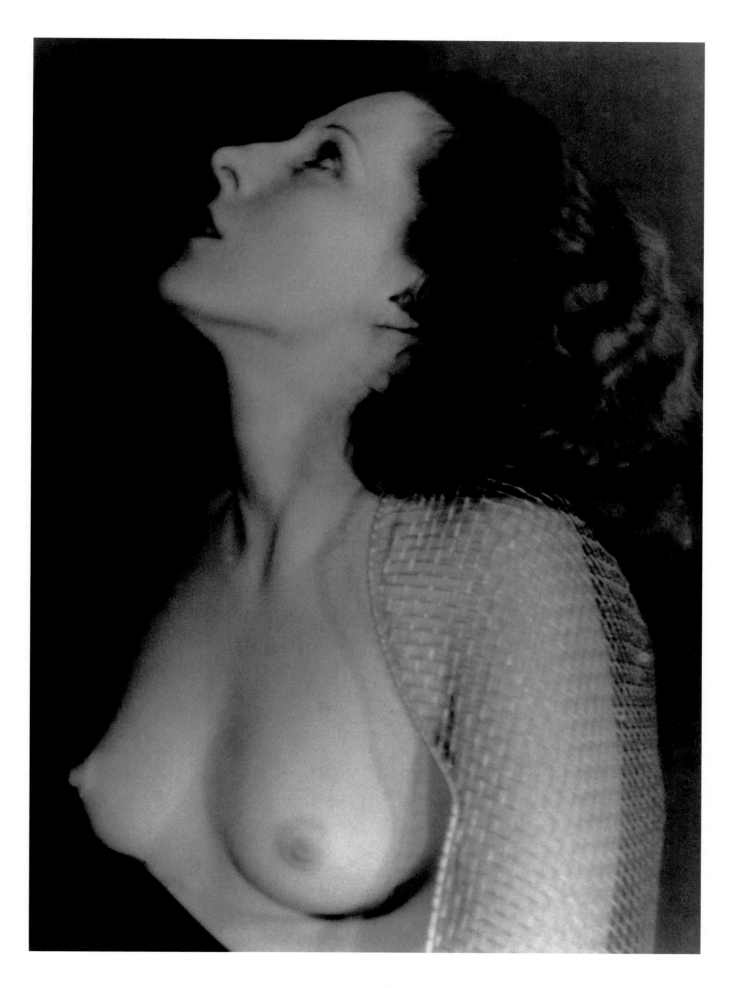

54 | Lee Miller
Nude with Wire Mesh Sabre Guard, Paris, c. 1930

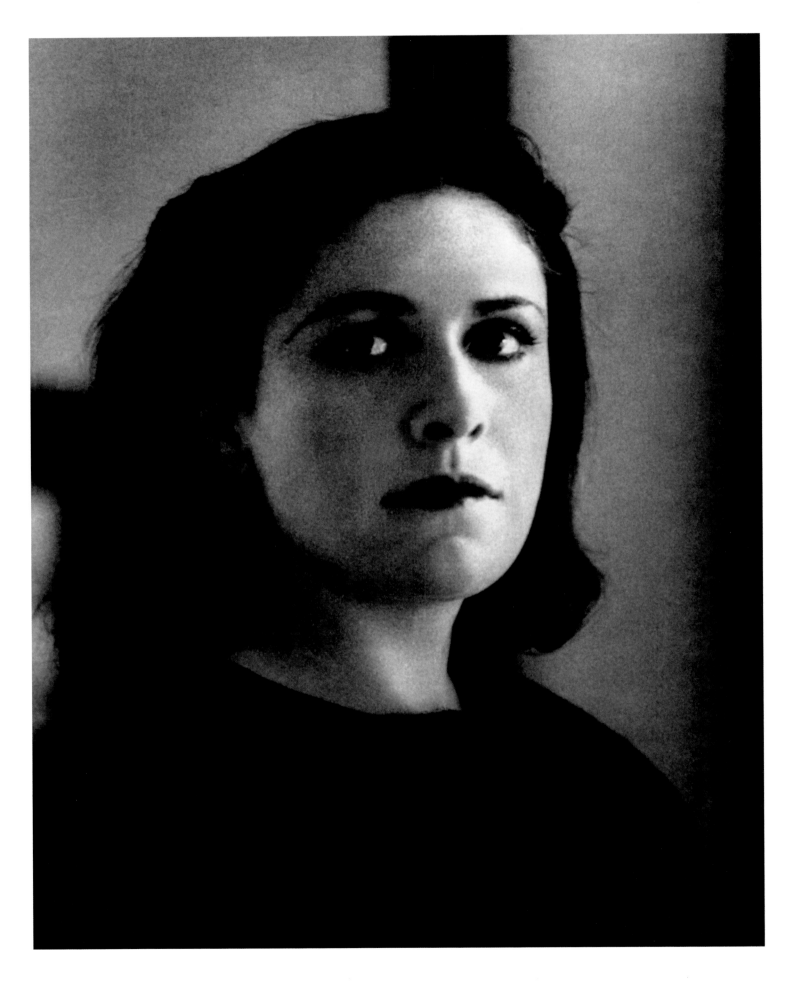

55 | Rogi André
Portrait of Dora Maar, 1937

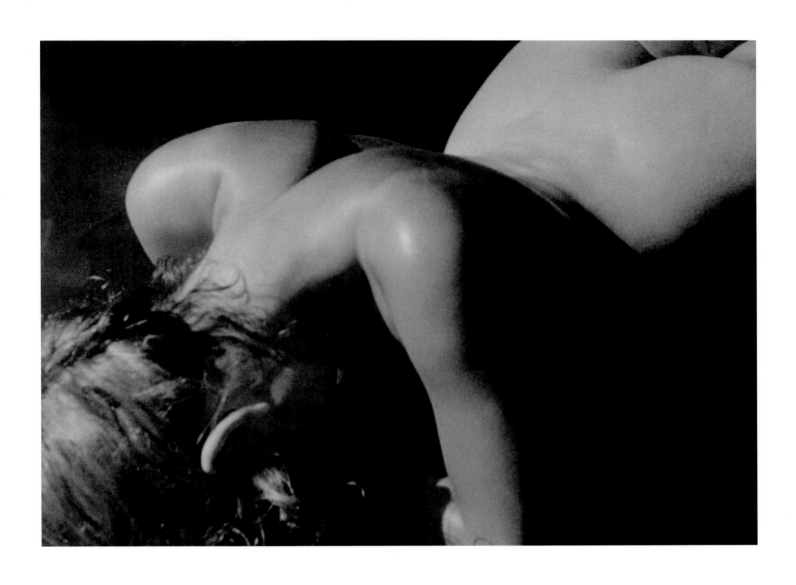

56 | Ergy Landau
Nude, 1933

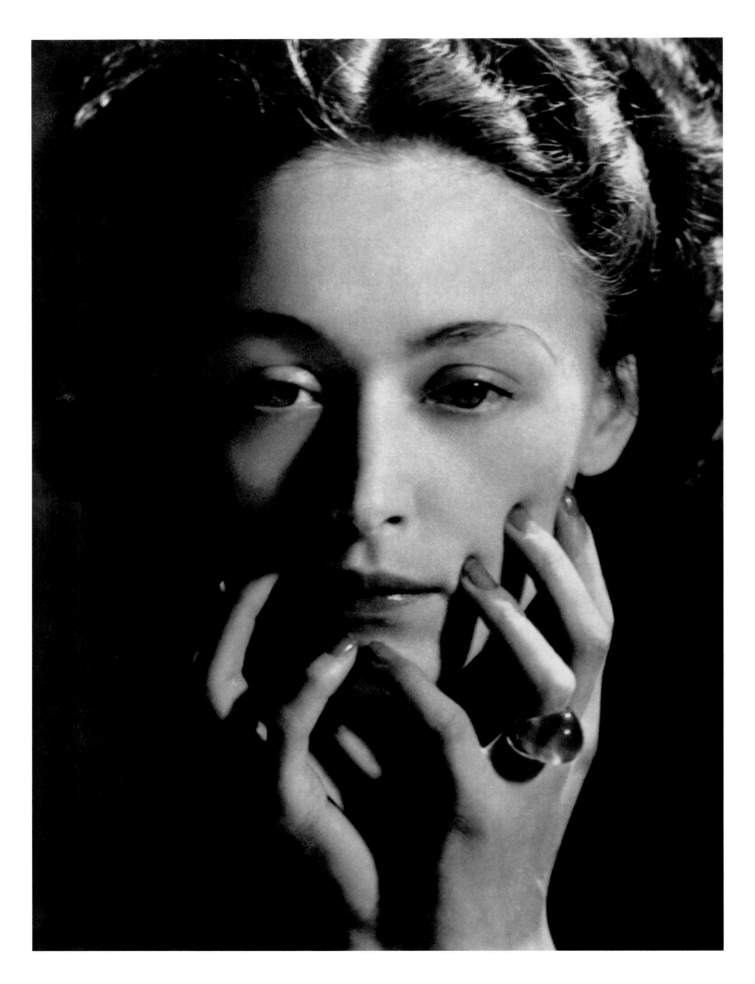

57 | Dora Maar
Nusch Eluard, Paris, c. 1935

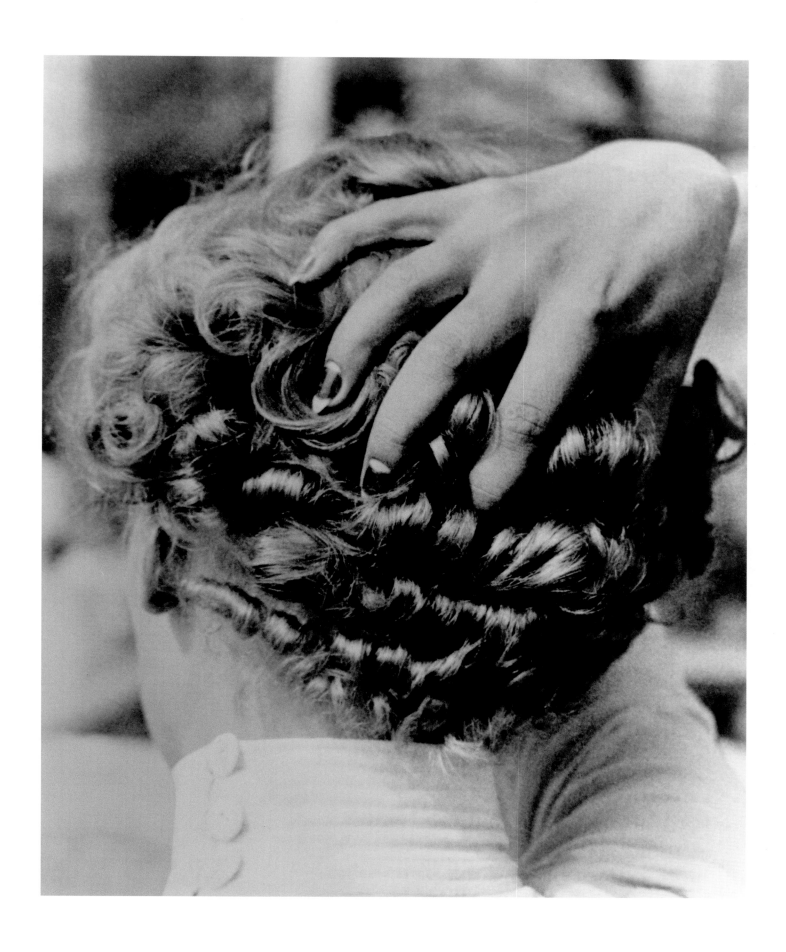

58 | Lee Miller
Woman with Hand on Head, Paris, 1931

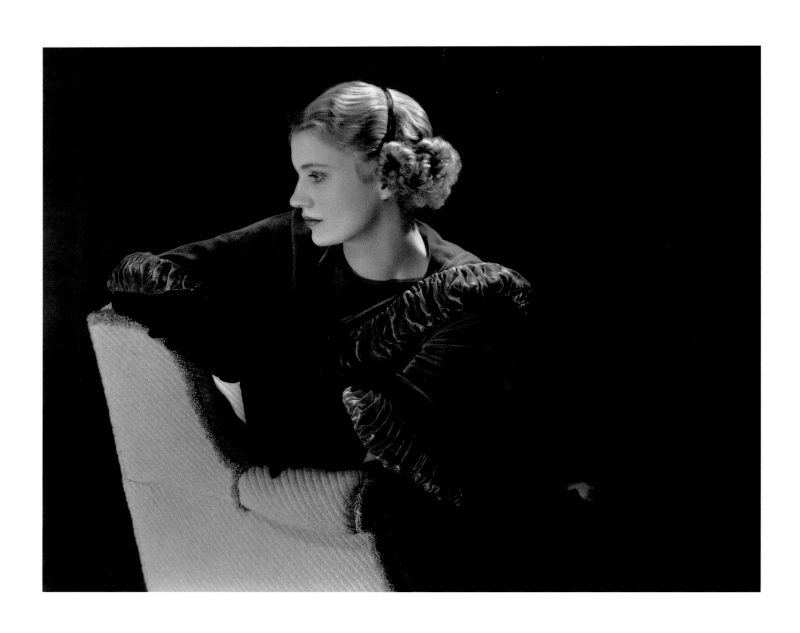

59 | Lee Miller
Self-portrait, New York, 1933

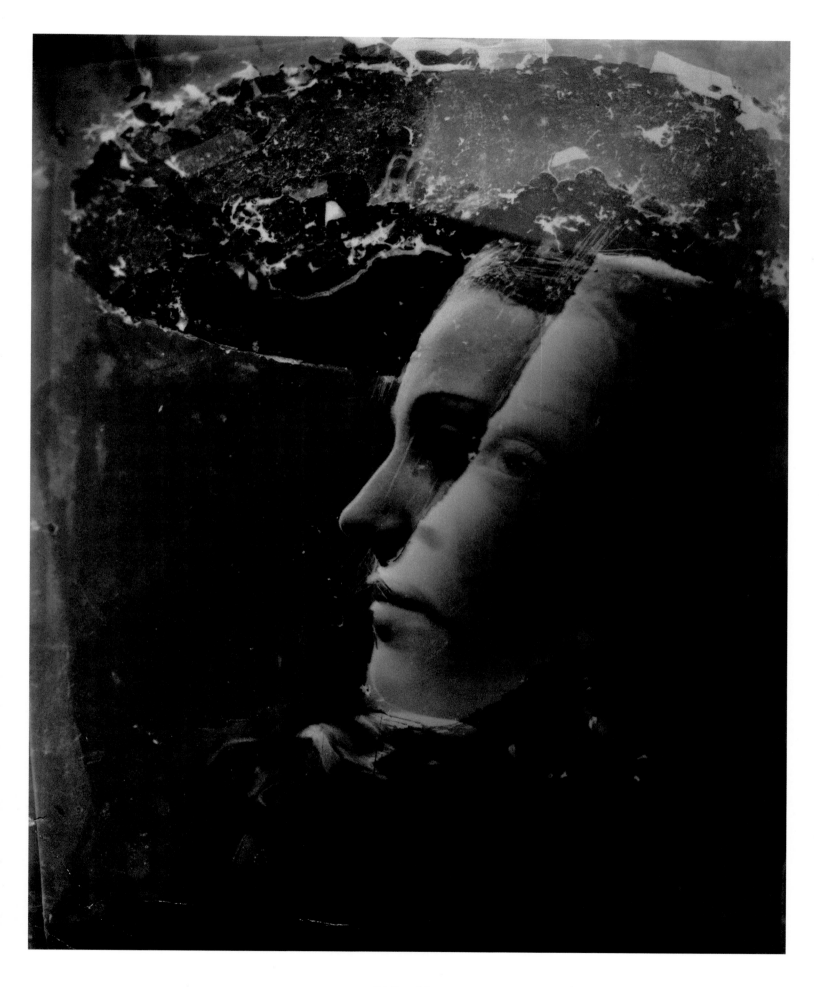

60 | Dora Maar
Double Portrait, 1930s

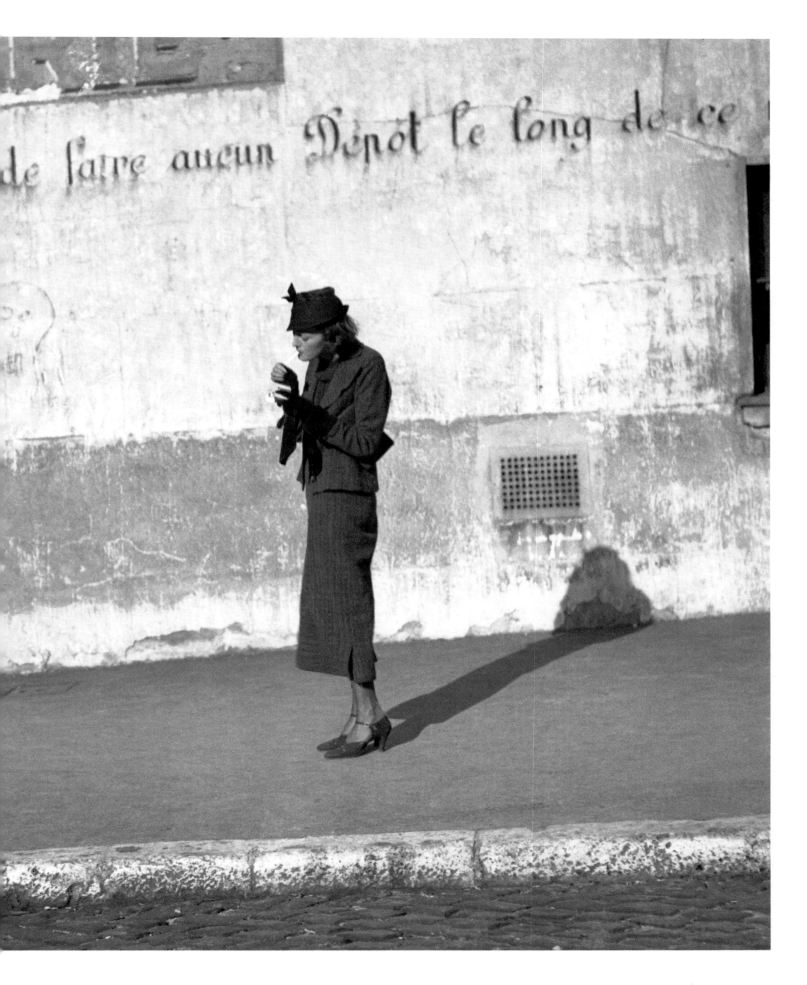

61 | Marianne Breslauer
"Défense d'afficher" (Jeanne Remarque), 1930s

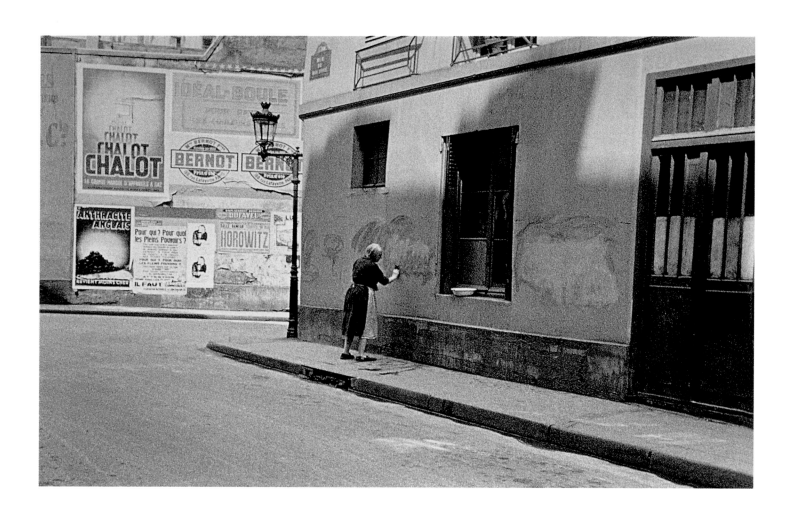

62 | Gisèle Freund
Woman Cleaning the Street, Paris, 1933

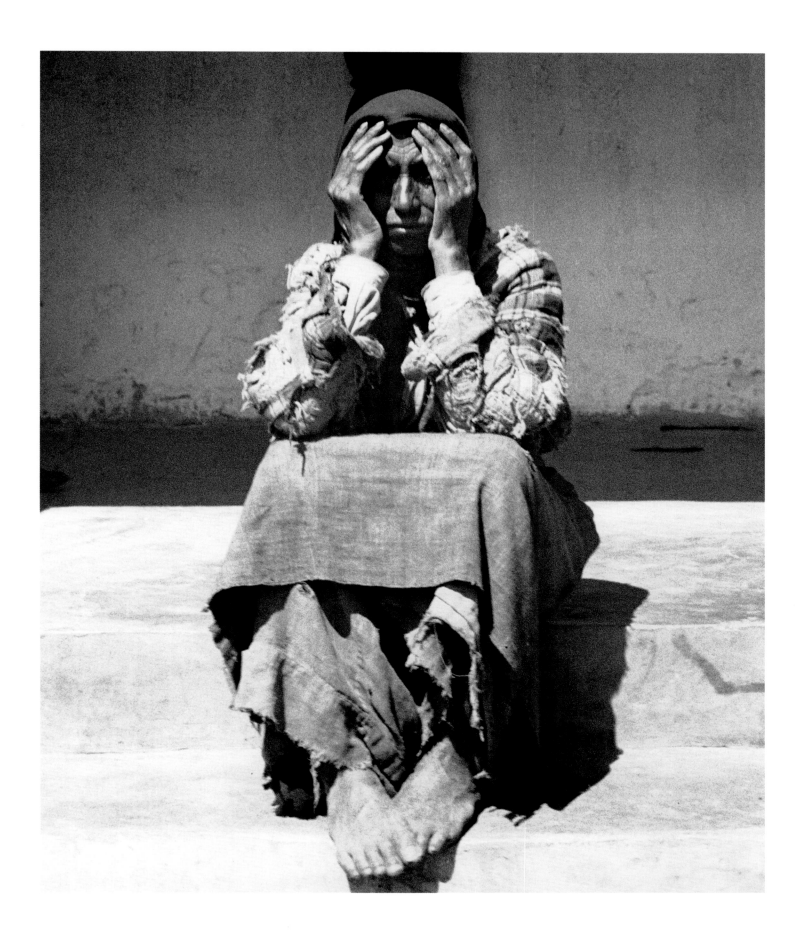

63 | Lucia Moholy
Gipsy, Yugoslavia, 1931

64 | Lisette Model
Promenade des Anglais, Nice, 1937

65 | Lisette Model
Promenade des Anglais, Nice, 1930s

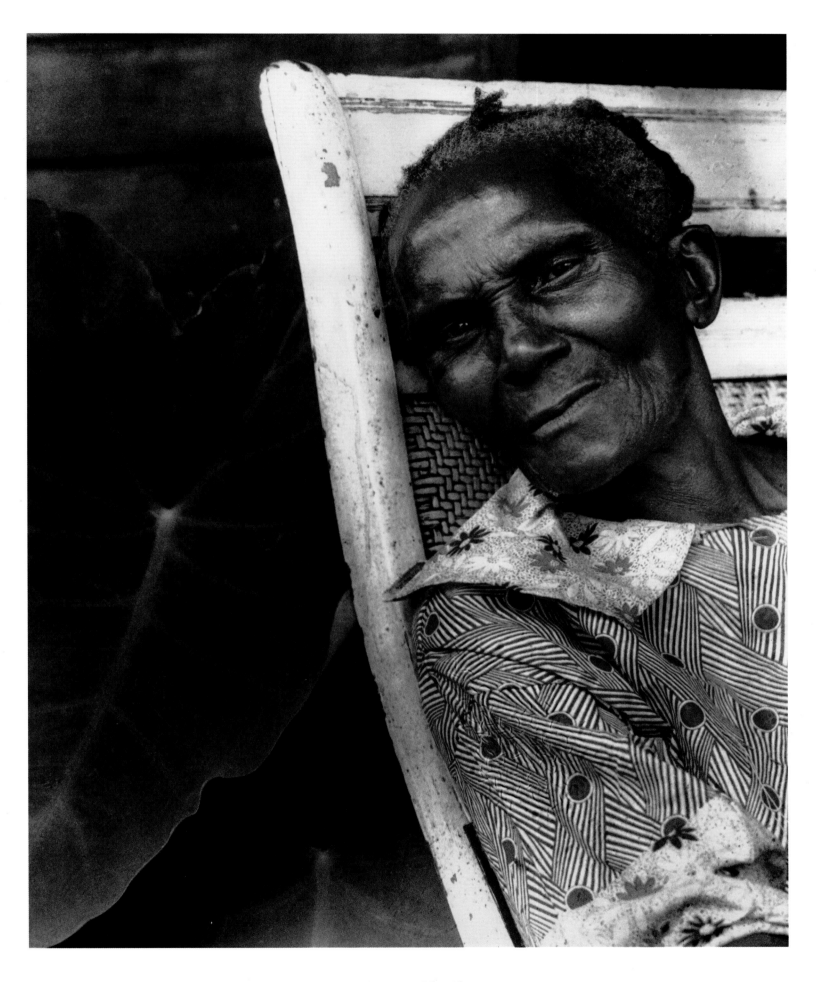

66 | Louise Dahl-Wolfe
Ophelia, Nashville, Tennessee, 1932

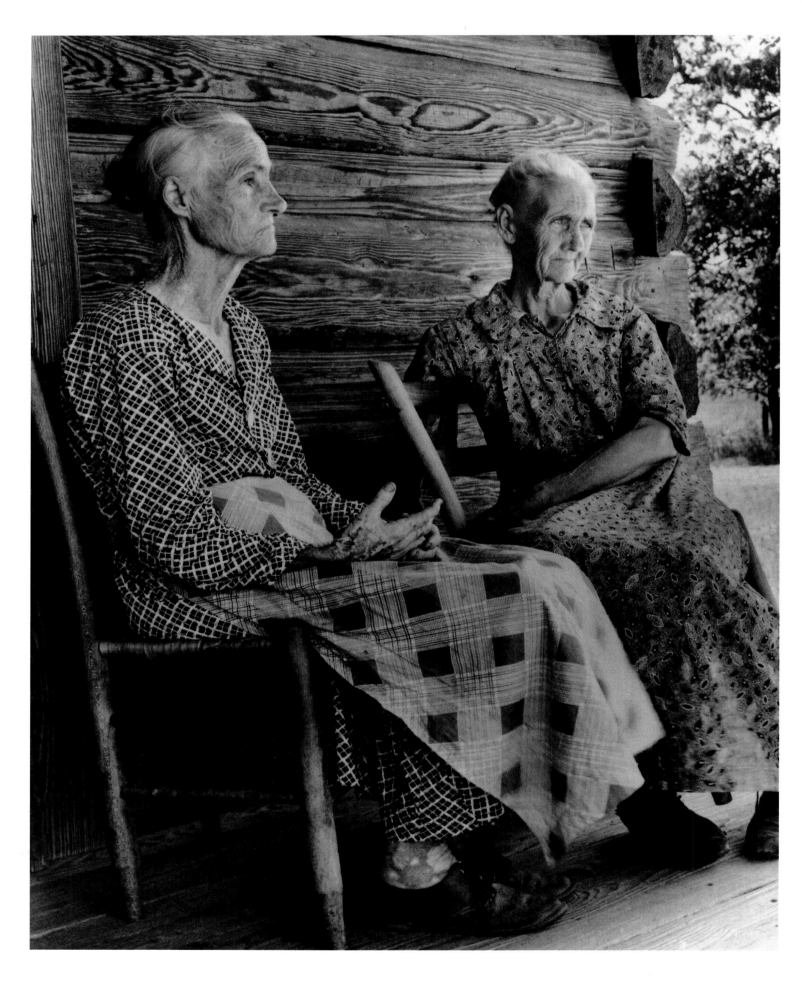

67 | Margaret Bourke-White
Two Elderly Women Sharecroppers, Lansdale, Arkansas, c. 1936

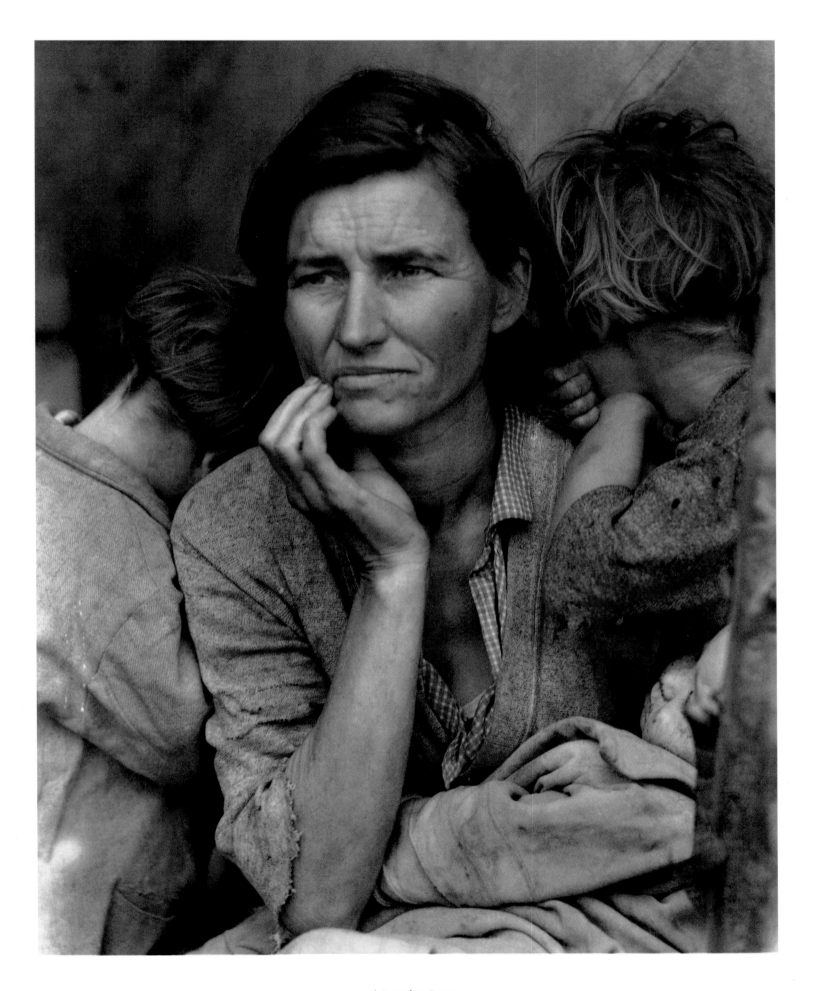

68 | Dorothea Lange
"Migrant Mother", Nipomo, California, 1936

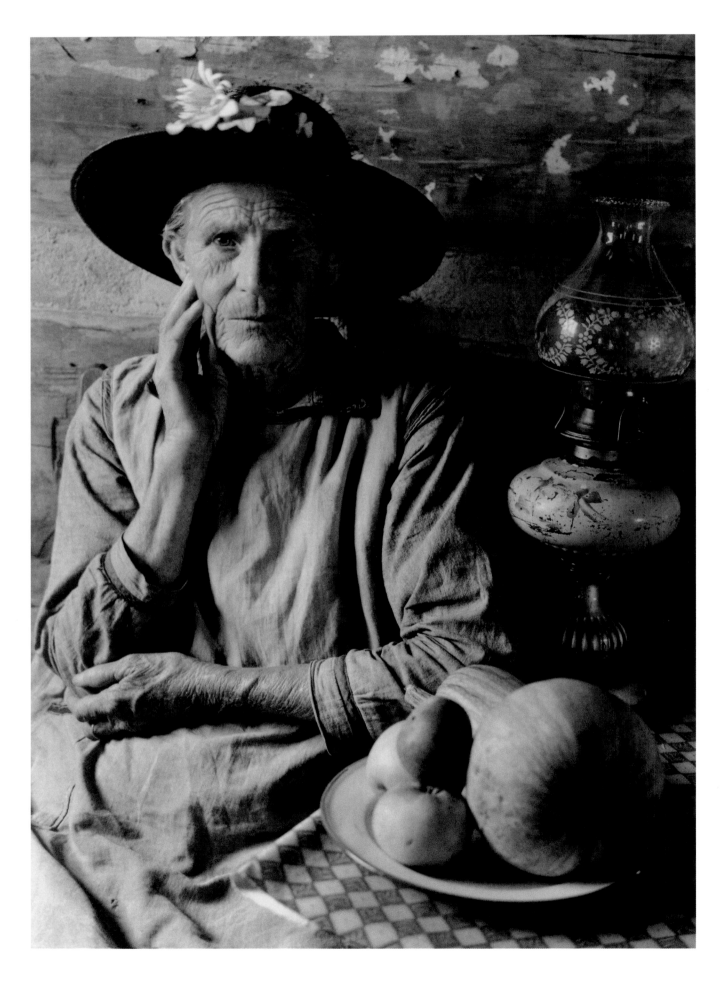

69 | Louise Dahl-Wolfe
Mrs. Ramsey, Smoky Mountains, Tennessee, 1931

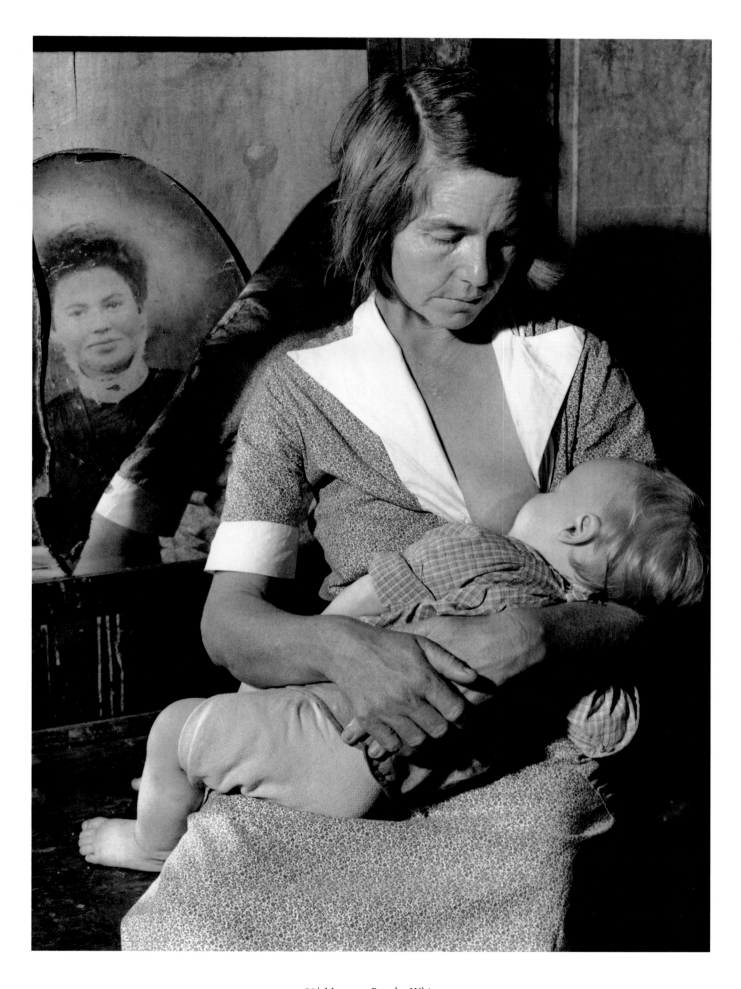

70 | Margaret Bourke-White
Breast-feeding Mother, Okefenokee Swamp, Georgia, 1936

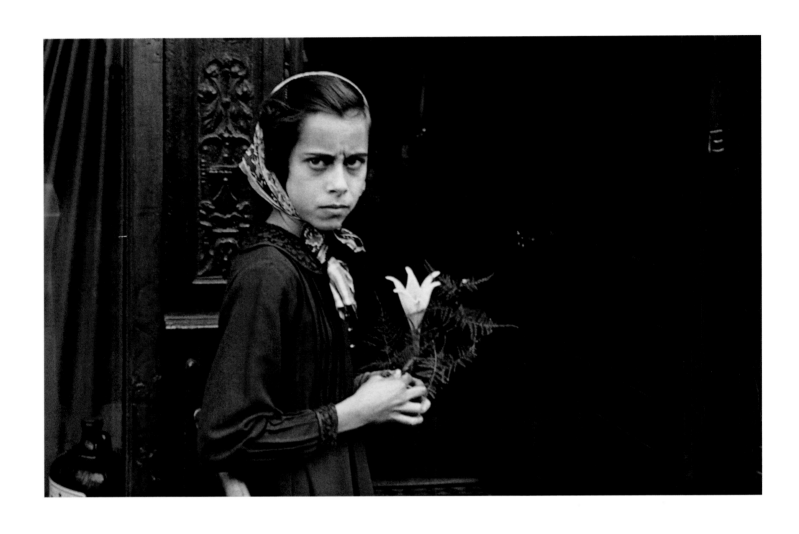

71 | Helen Levitt
Street Scene, New York, 1939

72 | Gisèle Freund
A Child, Maryport, England, 1936

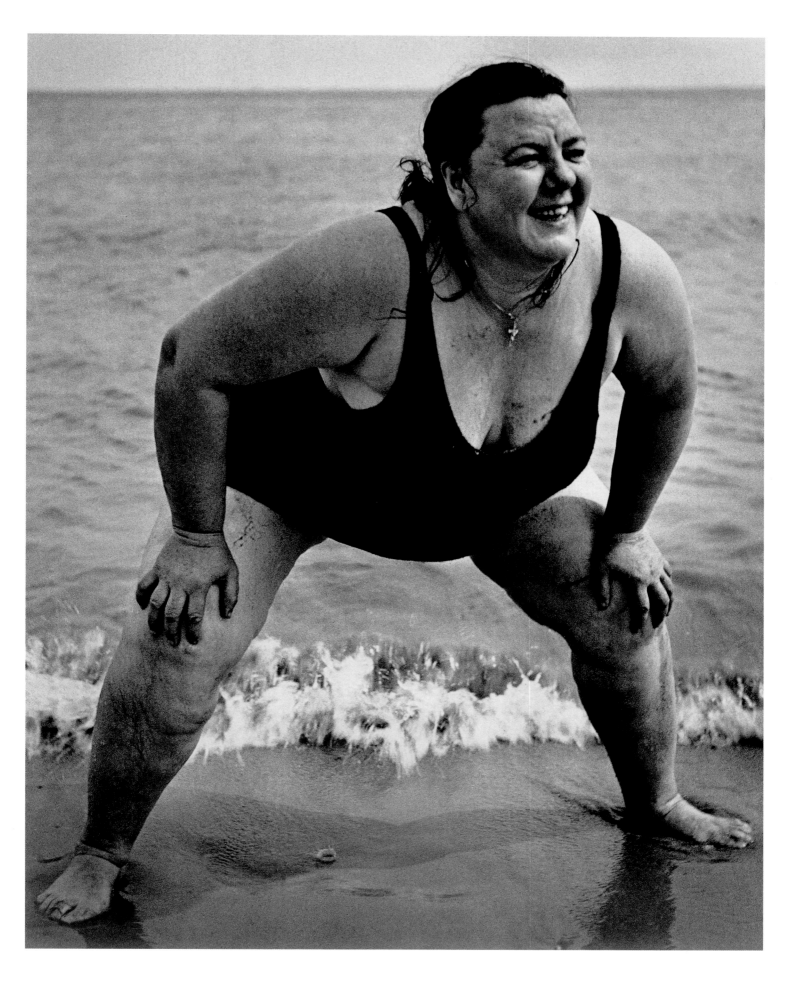

73 | Lisette Model
Woman on Coney Island, c. 1939

THE FOURTIES

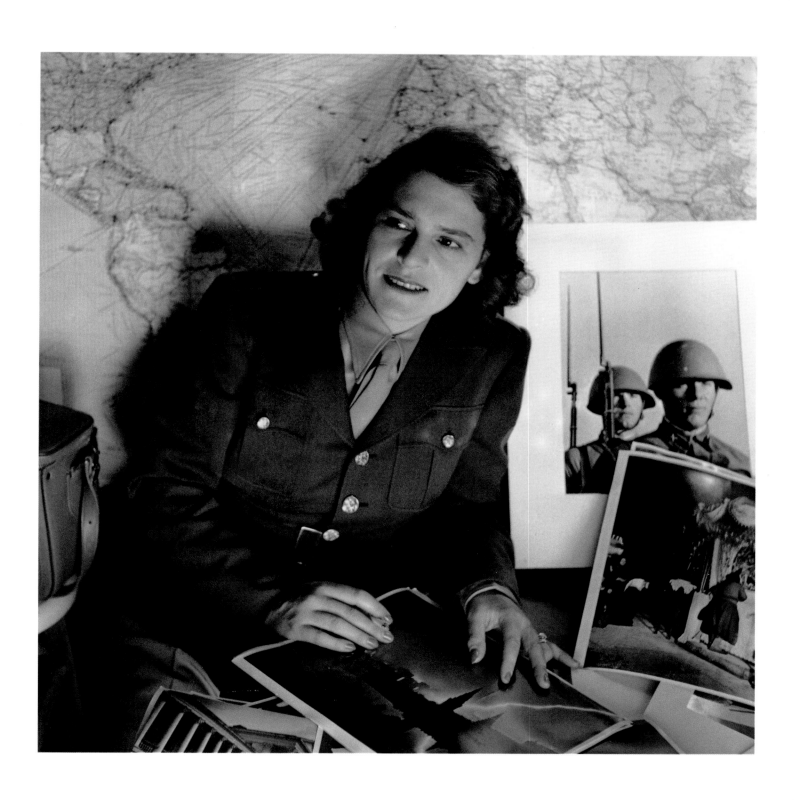

74 | Louise Dahl-Wolfe
Portrait of Margaret Bourke-White, 1942

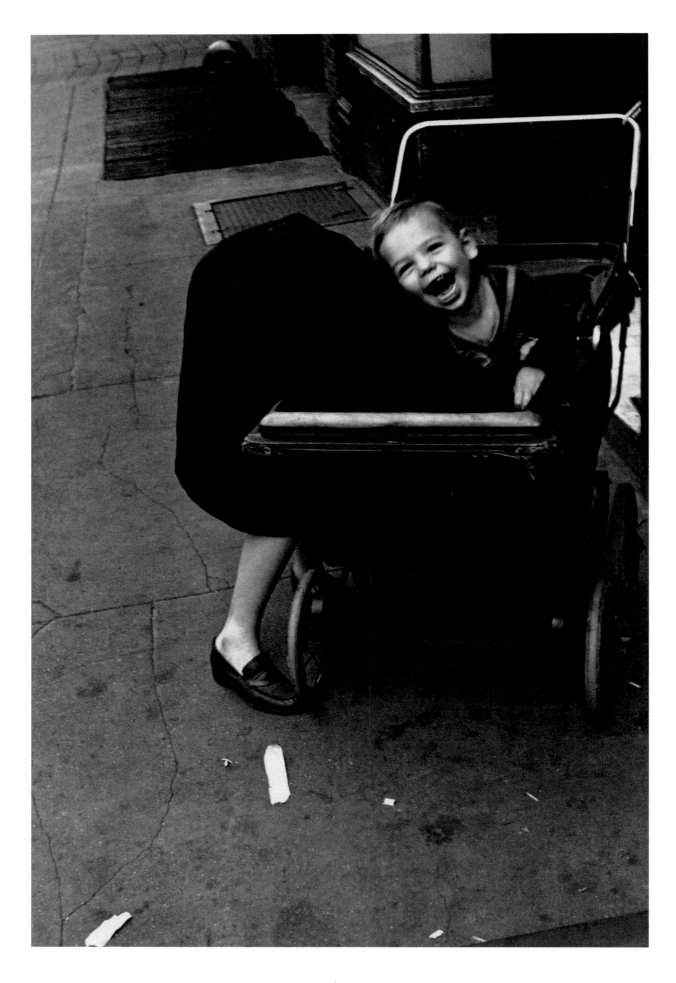

75 | Helen Levitt
Street Scene, New York, c. 1942

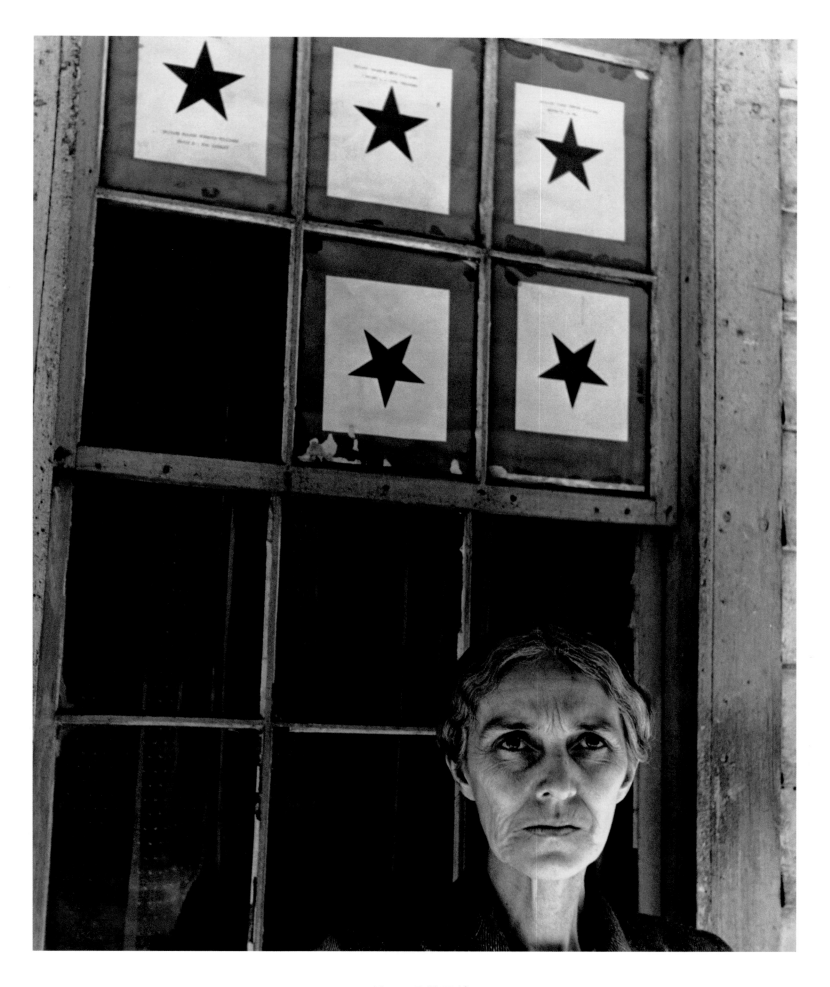

76 | Louise Dahl-Wolfe
Eudora Williams, Five Star Mother, Gatlinburg, Tennessee, 1944

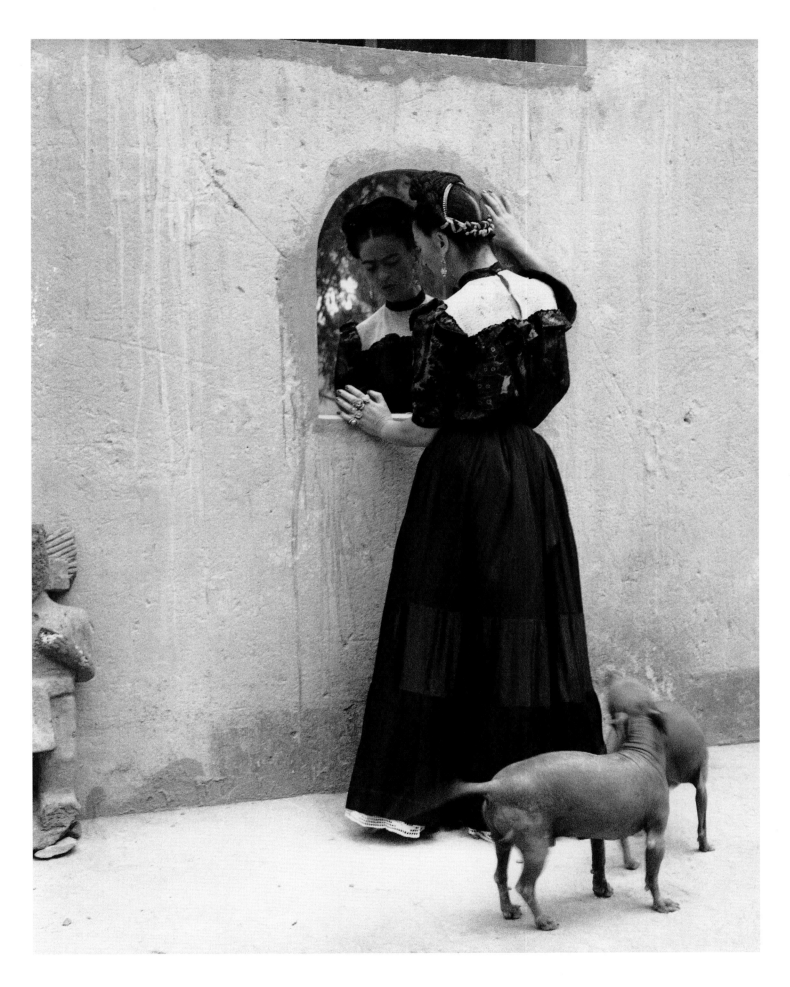

77 | Lola Alvarez Bravo
Frida Kahlo Facing Mirror in Patio of the Casa Azul with Two Hairless Dogs, Mexico City, c. 1944

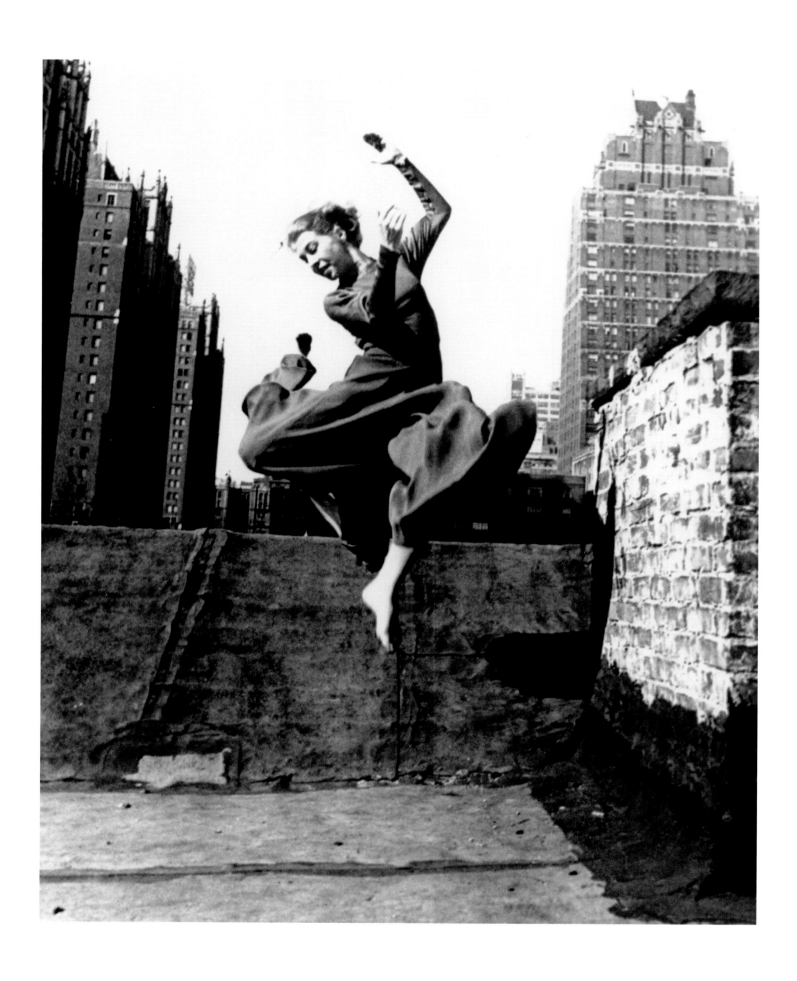

78 | Ellen Auerbach
The Dancer Renate Schottelius, New York, 1947

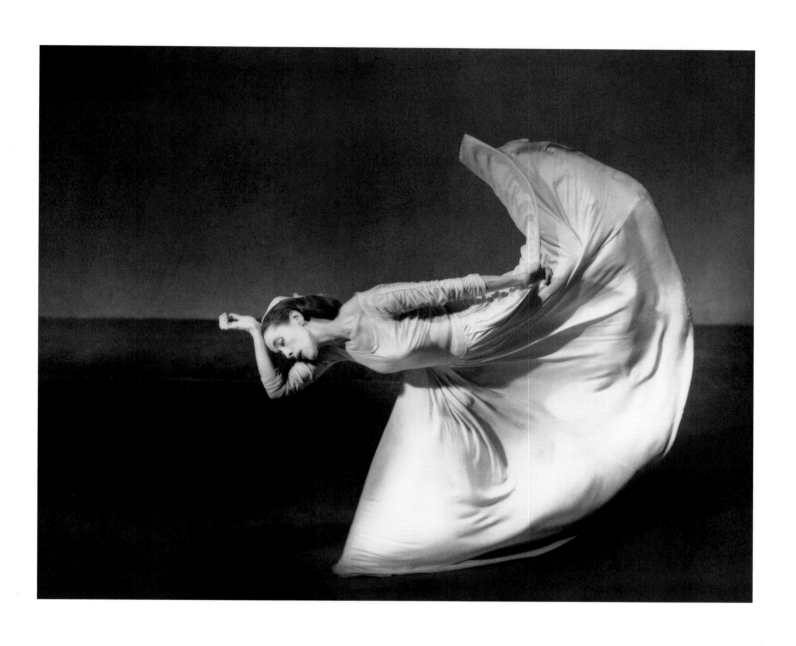

79 | Barbara Morgan
Martha Graham in "Letter to the World", 1940

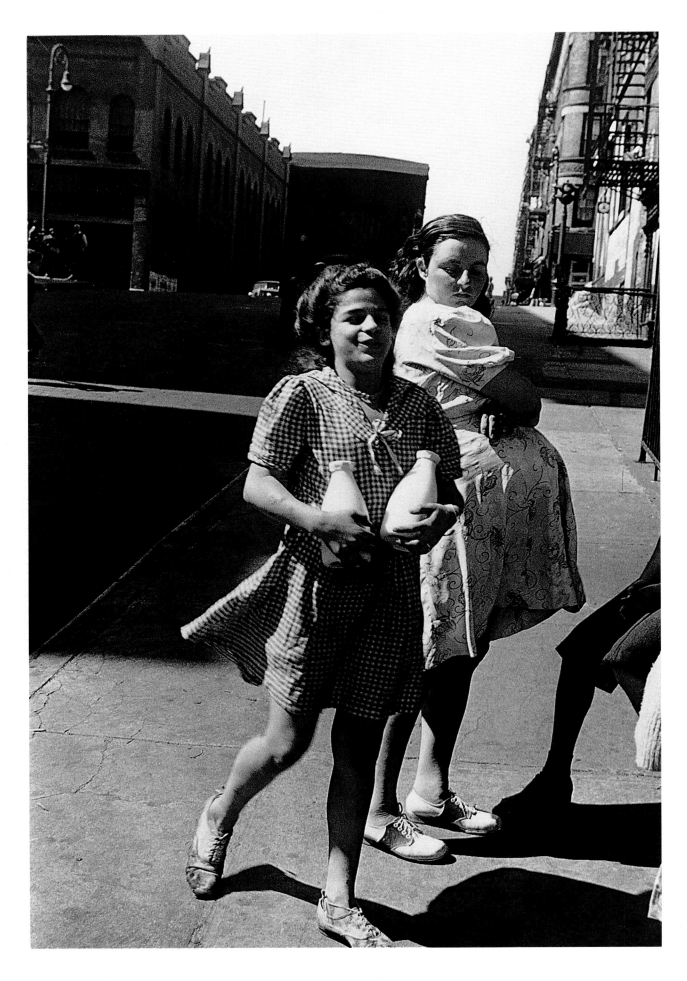

80| Helen Levitt
Street Scene, New York, c. 1945

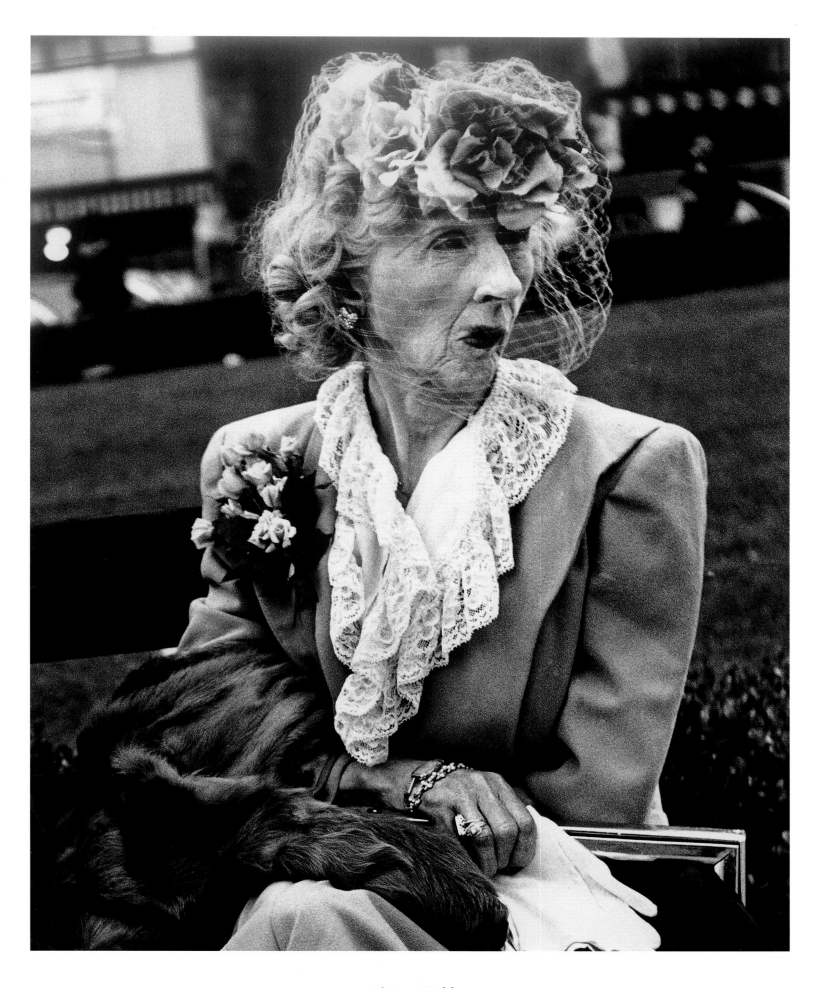

81 | Lisette Model
Woman with Veil, San Francisco, 1949

THE FIFTIES

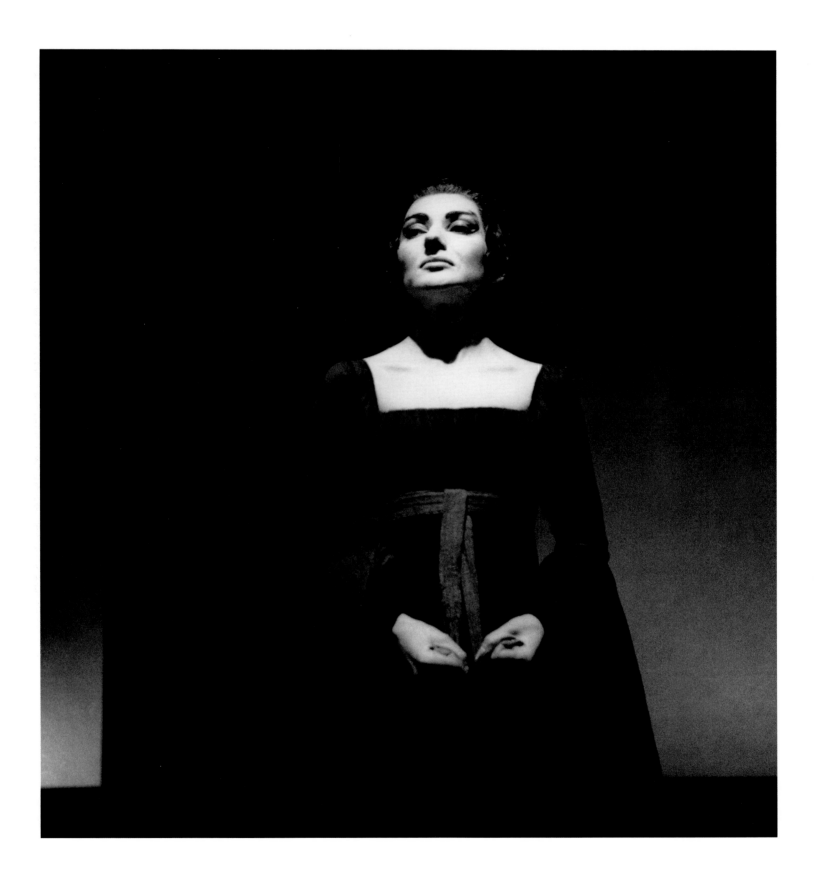

82 | Zoë Dominic
Maria Callas, "Medea", Covent Garden, London, 1959

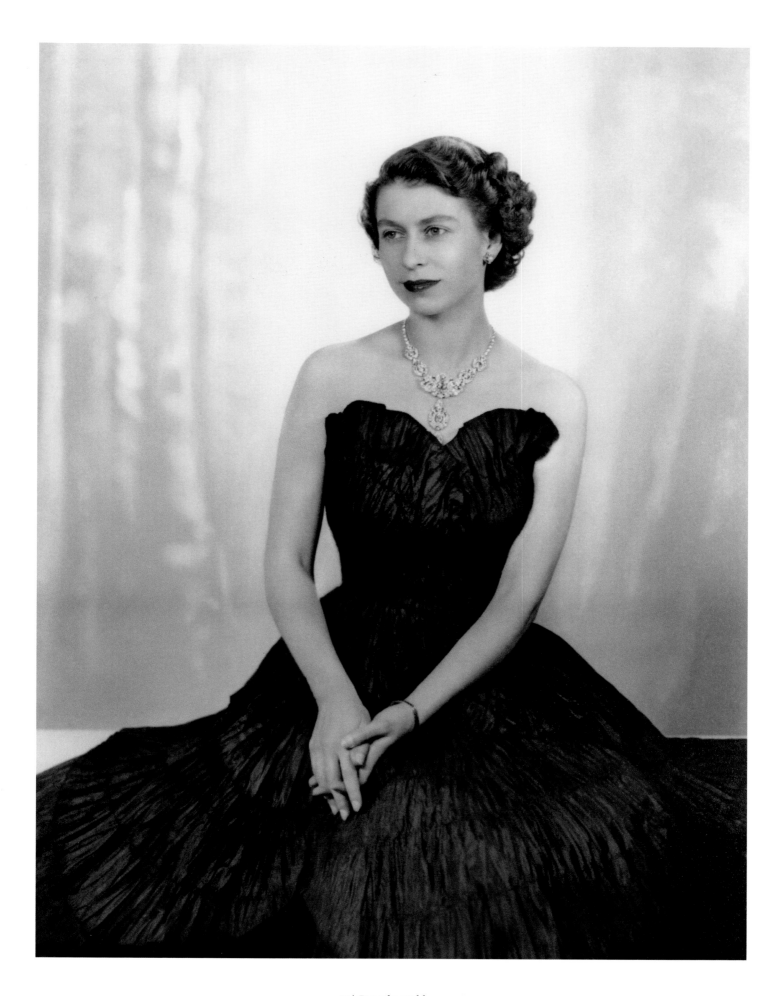

83 | Dorothy Wilding
Queen Elizabeth II, 1952

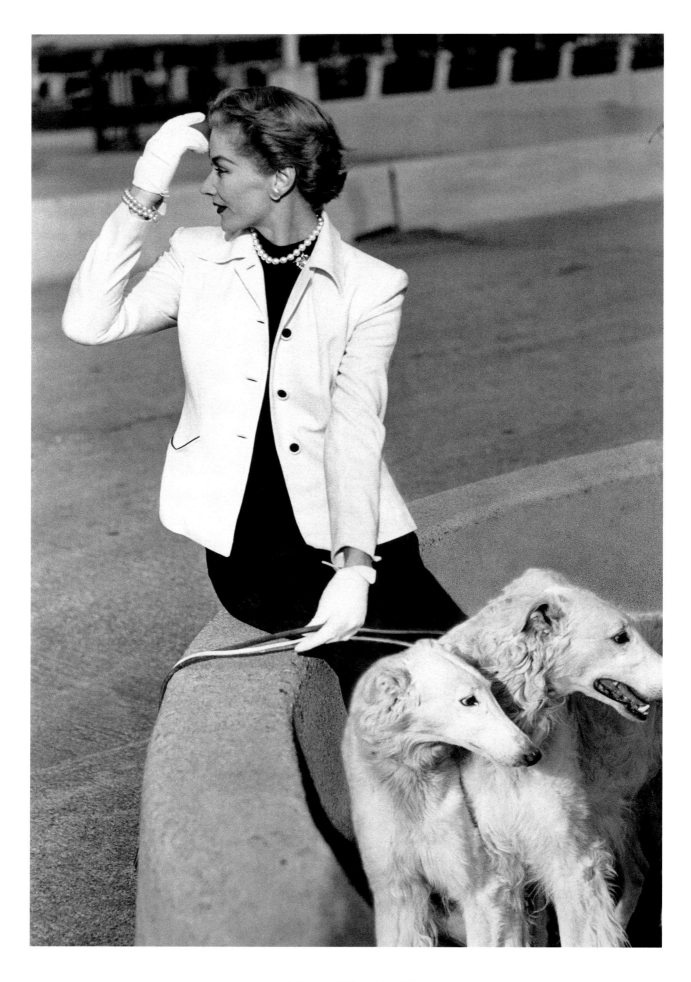

84 | Frances McLaughlin-Gill
Lisa Fonssagrives, Vogue, May 1, 1950

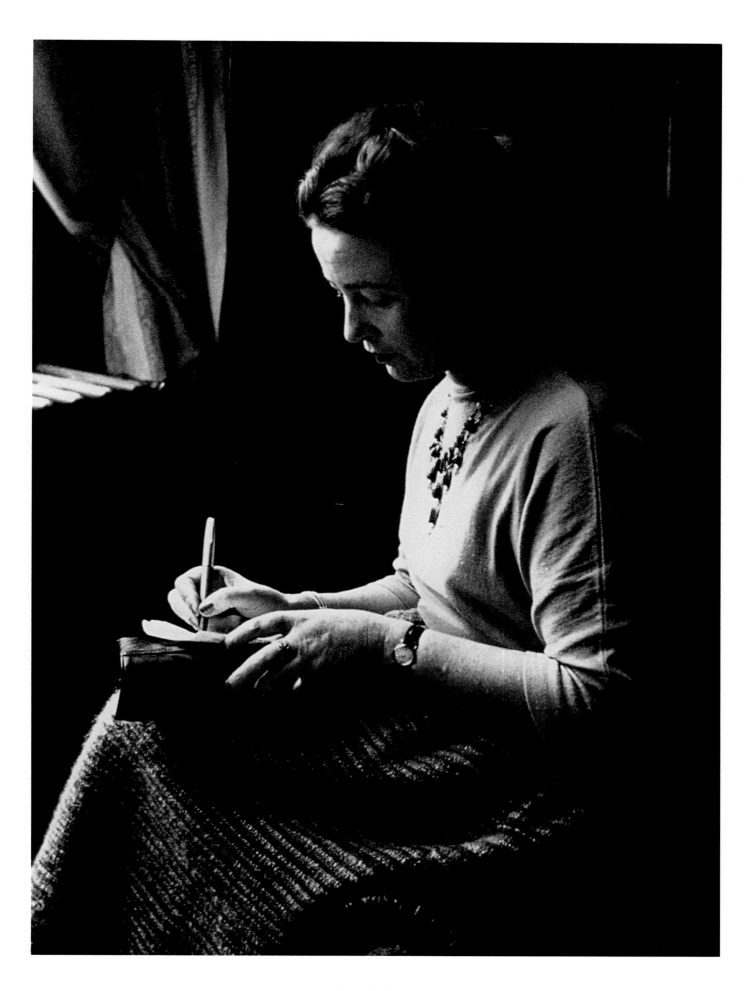

85 | Gisèle Freund
Simone de Beauvoir, Paris, 1954

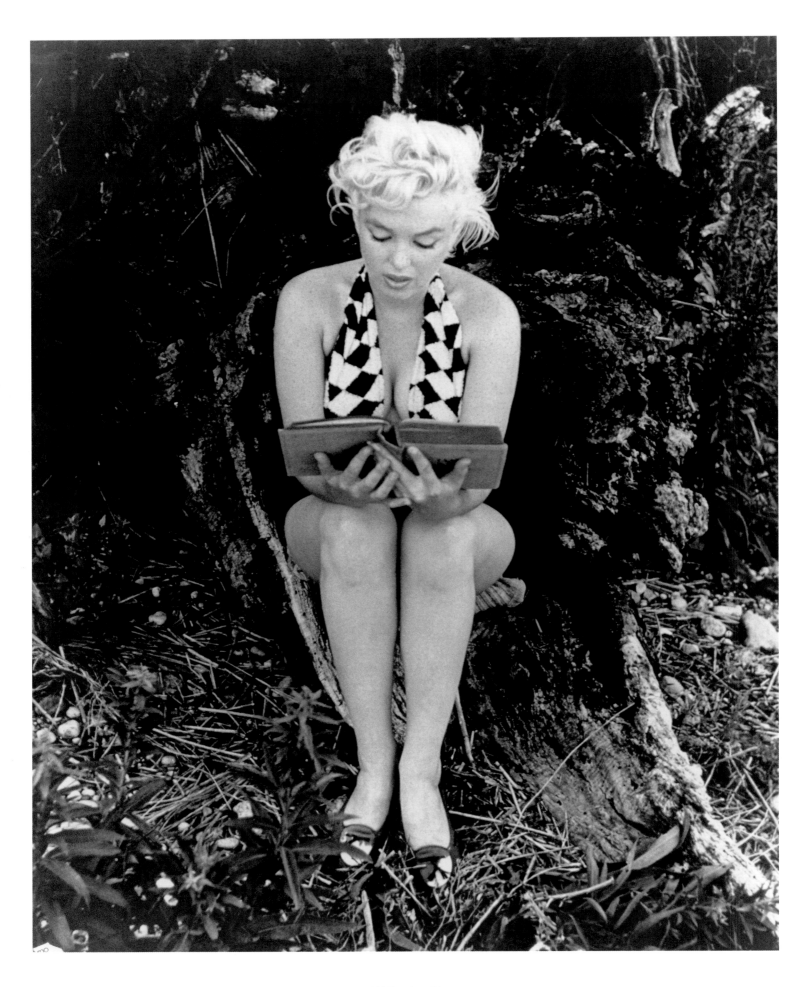

86 | Eve Arnold
Marilyn Monroe Reading James Joyce's "Ulysses", c. 1955

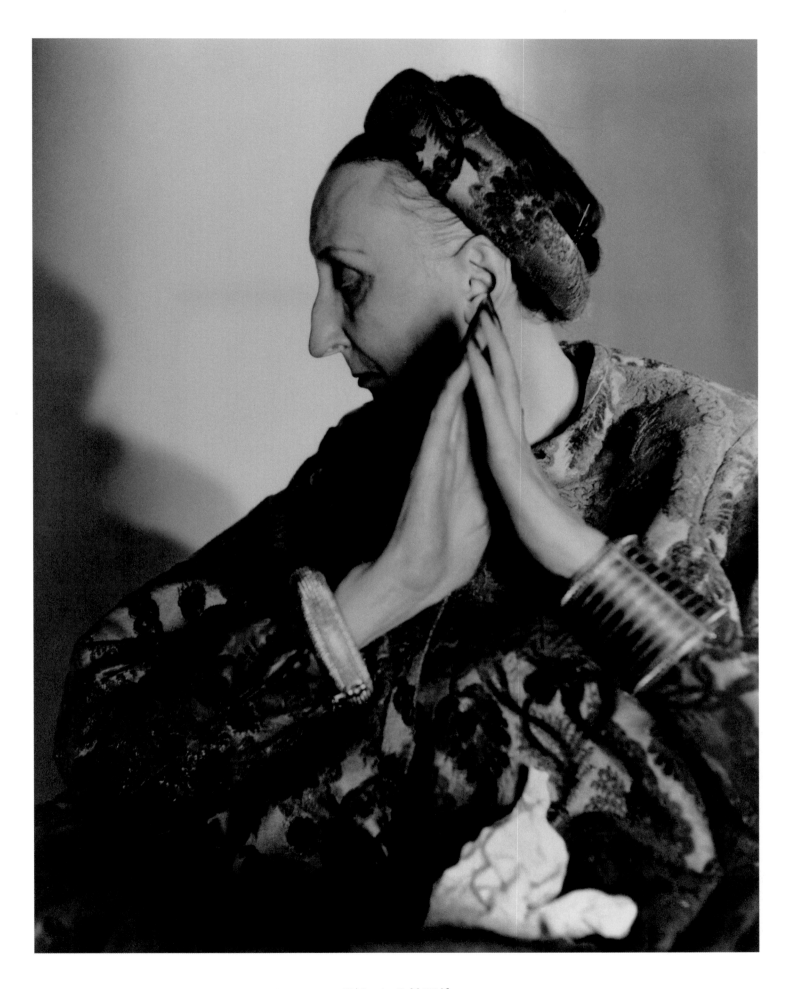

87 | Louise Dahl-Wolfe
Edith Sitwell, New York, 1951

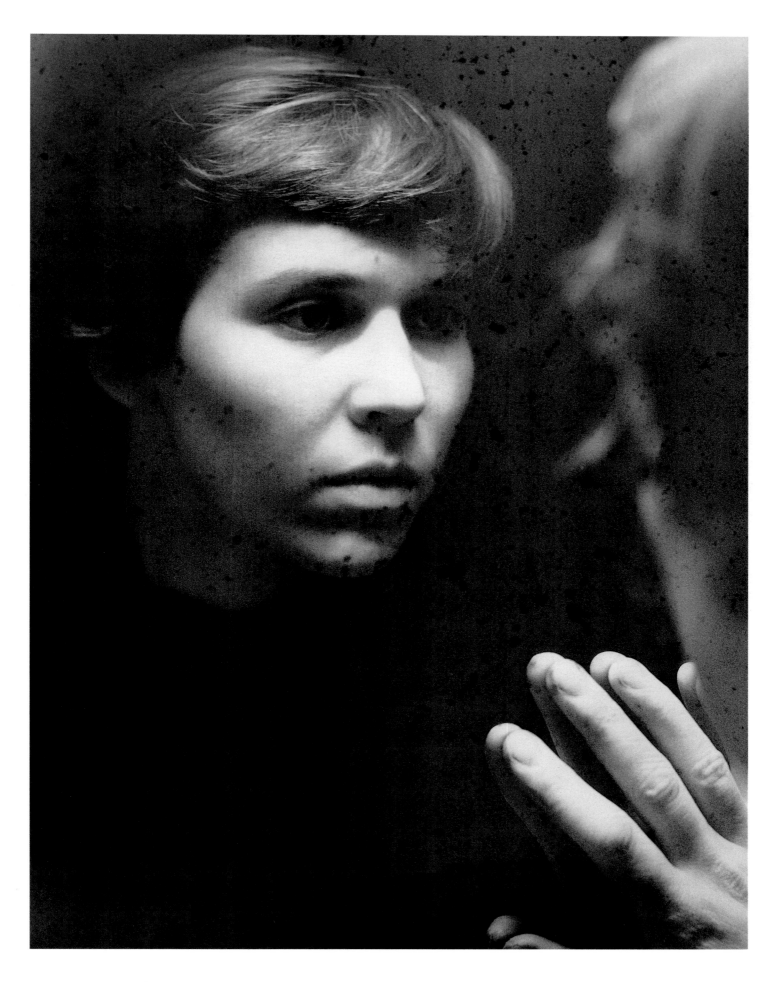

88 | Ingeborg Ludowici
Self-portrait, 1951-53

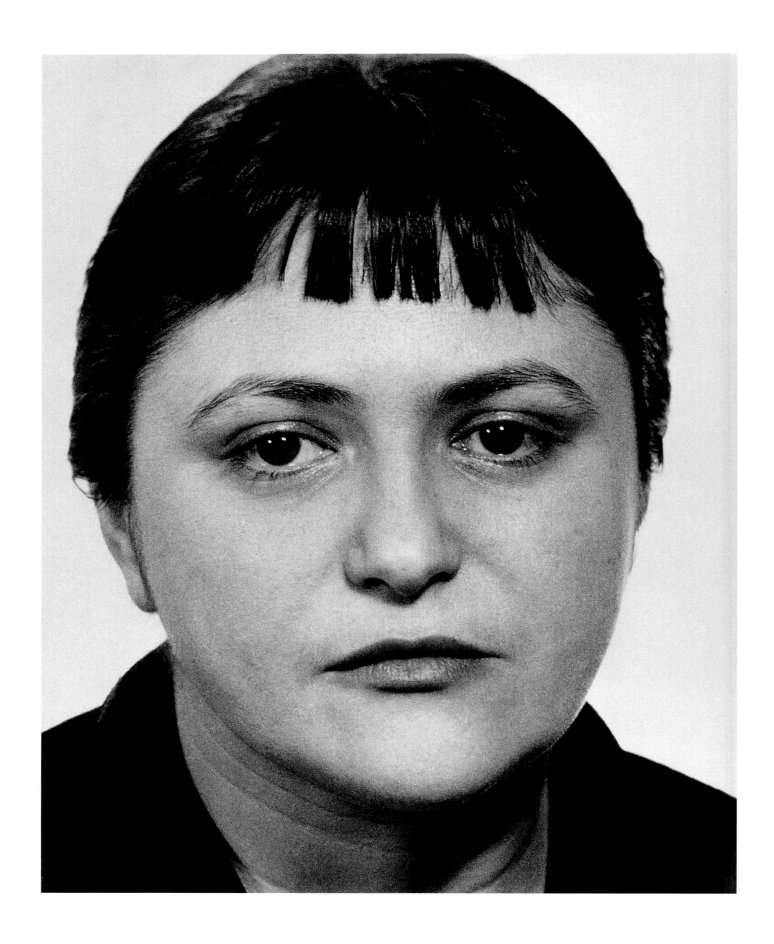

89 | Liselotte Strelow
Dina Vierny, 1951

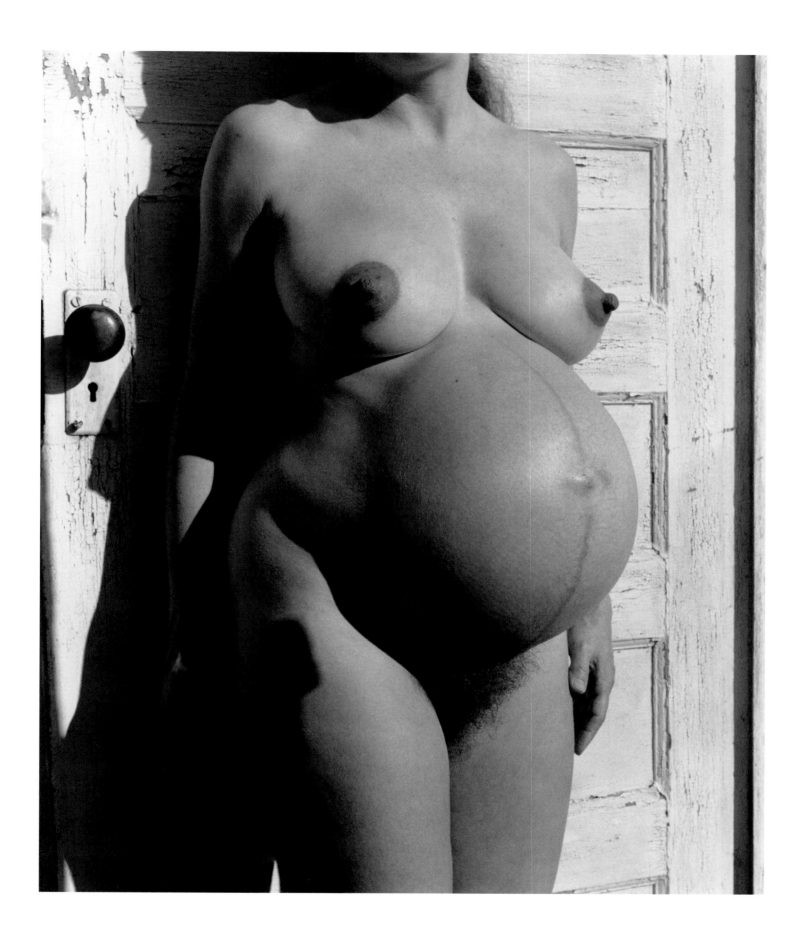

90 | Imogen Cunningham
Pregnant Nude, 1959

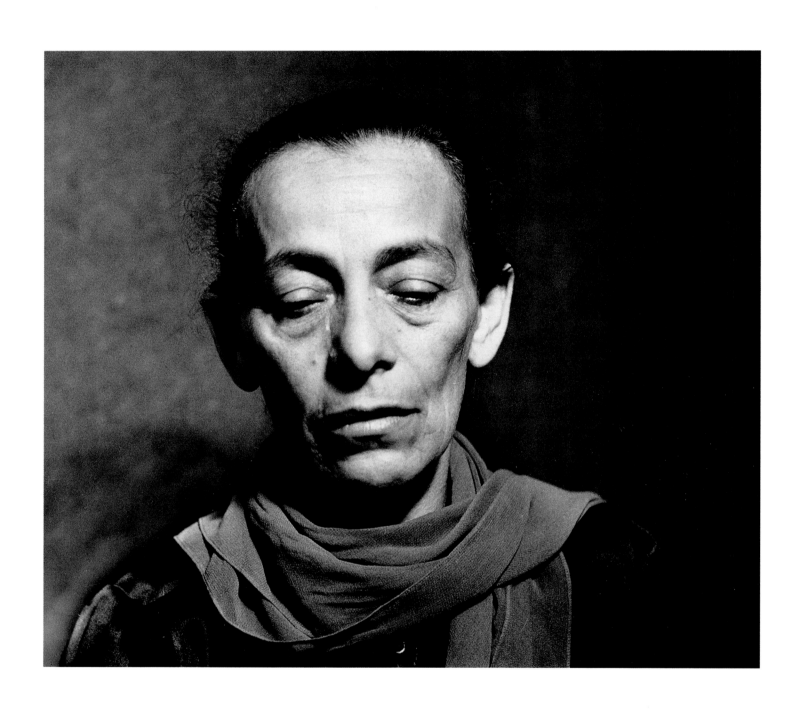

91 | Liselotte Strelow
Helene Weigel, 1950

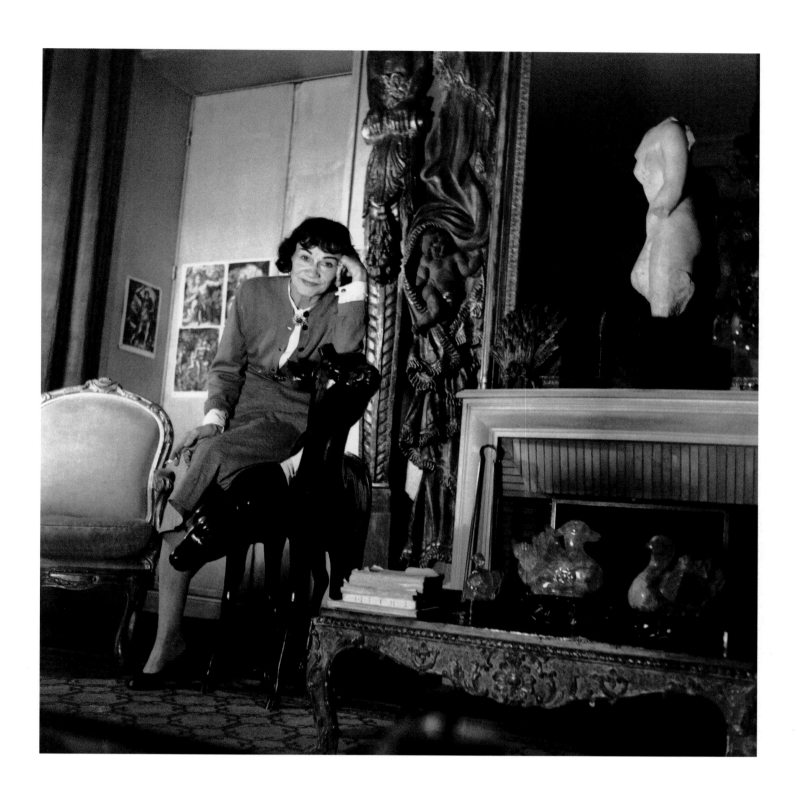

92 | Louise Dahl-Wolfe
Coco Chanel, 1954

THE SIXTIES

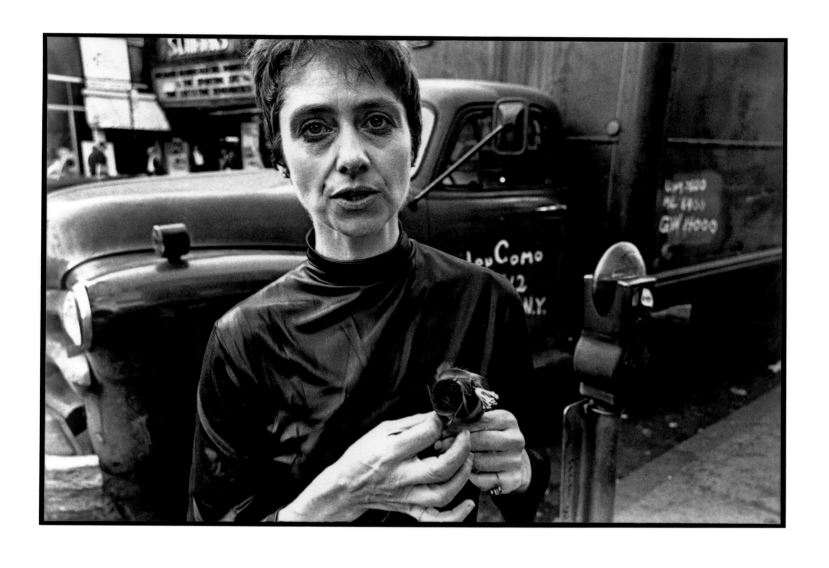

93 | Mary Ellen Mark
Portrait of Diane Arbus, New York, 1969

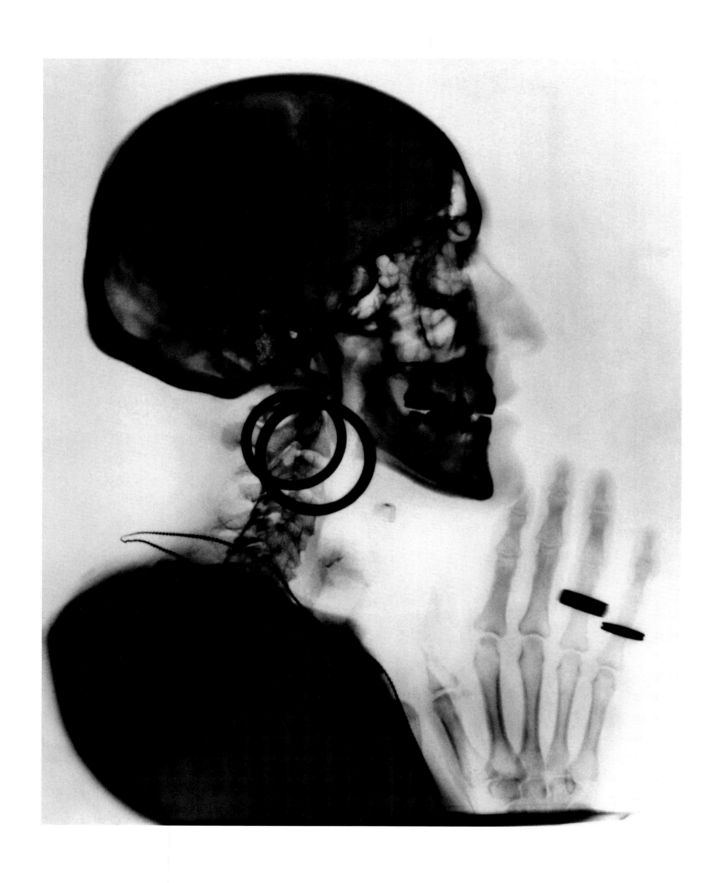

94 | Meret Oppenheim
"*X-Ray of My Skull*", 1964

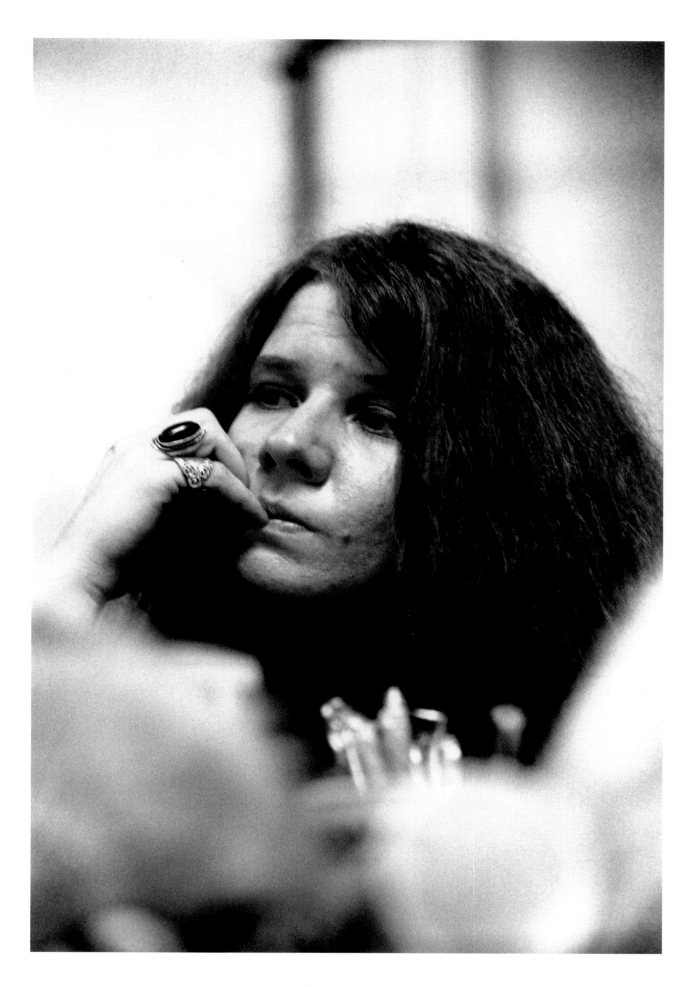

95 | Linda McCartney
Janis Joplin, 1960s

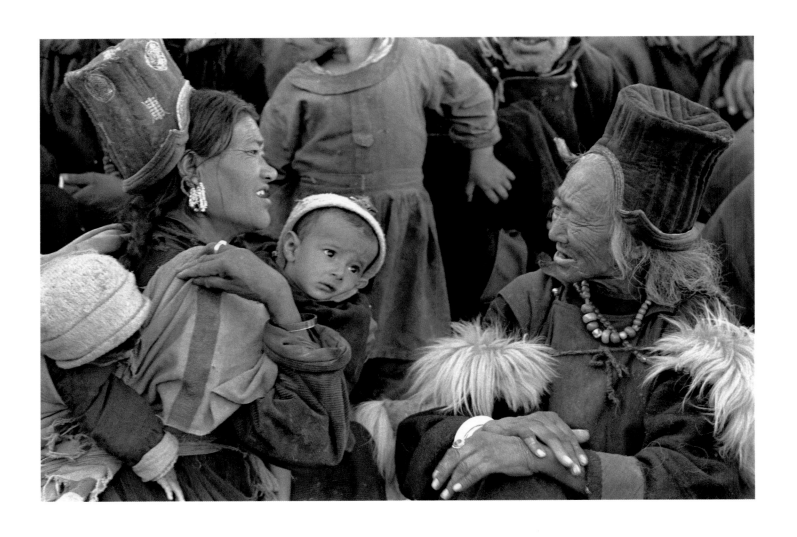

96 | Marilyn Silverstone
Two Ladakhi Women in a Crowd, Watching a Polo Match, Ladakh, 1969

97 | Eve Arnold
Queen Elizabeth II. Signs 'The Book', Manchester, 1968

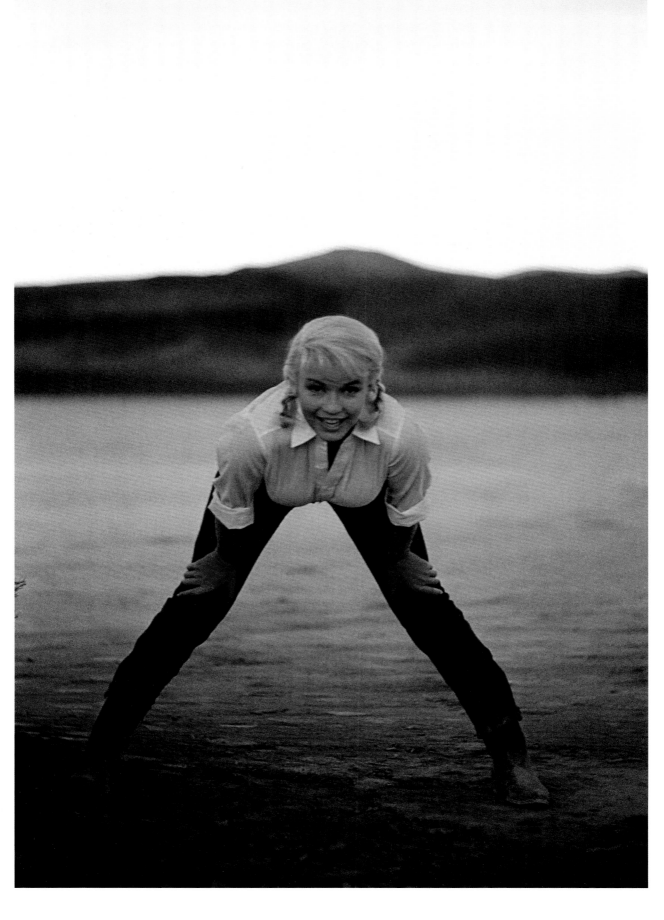

98 | Eve Arnold
Publicity Shot of Marilyn Monroe During Shooting of "The Misfits",
Nevada, 1960

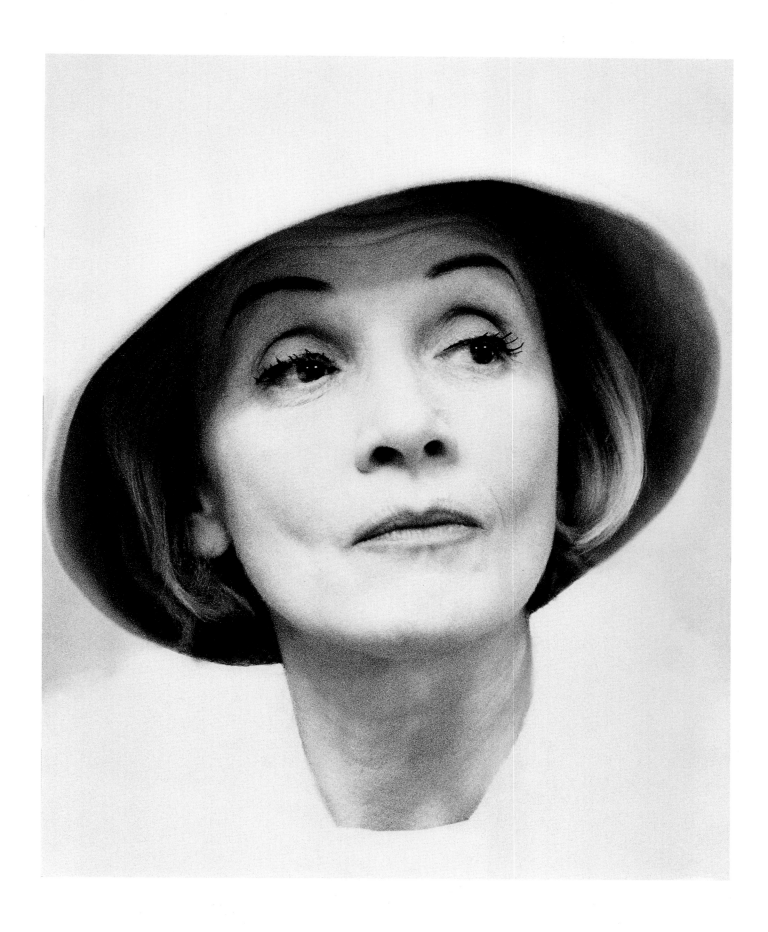

99 | Liselotte Strelow
Marlene Dietrich, 1960

100 | Inge Morath
Young Woman with Mask in Fur, 1961

101 | Ute Klophaus
Charlotte Moorman in the Action "24 Stunden", Wuppertal, 1965

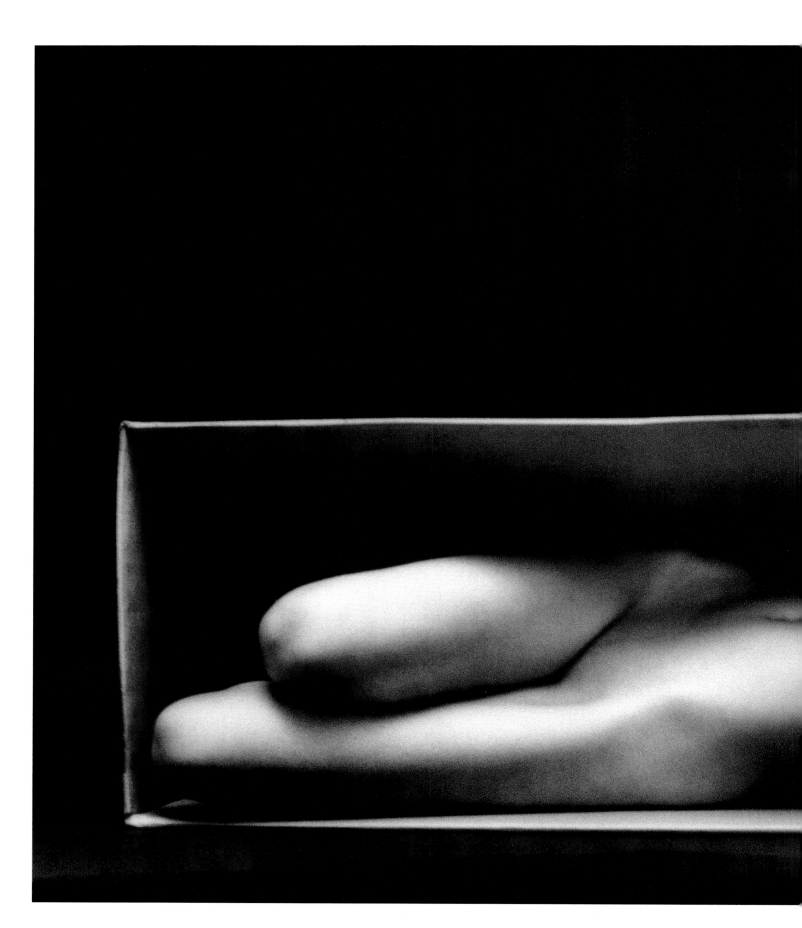

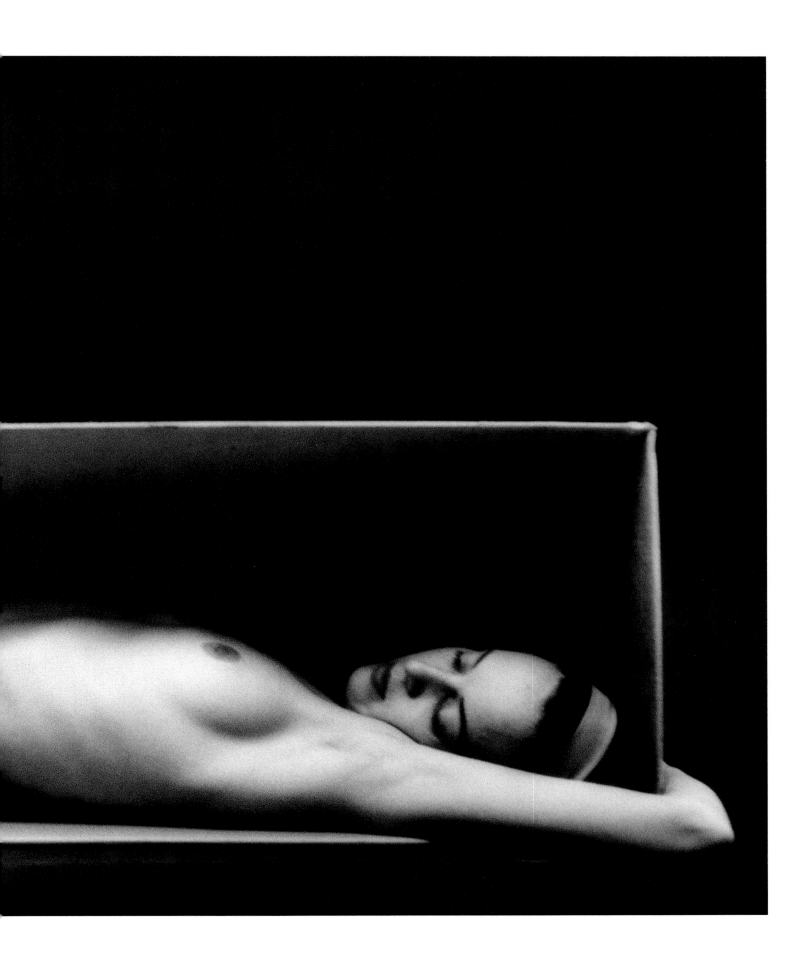

102 | Ruth Bernhard
"In the Box, Horizontal", 1962

THE SEVENTIES

103 | Annie Leibovitz
Marilyn Leibovitz, Ellenville, New York, 1974

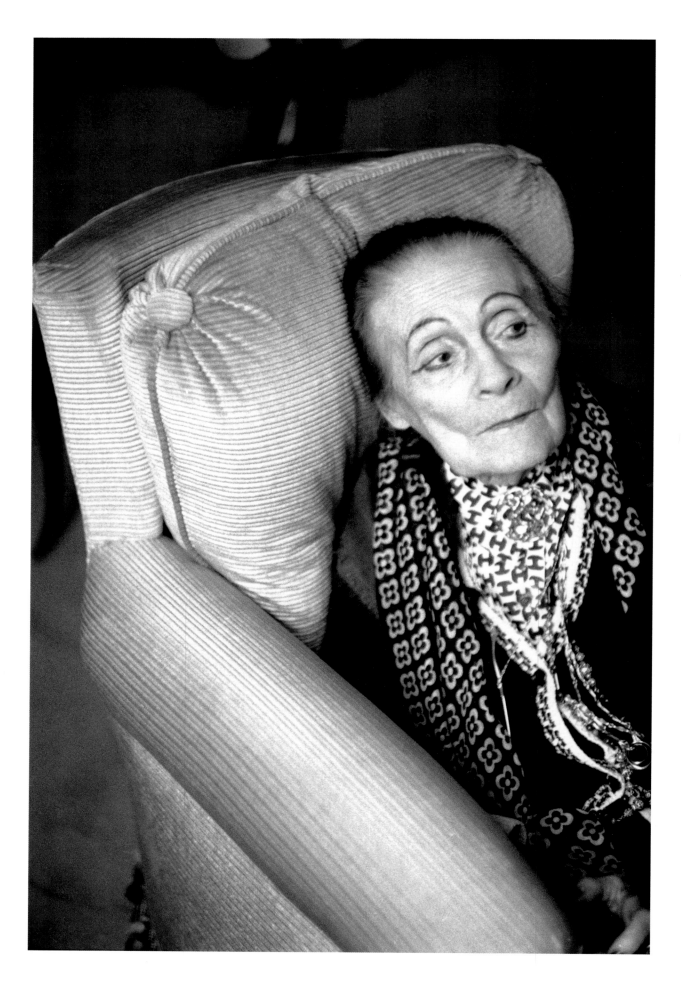

104| Martine Franck
Lily Brik, Hotel Plaza Athénée, Paris, 1976

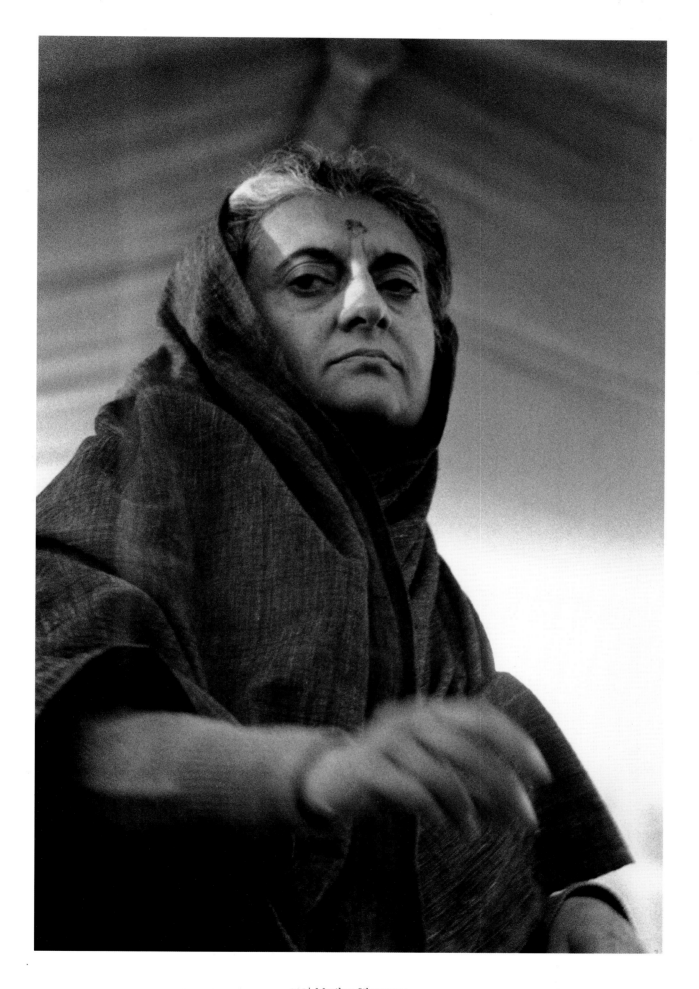

105 | Marilyn Silverstone
Indira Gandhi Campaigning, India, 1971

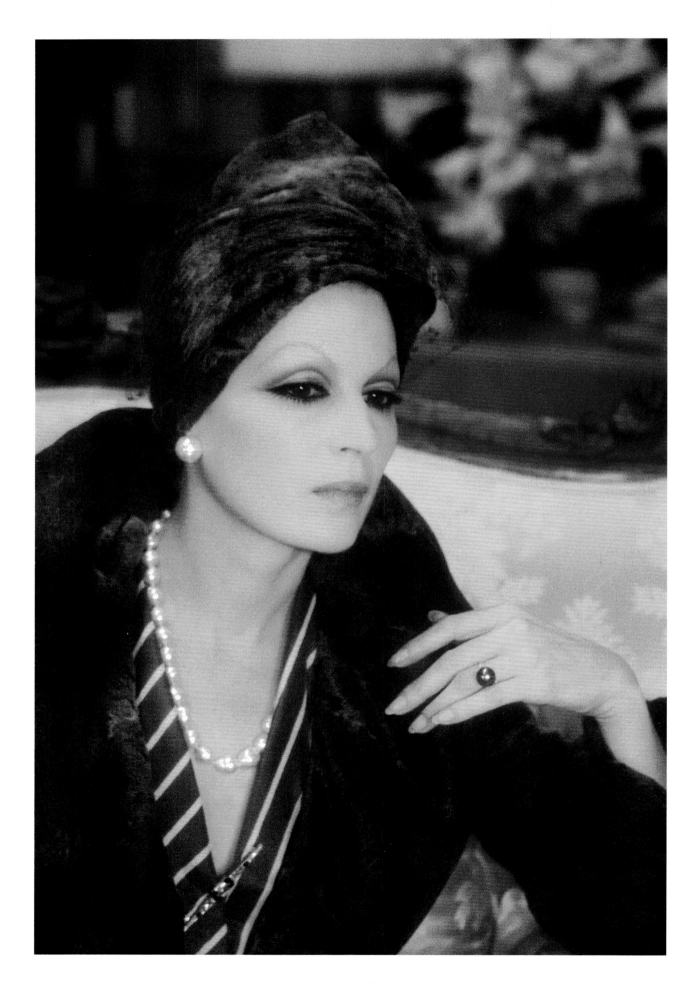

106| Elisabetta Catalano
Silvana Mangano, 1974

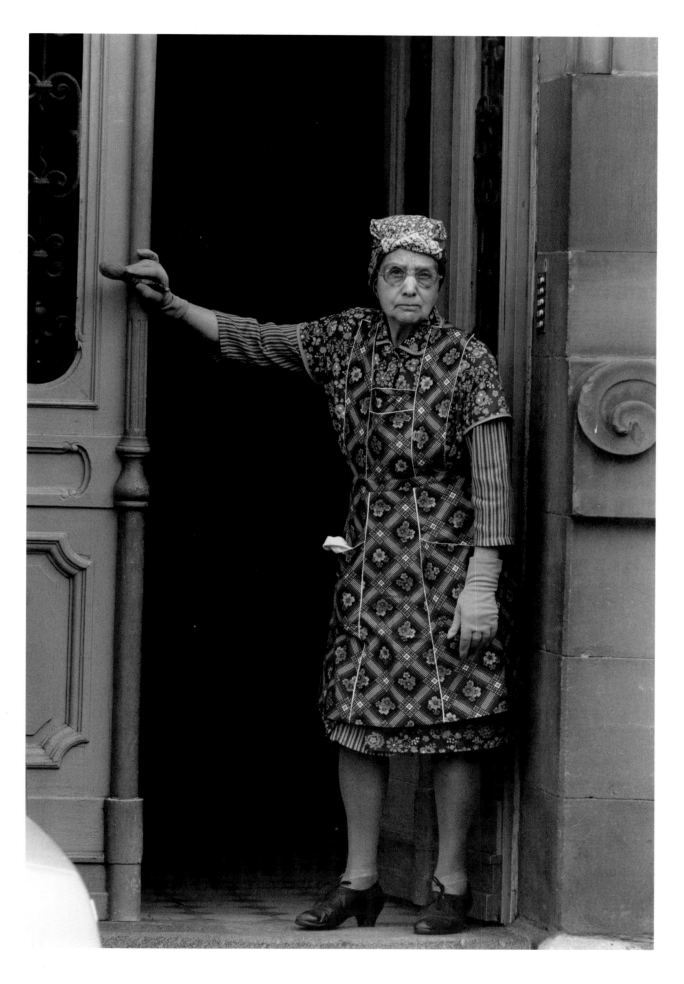

107 | Barbara Klemm
Woman in Apron Dress, Frankfurt, 1974

108| Mary Ellen Mark
Women's Bar, Upper East Side, New York, 1977

109 | Barbara Klemm
School in Soweto, South Africa, 1978

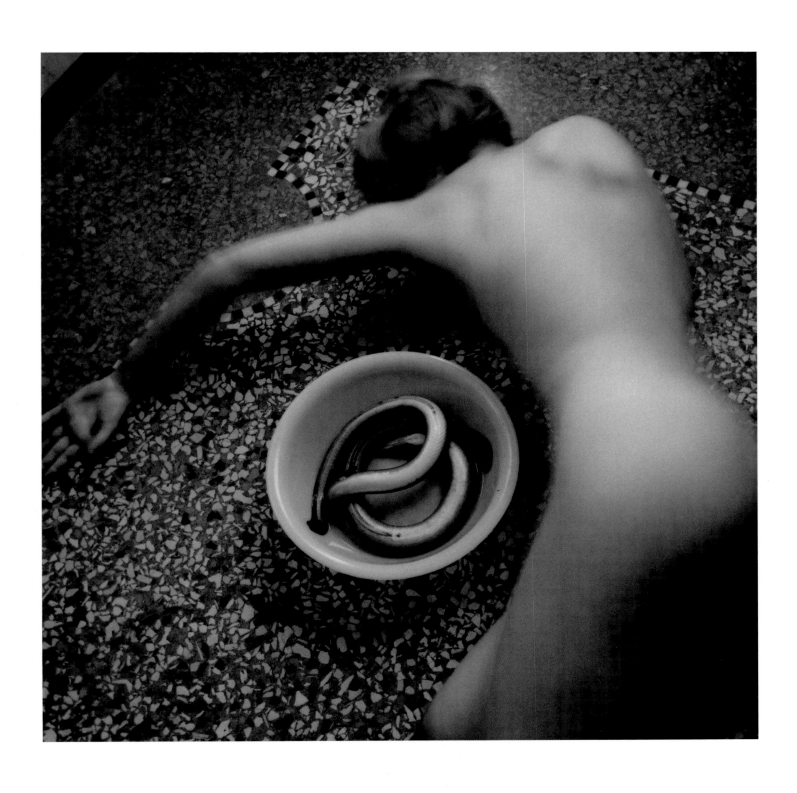

110 | Francesca Woodman
"Italy, May 1977 — August 1978"

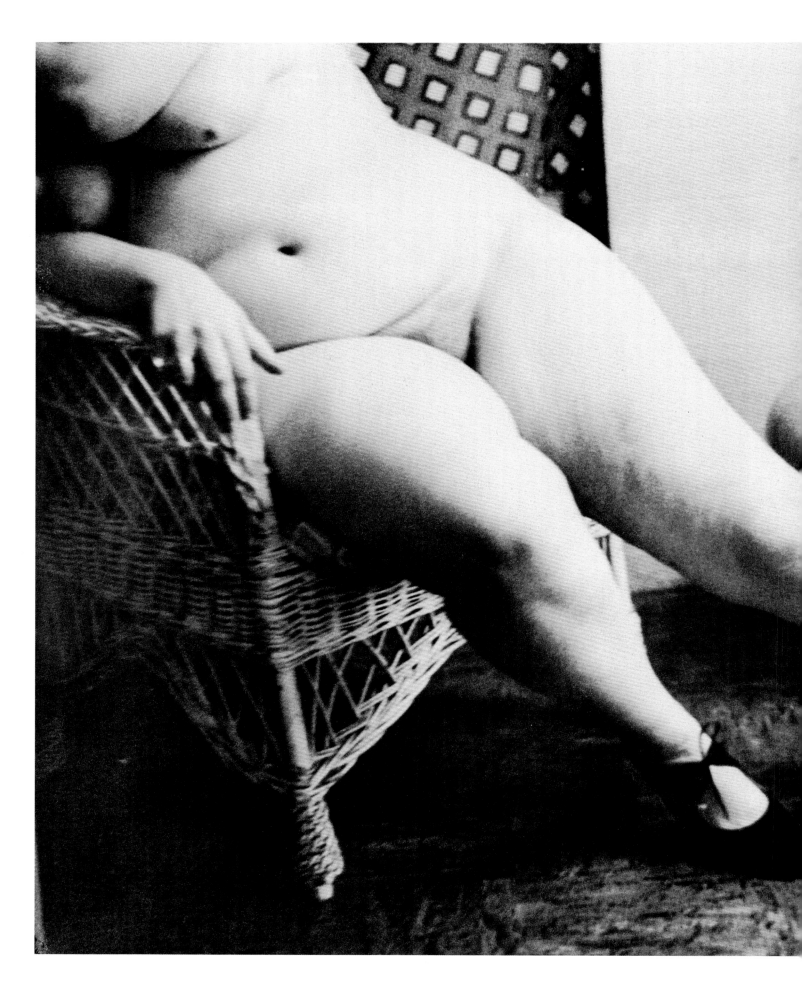

111 | Deborah Turbeville
Mary Martz in Her Apartment, New York, 1979

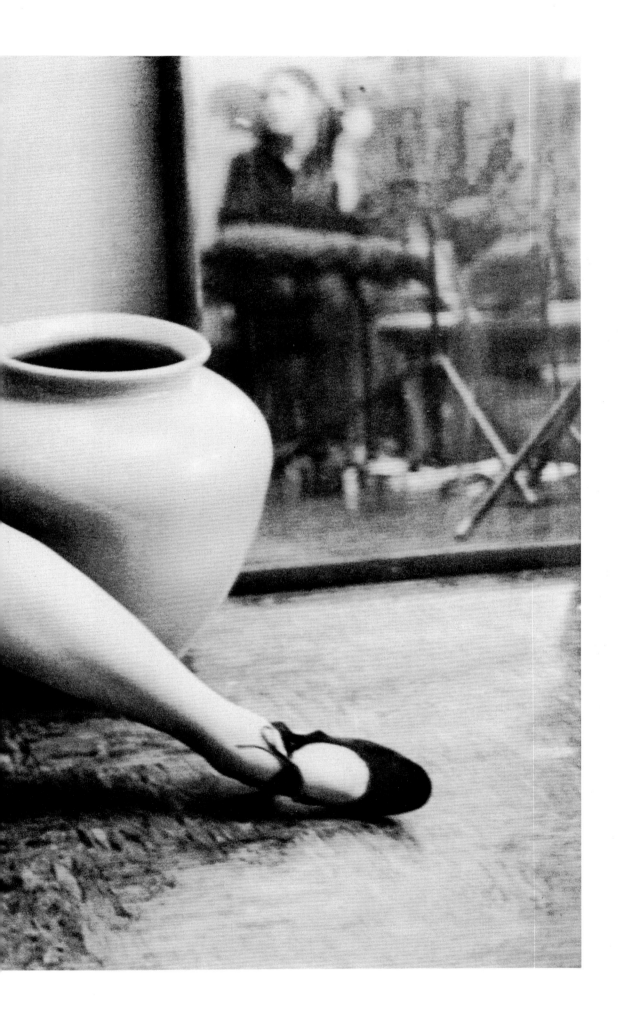

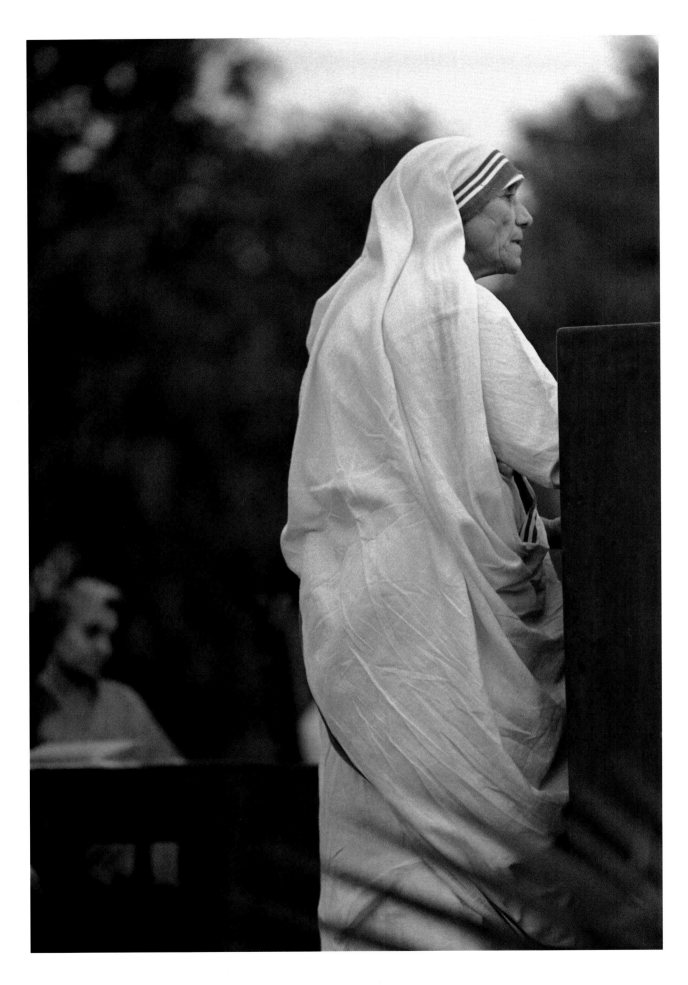

112| Marilyn Silverstone
Mother Theresa, India, 1972

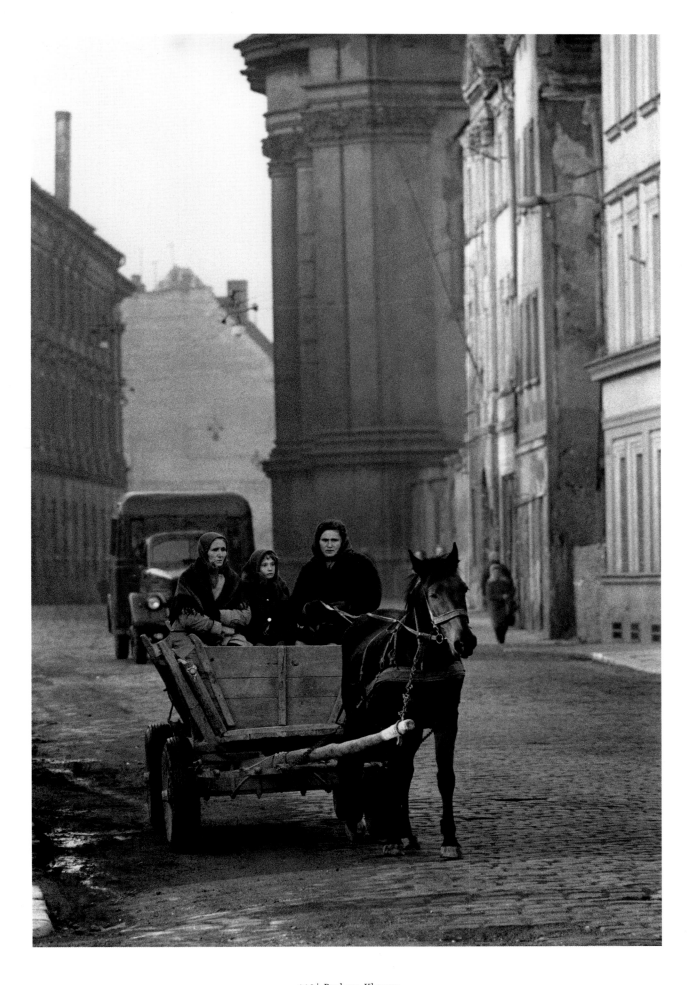

113 | Barbara Klemm
Horse-drawn Vehicle with Women, Legnica, Poland, 1970

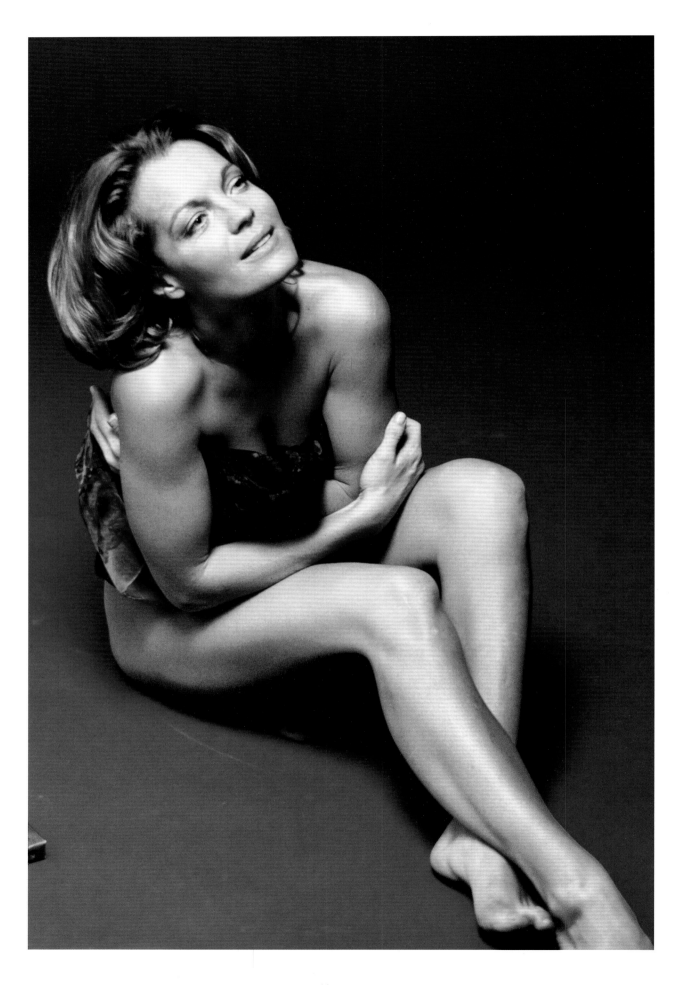

114| Eva Sereny
Romy Schneider, Rome, 1971

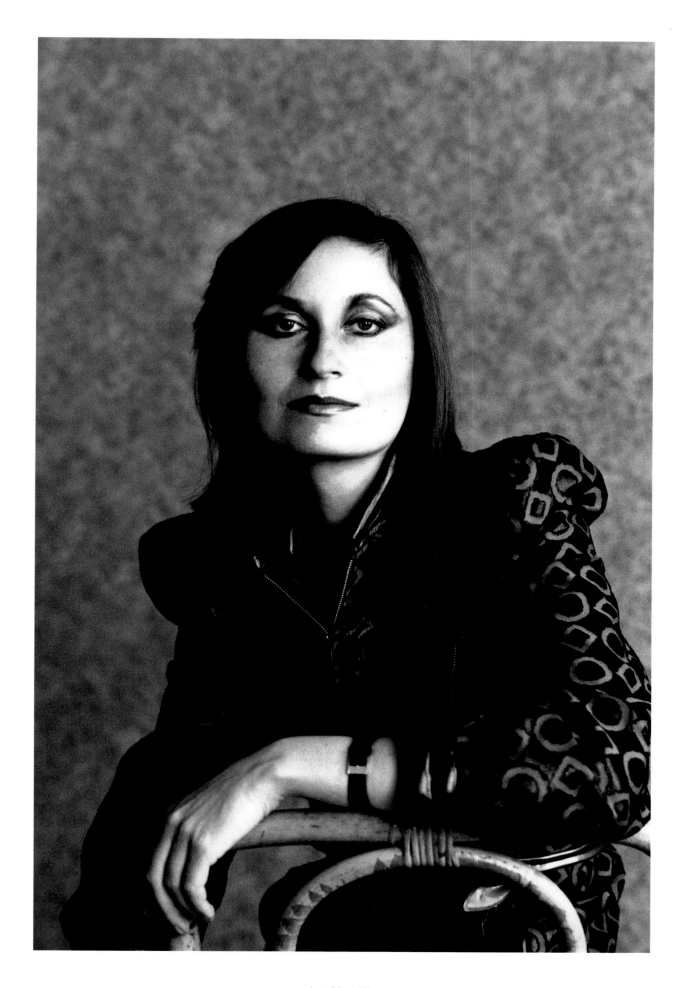

115 | Isolde Ohlbaum
Elfriede Jelinek, Munich, 1979

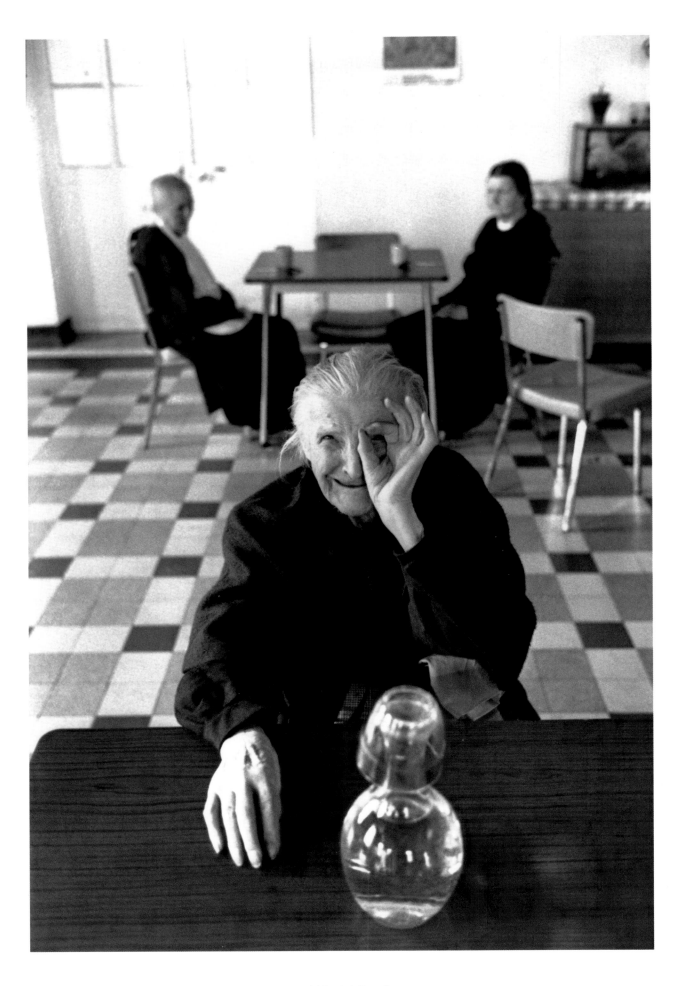

116 | Martine Franck
Old-Age Home, Ivry-sur-Seine, France, 1975

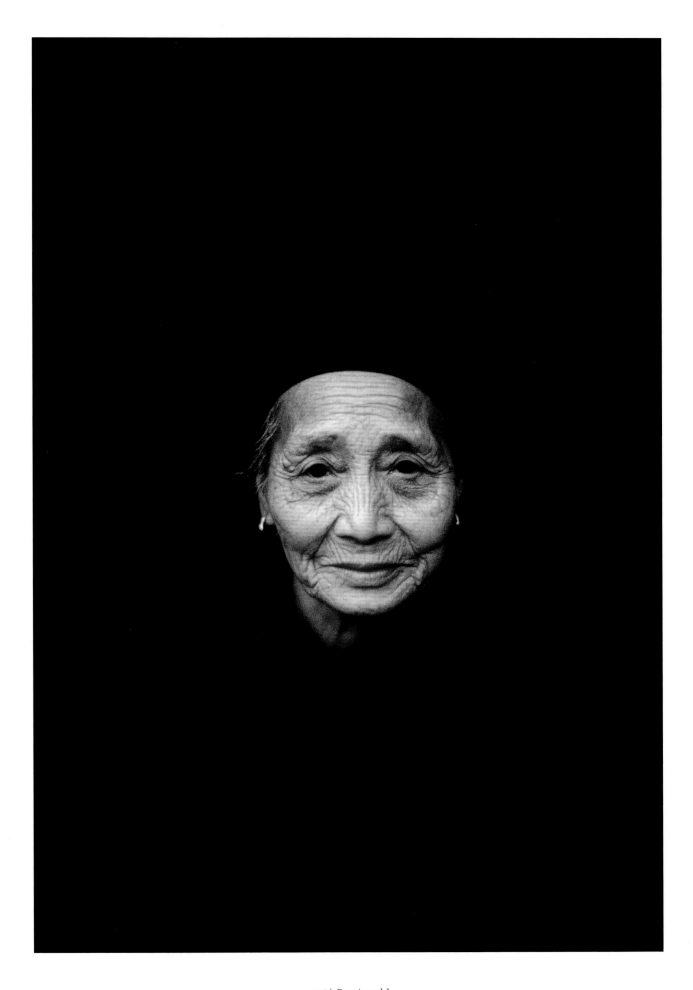

117 | Eve Arnold
Retired Worker, China, 1979

THE EIGHTIES

118 | Dominique Issermann
Anne Rohart, c. 1987

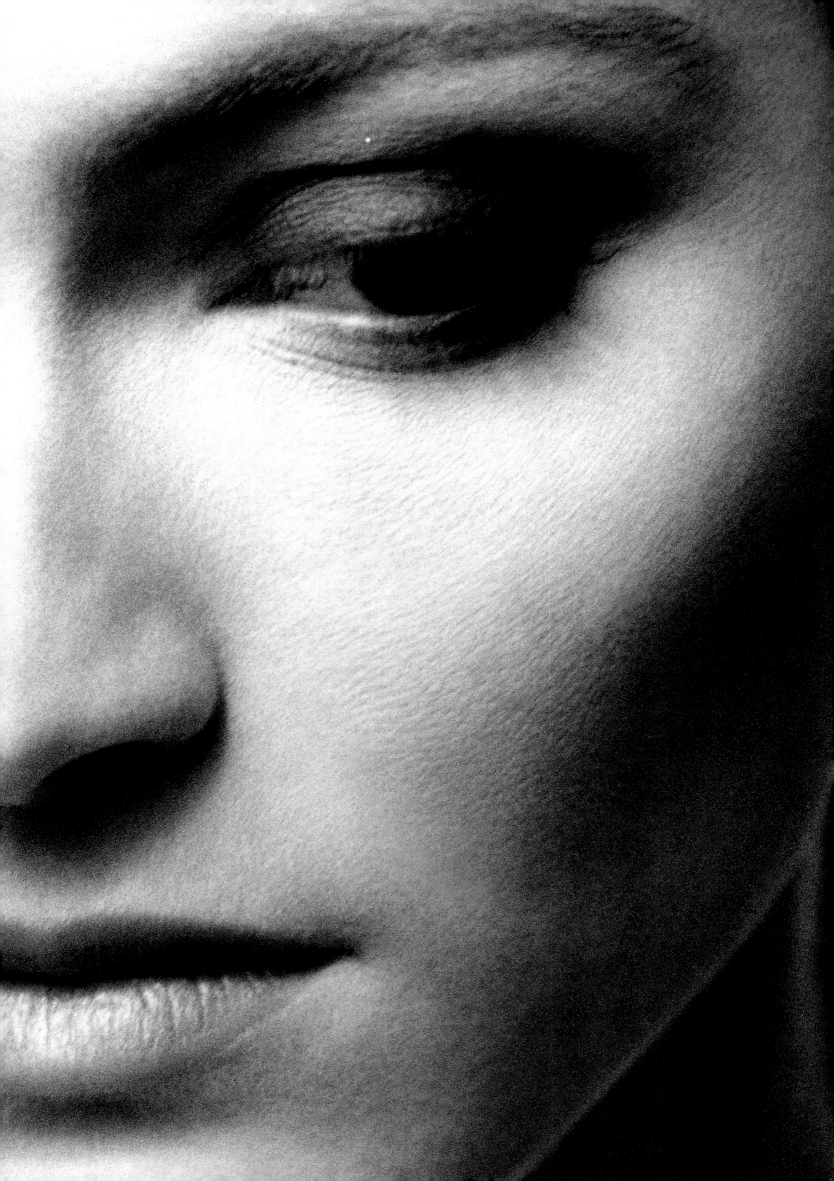

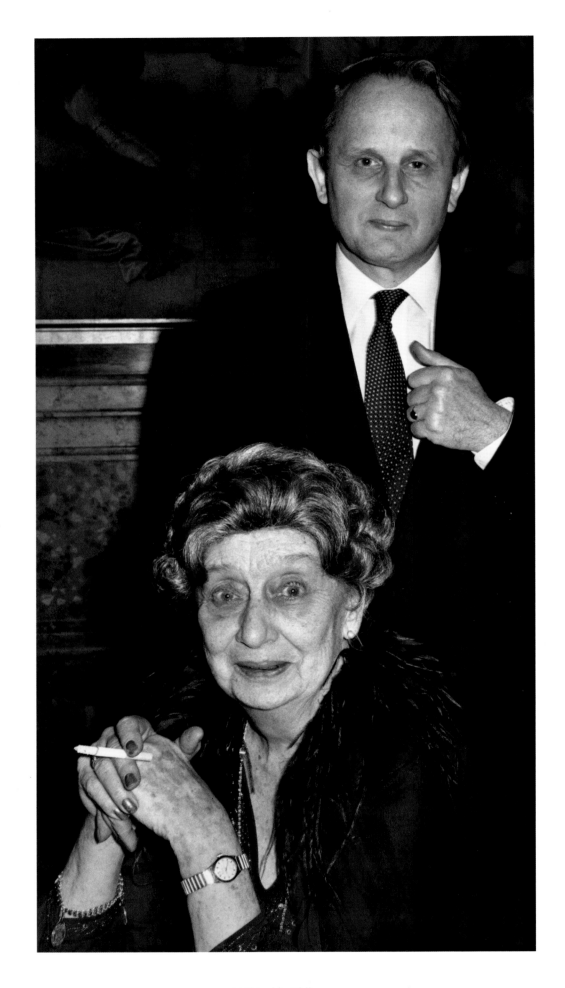

119| Isolde Ohlbaum
Rolf Hochhuth with His Mother Ilse Hochhuth, born Holzapfel, Munich, 1980

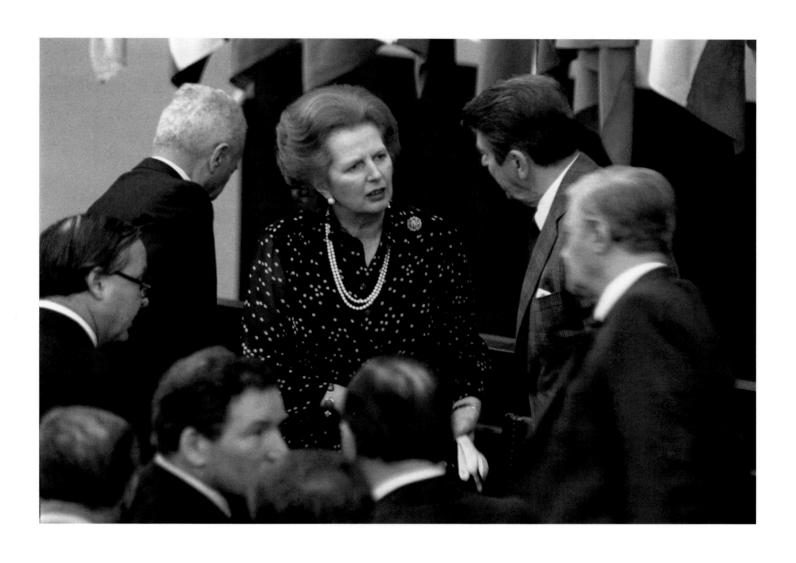

120 | Barbara Klemm
Margaret Thatcher, NATO Summit, Bonn, 1982

121 | Barbara Klemm
Edith Clever, Berlin, 1984

122 | Isolde Ohlbaum
Anita Albus, Chatoillenot, 1989

123 | Bettina Rheims
Jessye Norman, Paris, 1987

124| Deborah Turbeville
Steam Bath, Vogue Italia, New York, 1984

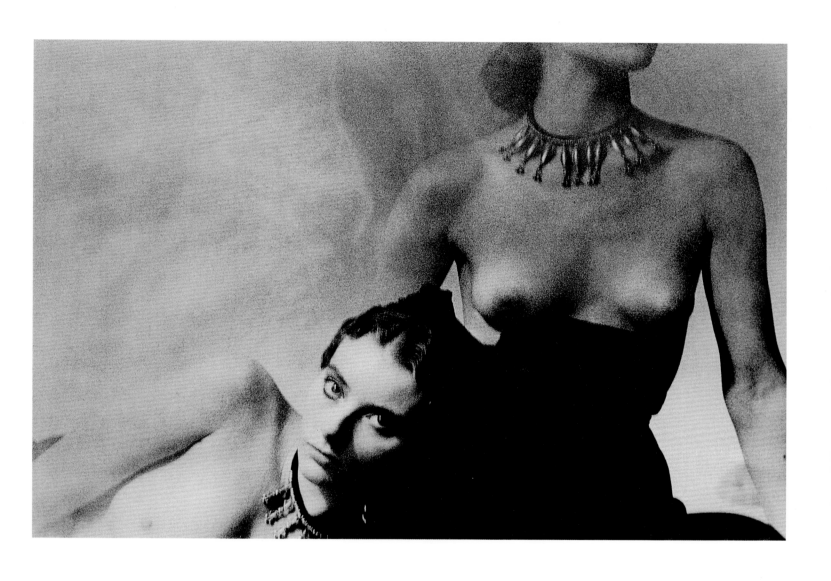

125 | Deborah Turbeville
Steam Bath, Vogue Italia, New York, 1984

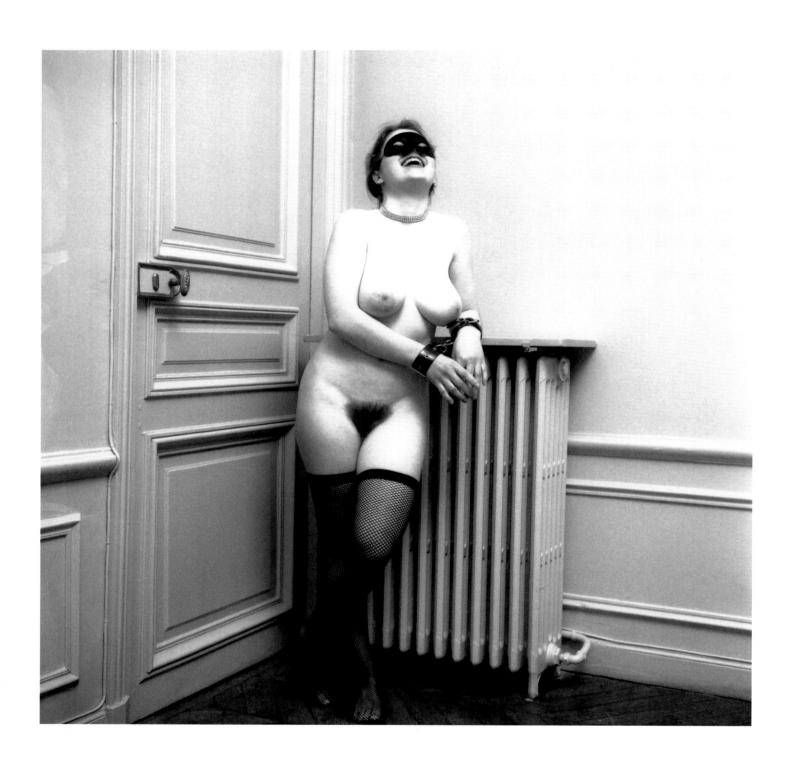

126| Bettina Rheims
"C. at the Radiator", Paris, 1981

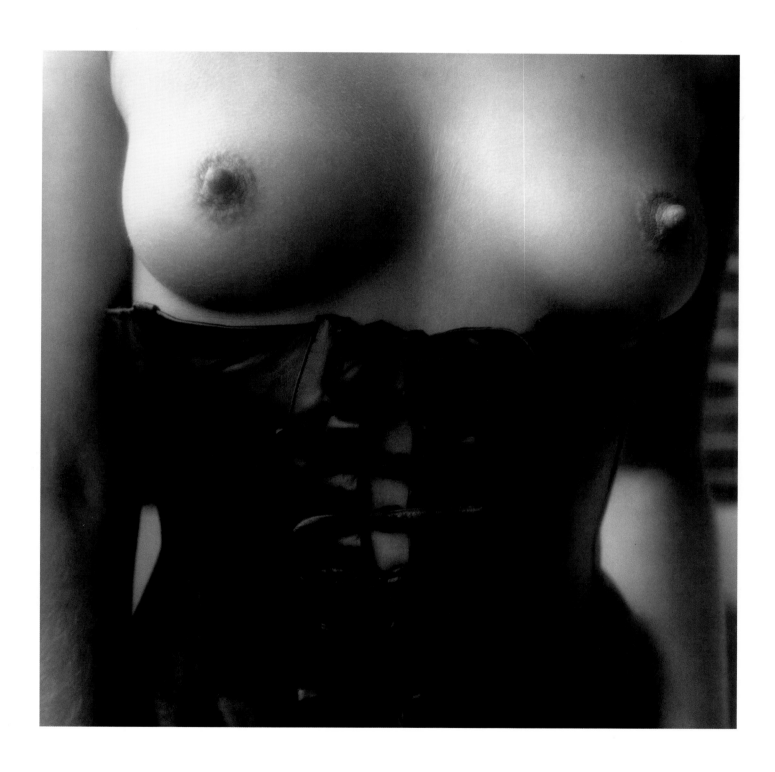

127 | Karin Székessy
Vicky's Corsage, 1985

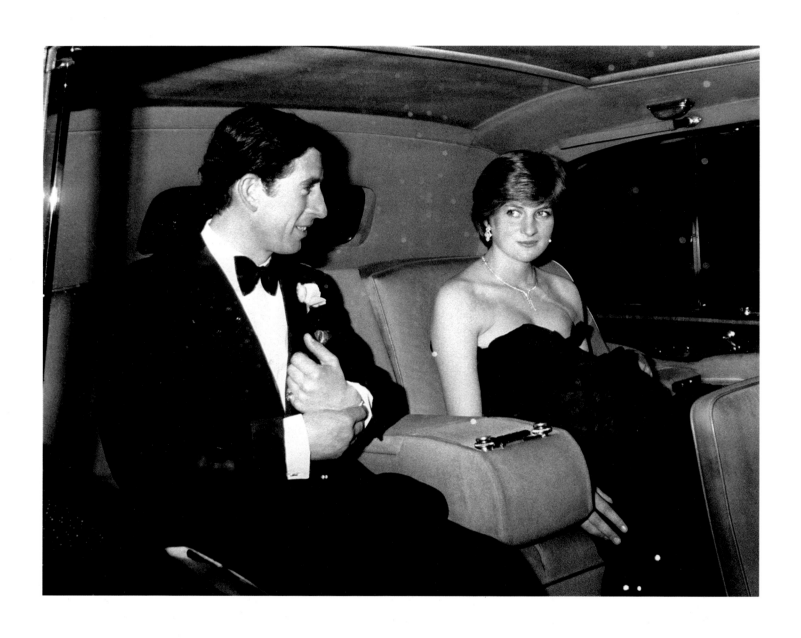

128 | Jayne Fincher
Princess Diana and Prince Charles, London, March, 1981

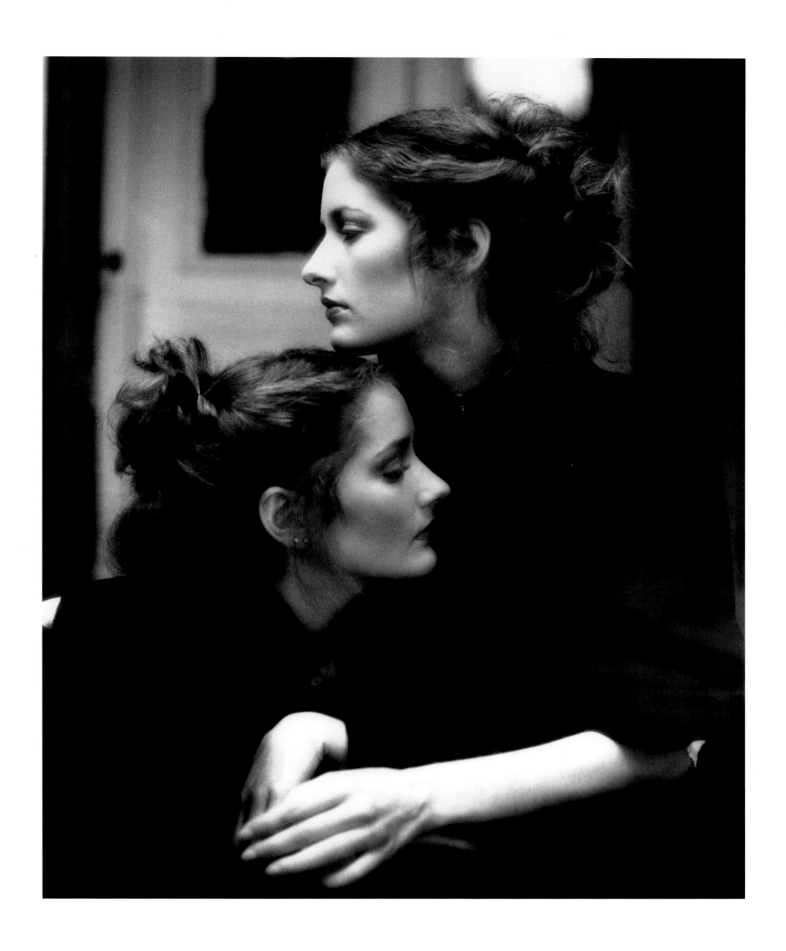

129 | Frances McLaughlin-Gill
Amy and Ann McCandless, Models, New York, 1979

THE NINETIES

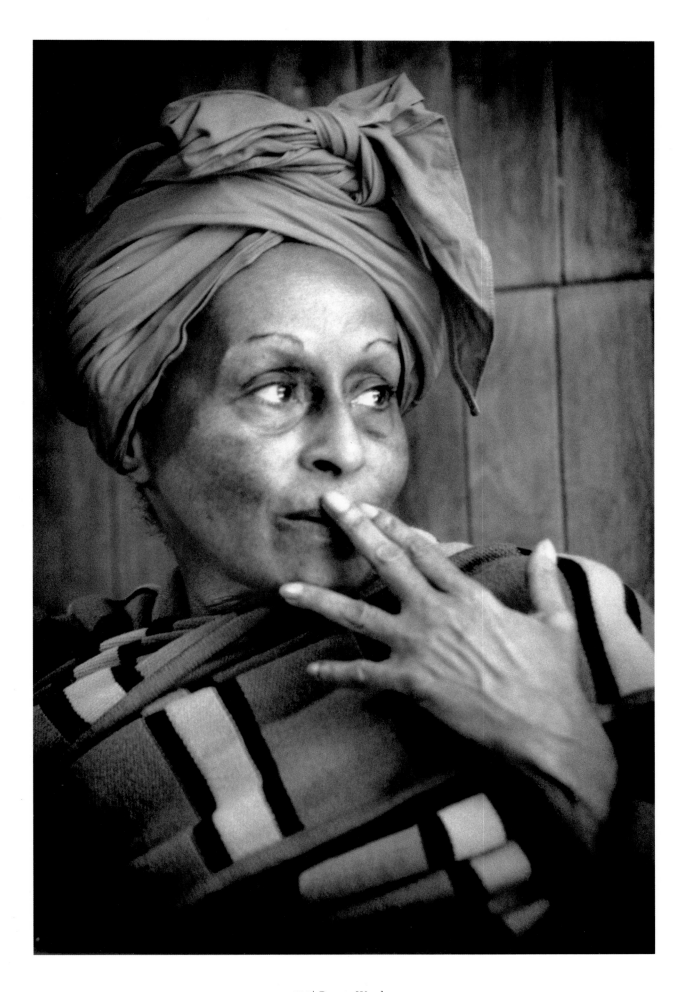

130 | Donata Wenders
Omara Portuondo, Havana, 1998

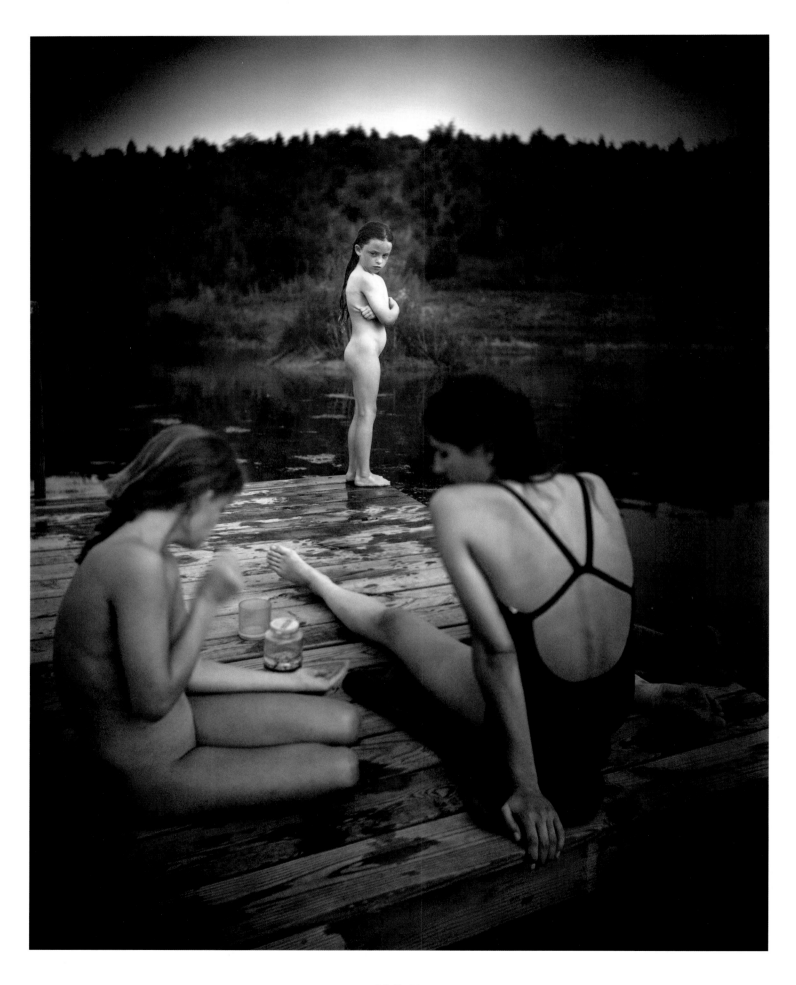

131 | Sally Mann
"*The Big Girls*", 1992

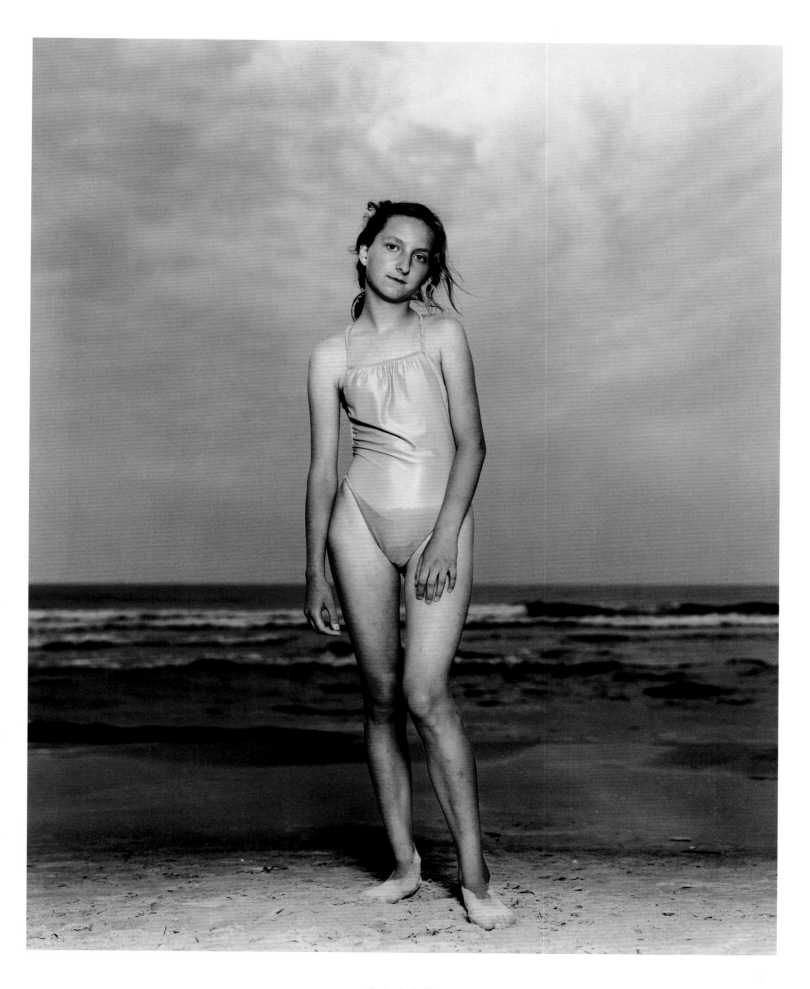

132| Rineke Dijkstra
Girl at the Beach, Kolobrzeg, Poland, July 26, 1992

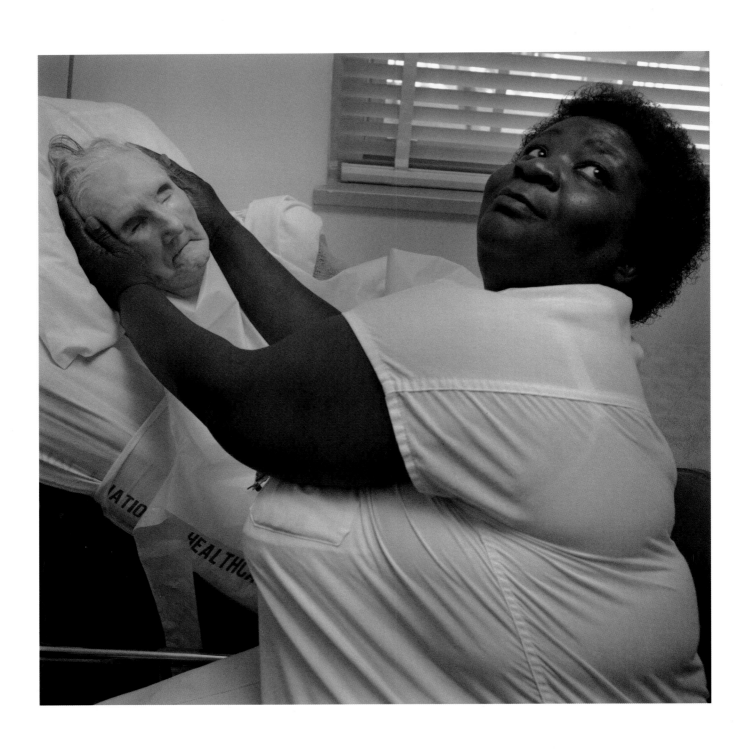

133 | Mary Ellen Mark
Leprosy Patient with her Nurse, National Hansen's Disease Center, Carville, Louisiana, 1990

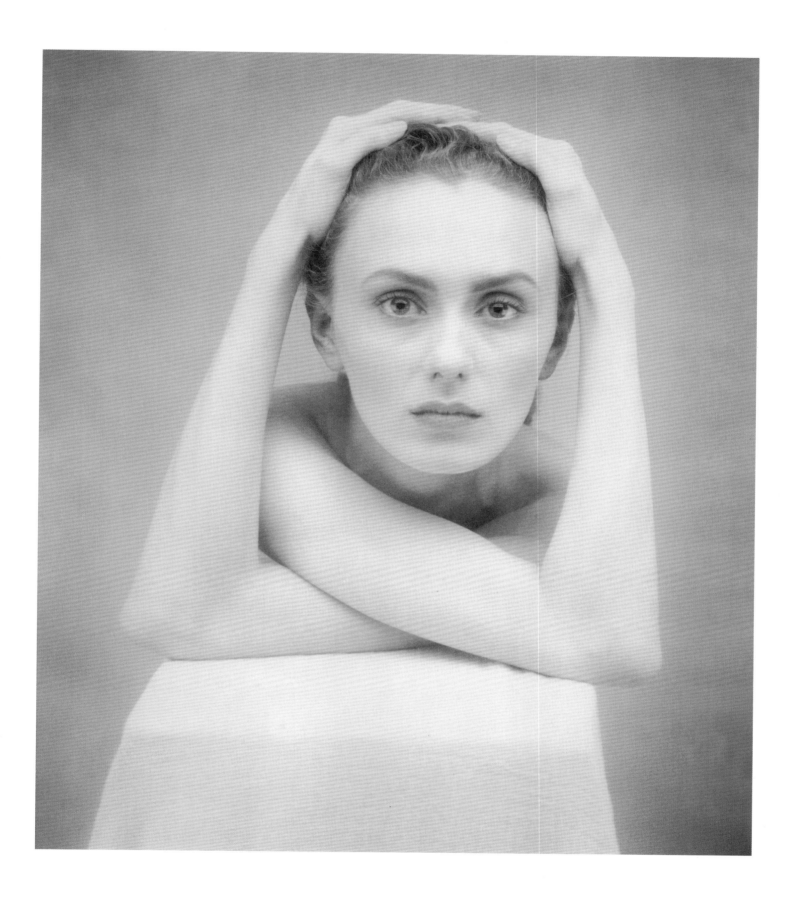

134 | Joyce Tenneson
"Suzanne in Contortion", 1990

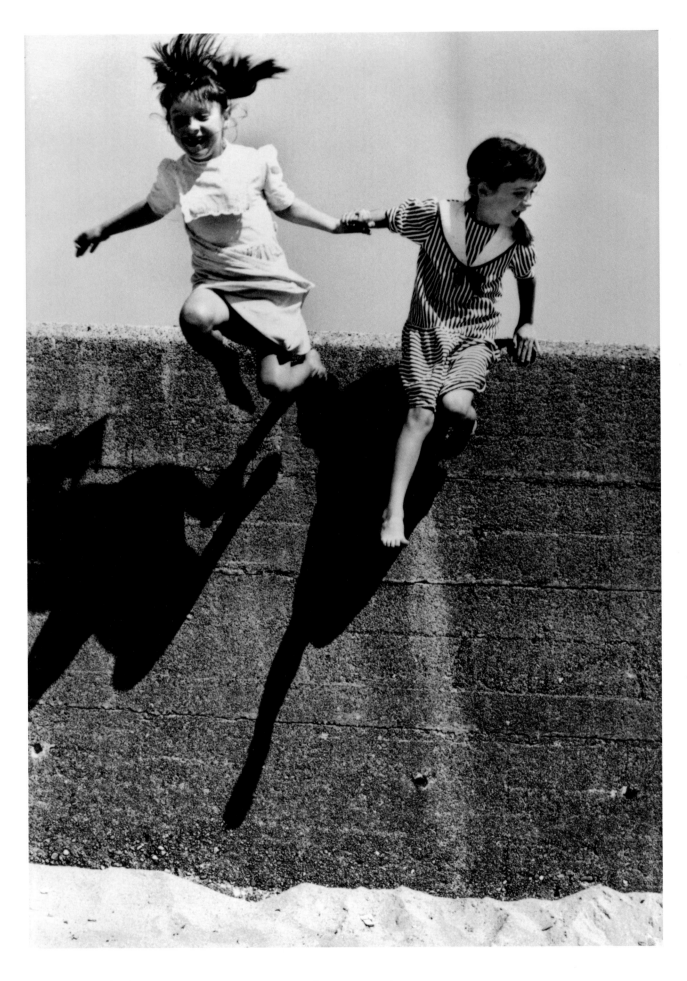

135 | Martine Franck
Playing Children, Tory Island, Donegal, Ireland, 1995

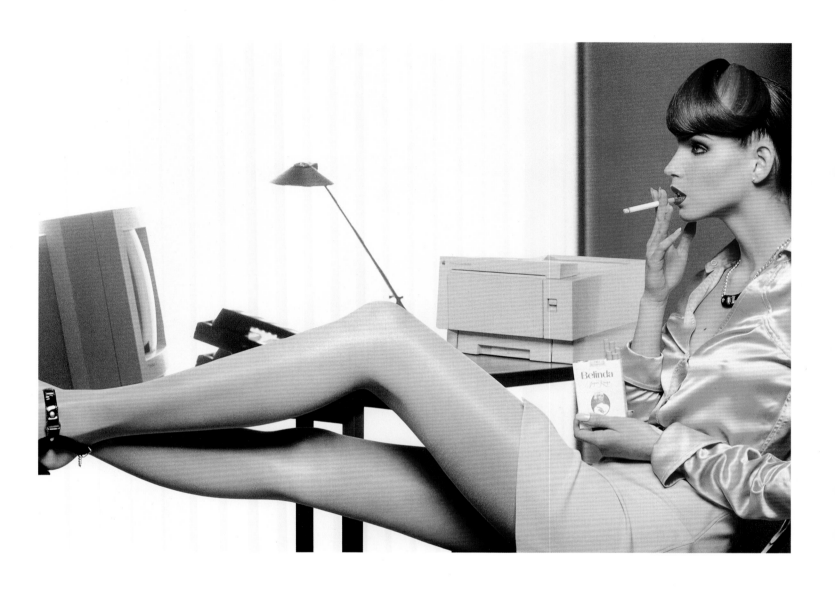

136| Inez van Lamsweerde with Vinoodh Matadin
"*My mother? I'll tell you about my mother, Kym,*" 1994

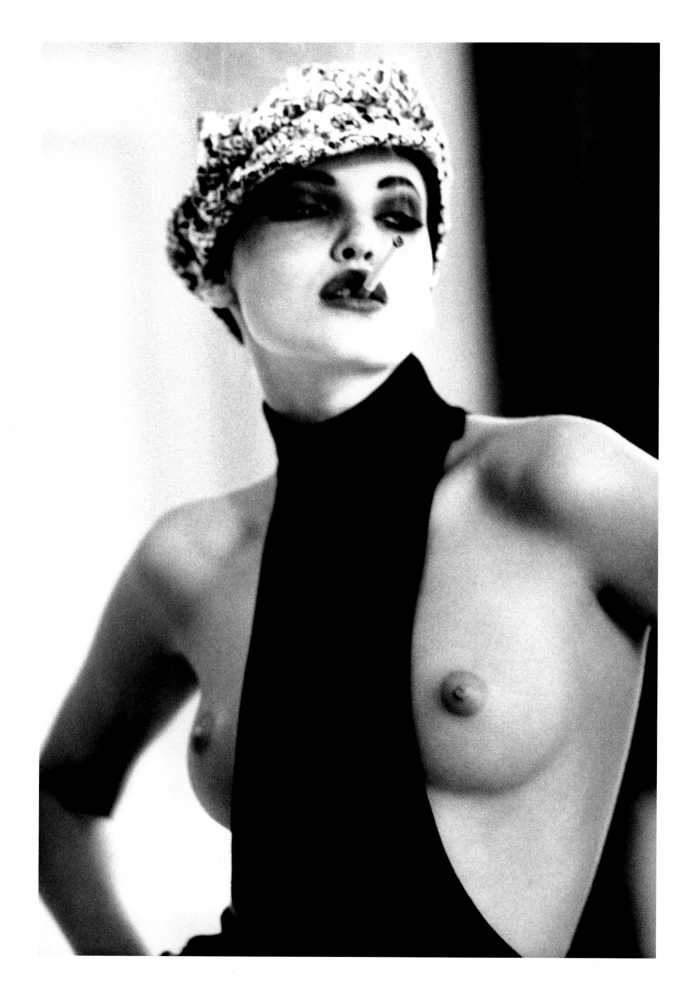

137 | Ellen von Unwerth
Nadja Auermann, October, 1991

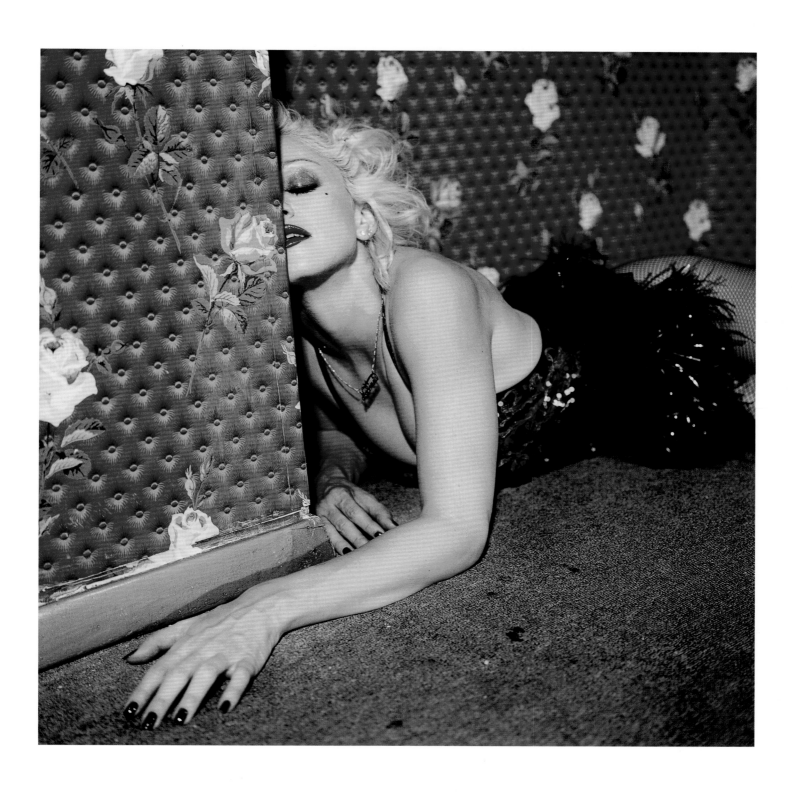

138 | Bettina Rheims
"Madonna Lying on the Floor of a Red Room I", New York, September, 1994

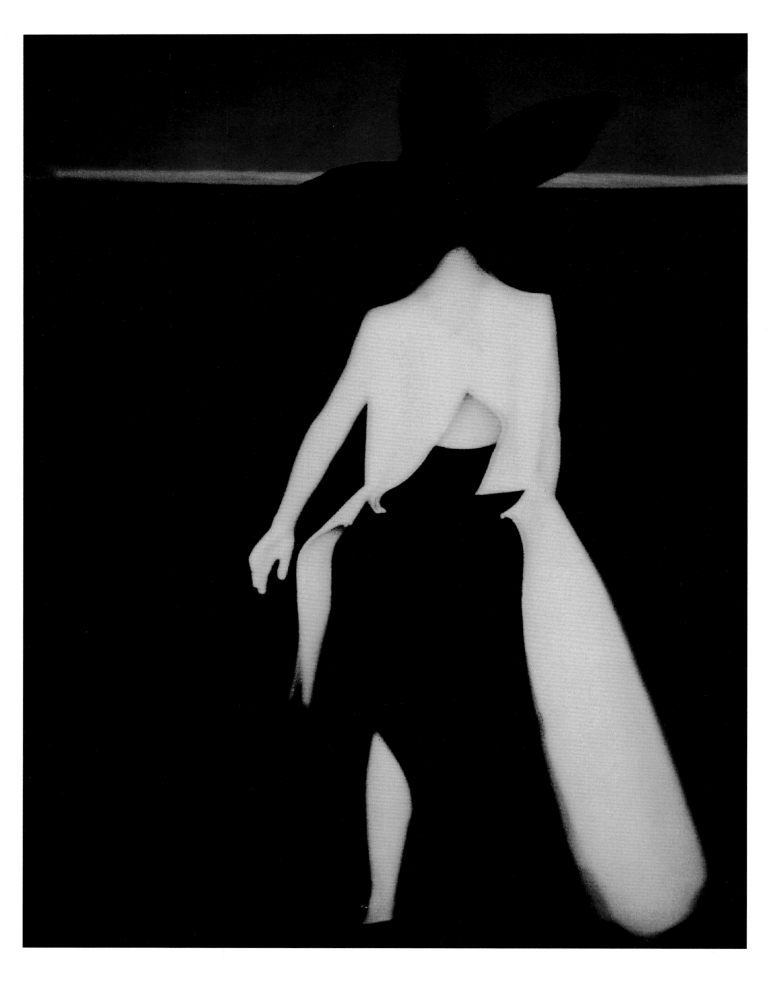

139 | Sarah Moon
"Fashion 4, Yohji Yamamoto", 1996

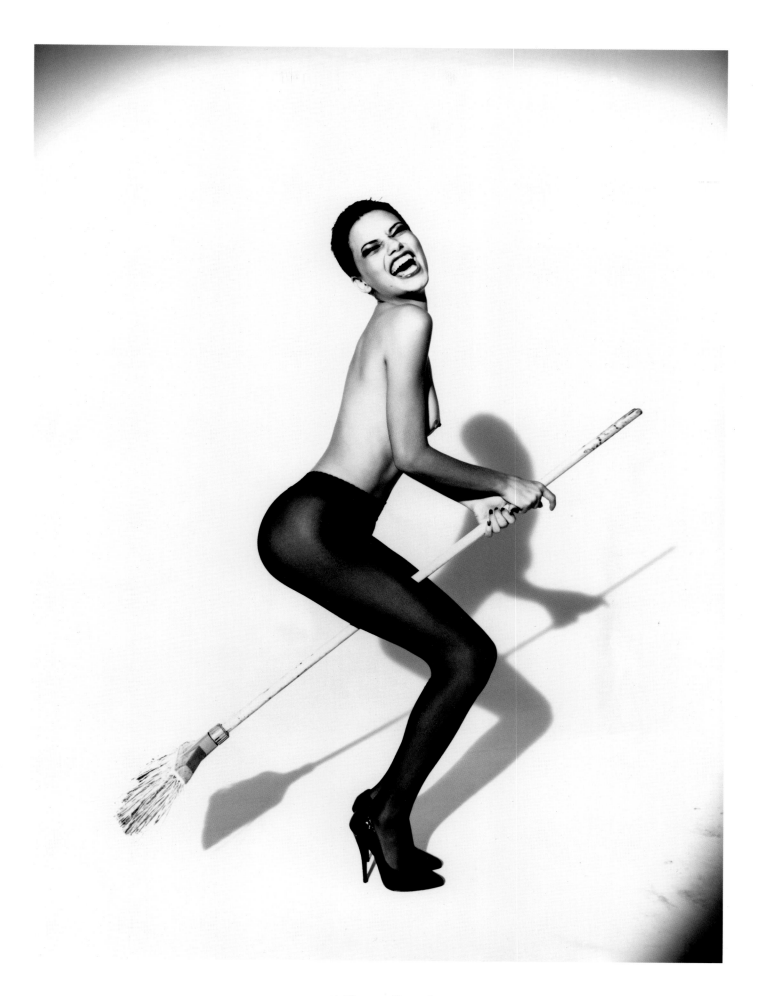

140| Ellen von Unwerth
Adriana Lima, c. 1998

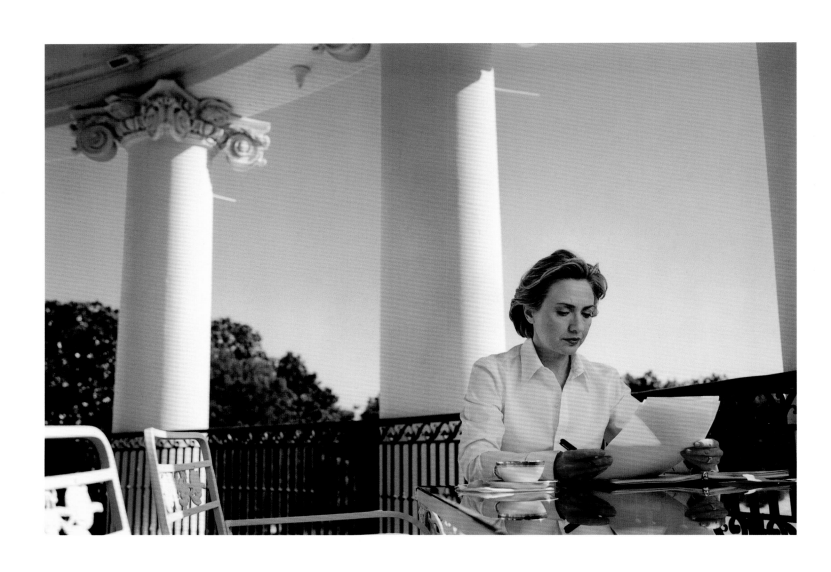

141| Annie Leibovitz
Hillary Rodham Clinton, The White House, Washington, D.C., 1998

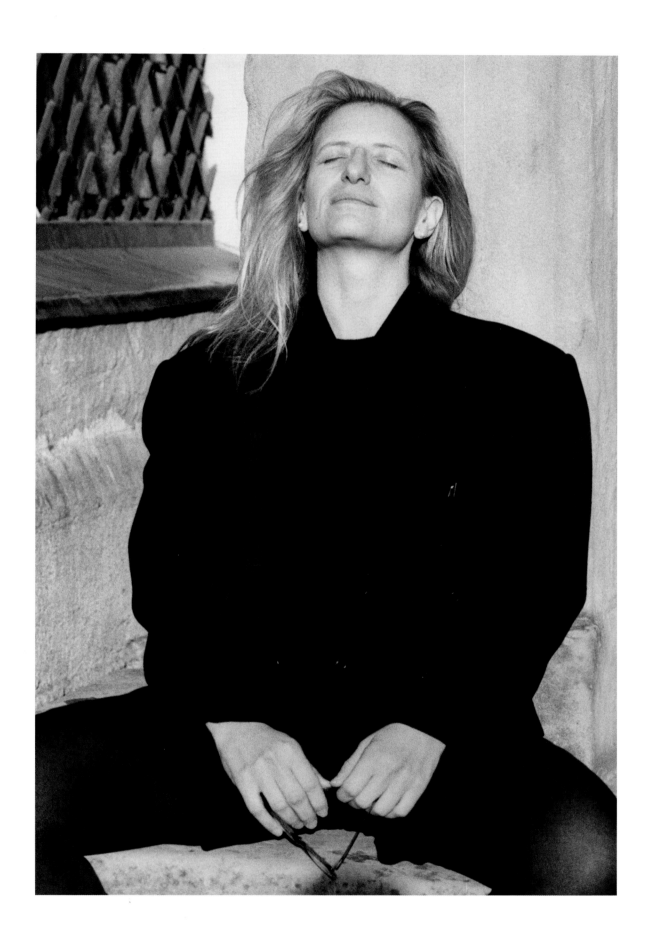

142 | Vera Isler
Annie Leibovitz, Munich, January 1992

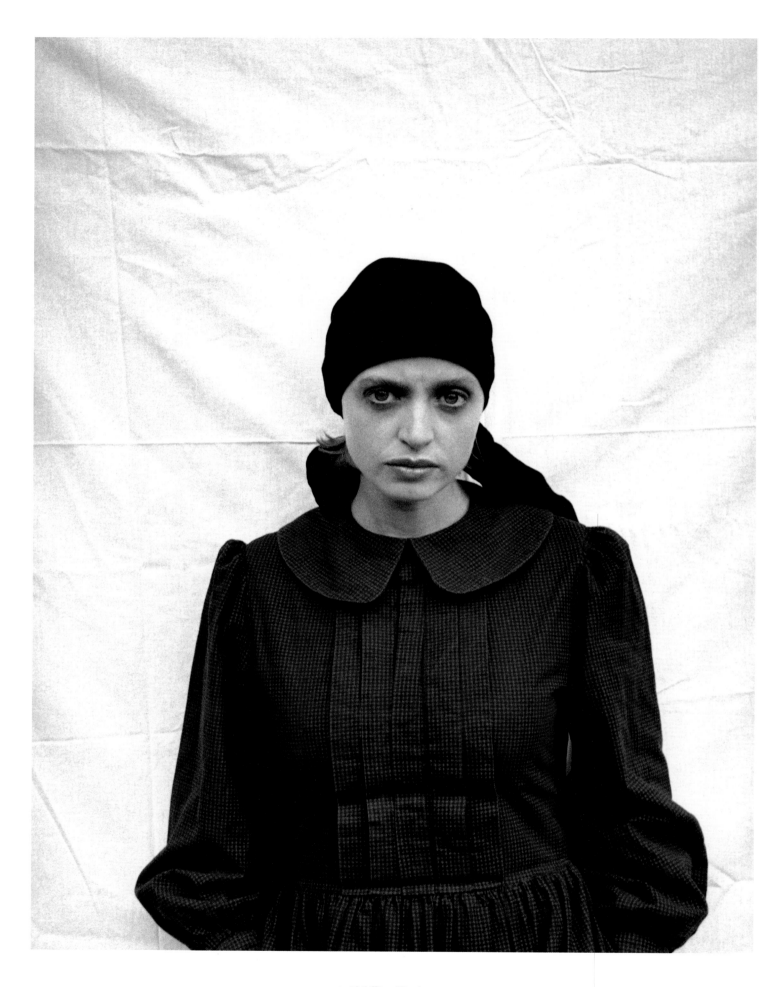

143 | Lillian Birnbaum
Katharina Thalbach, 1990

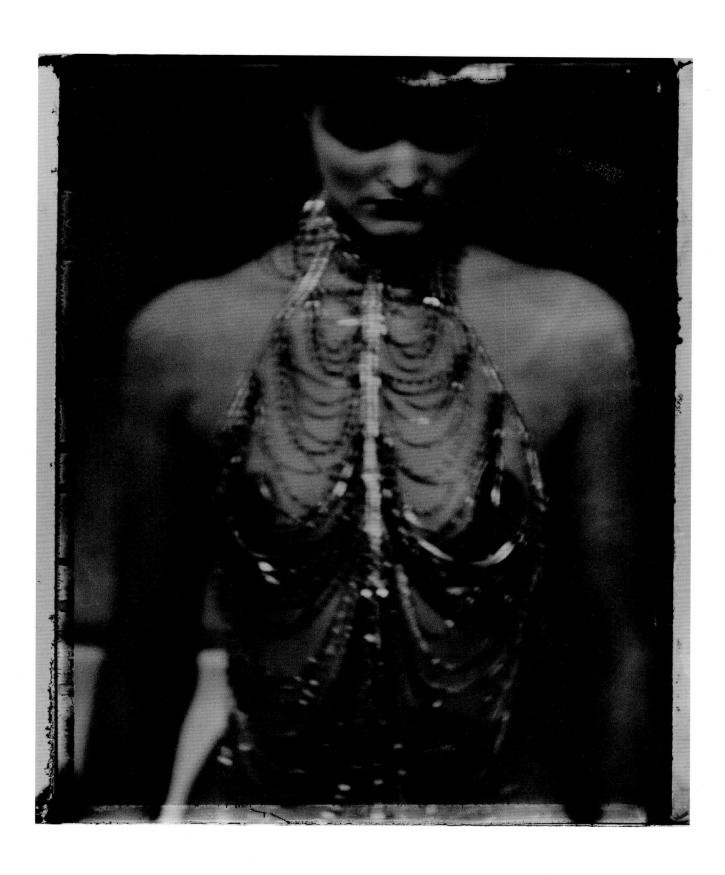

144 | Sarah Moon
Eva, 1997

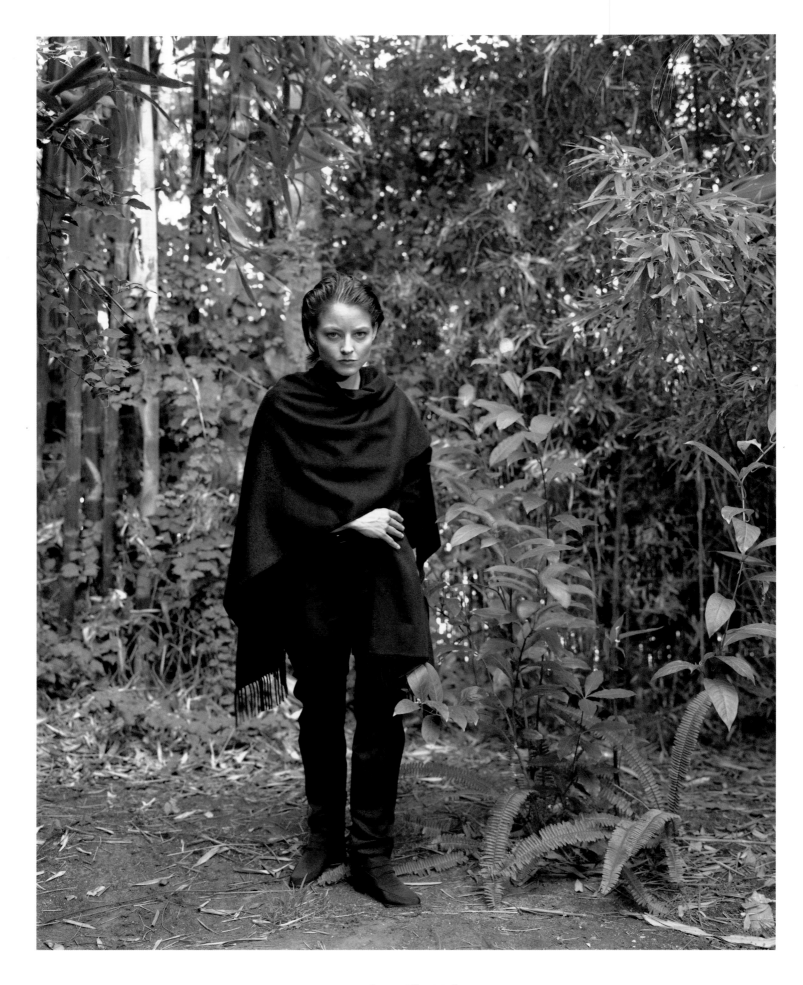

145| Mary Ellen Mark
Jodie Foster, Los Angeles, 1994

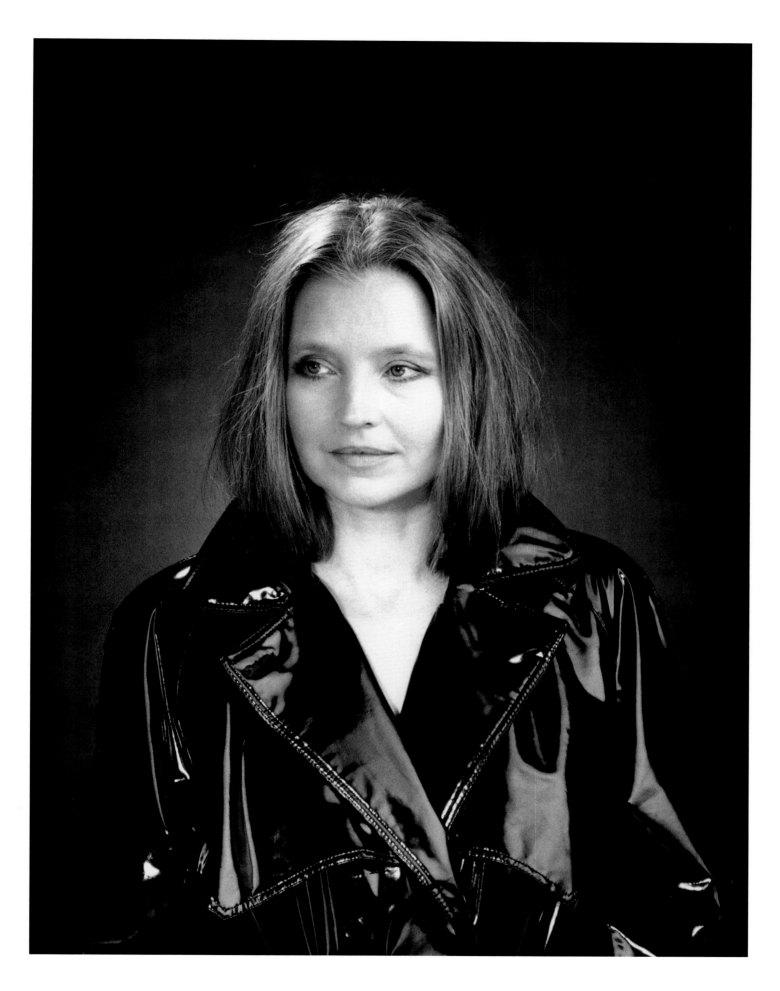

146| Lillian Birnbaum
Hanna Schygulla, 1990

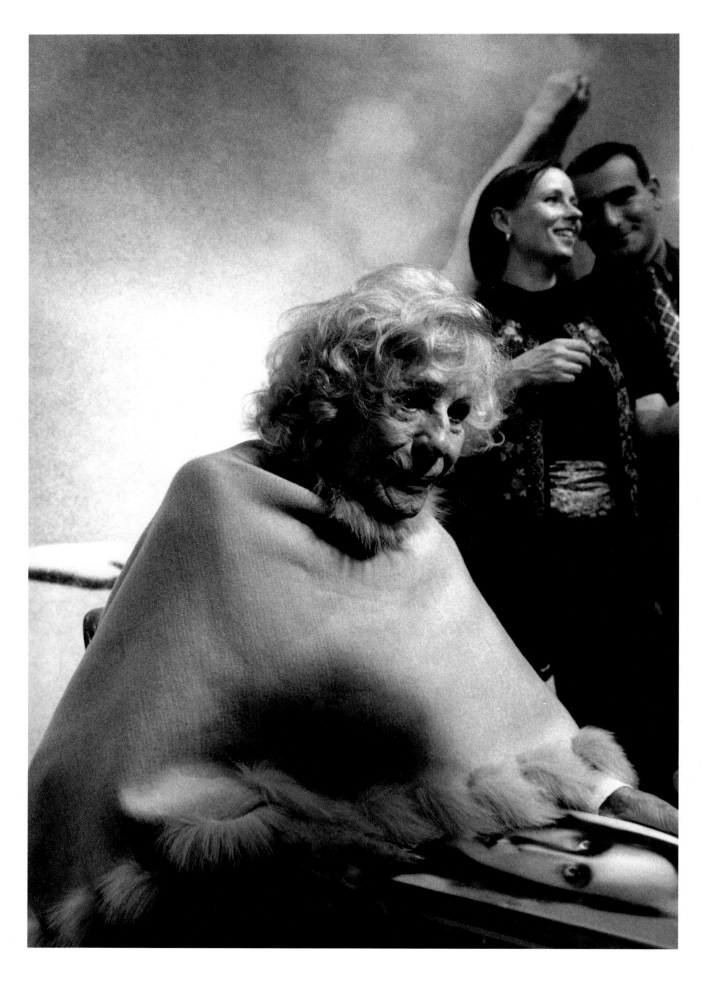

147 | Barbara Klemm
Leni Riefenstahl, Frankfurt Book Fair, 2000

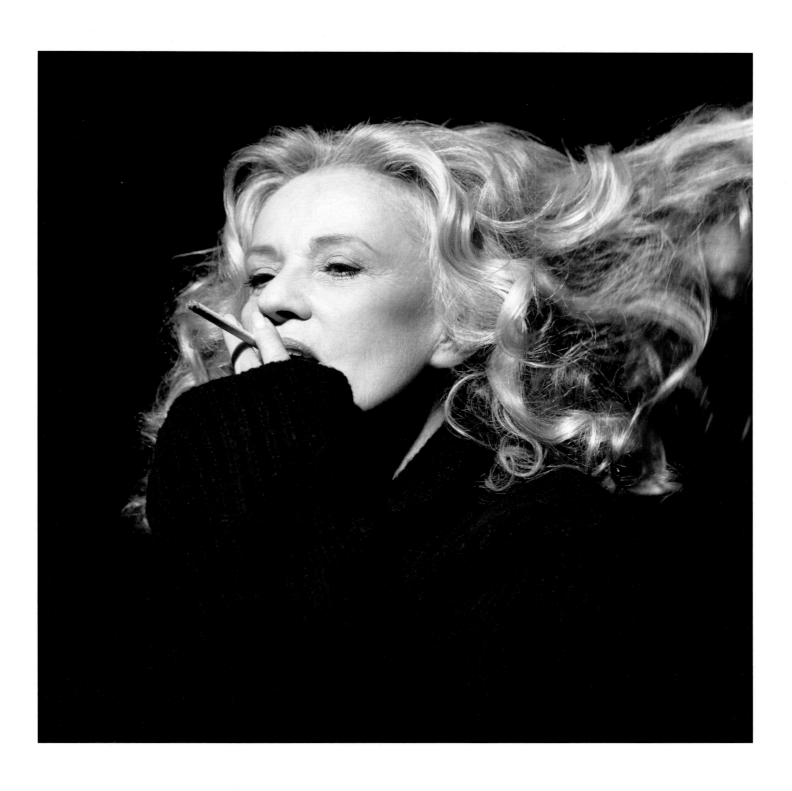

148| Brigitte Lacombe
Jeanne Moreau, New York, 1996

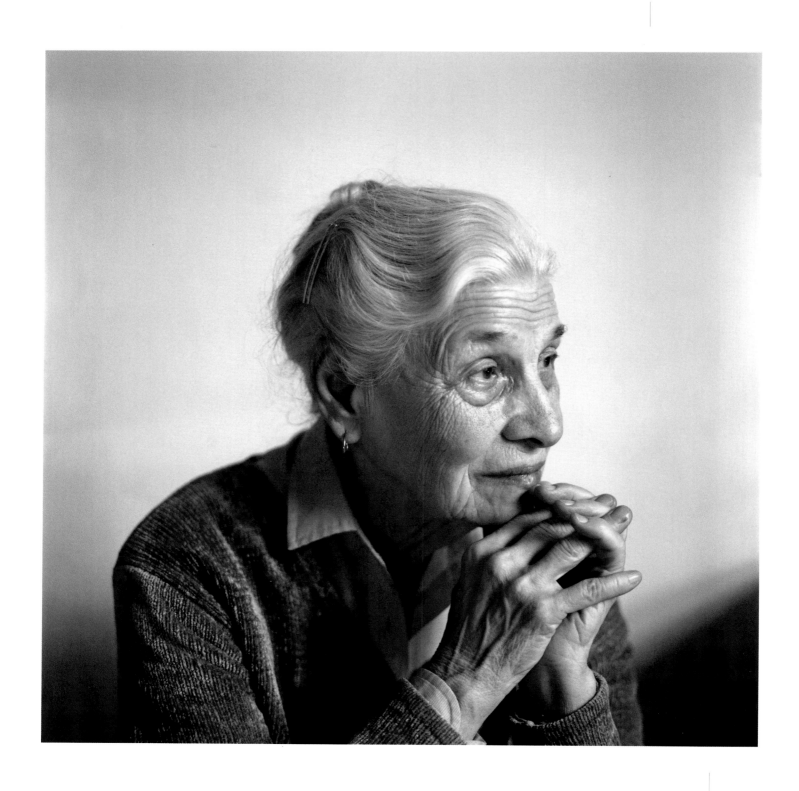

149 | Brigitte Lacombe
Eve Arnold, London, 1995

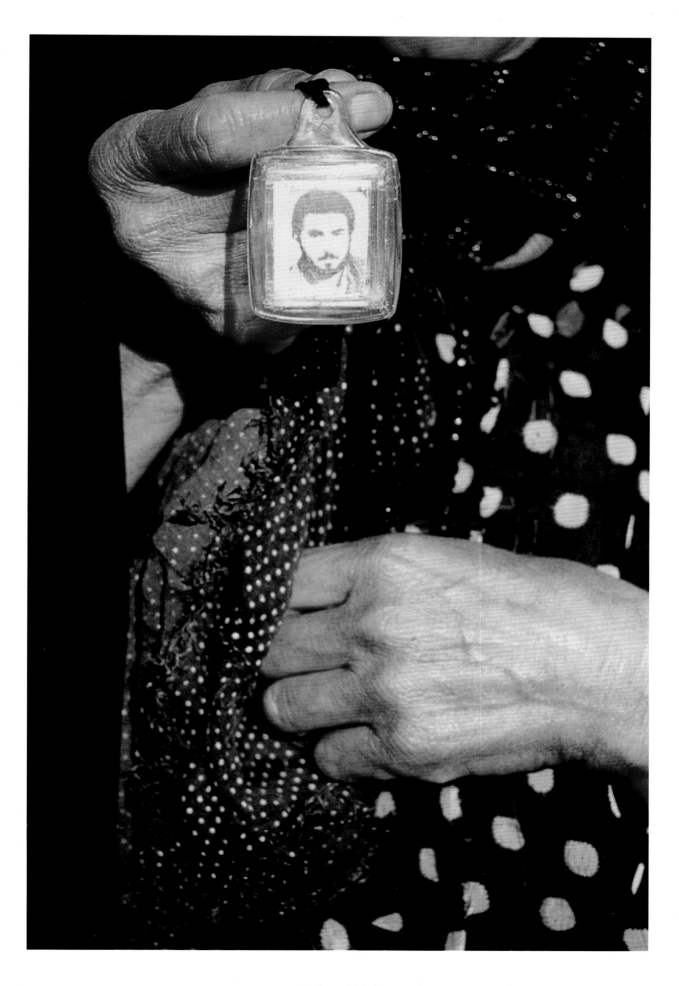

150 | Susan Meiselas
Mother with Picture of Her Dead Son, Sulaimania Cemetery, Iraq, 1992

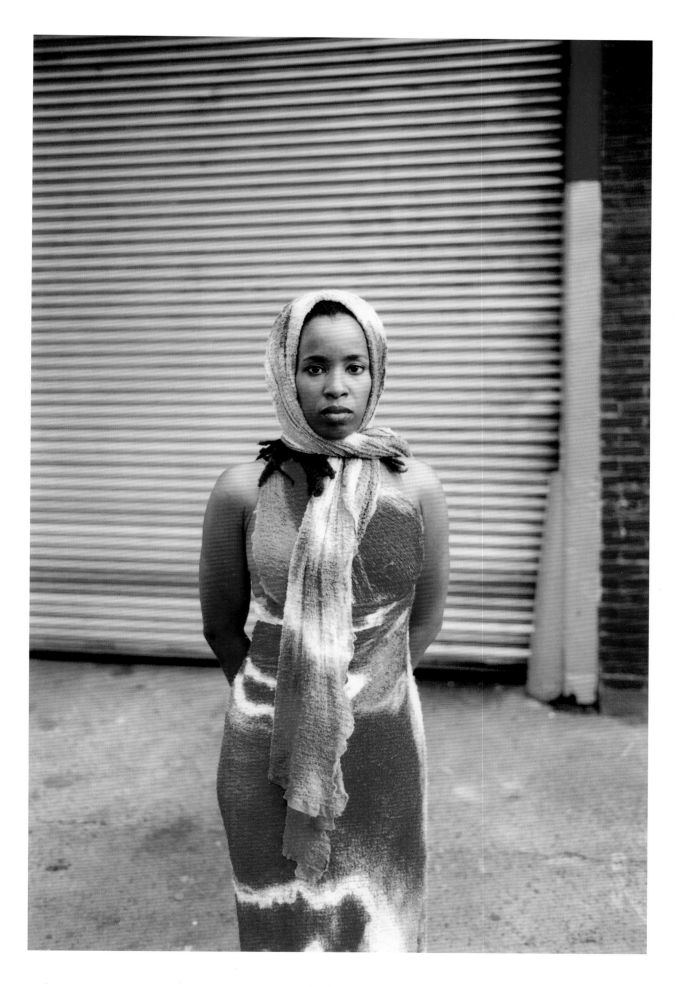

151 | Jitka Hanzlová
Jacqueline, Chelsea, 1999

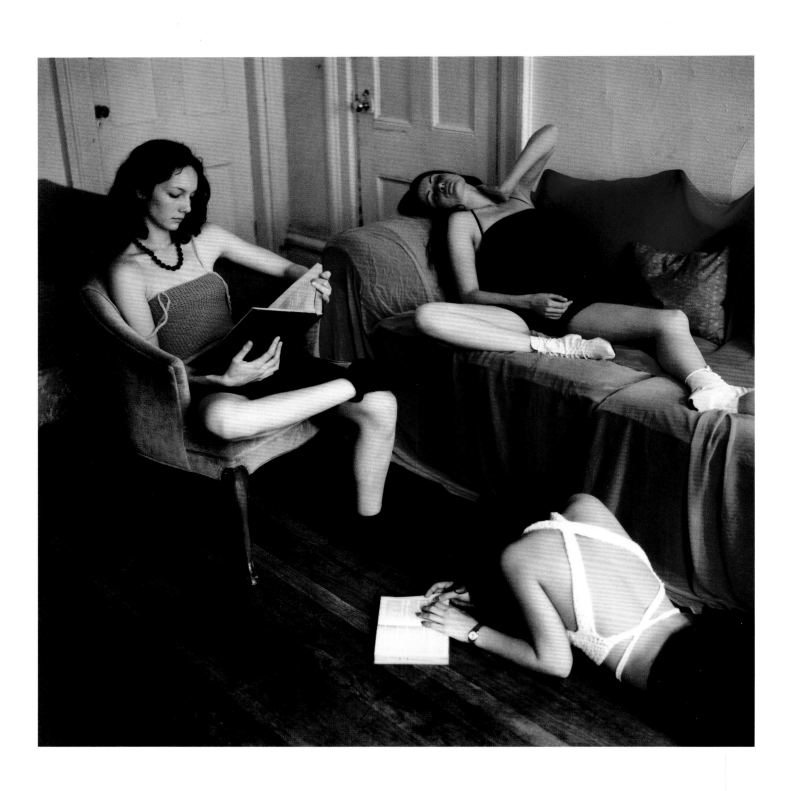

152 | Vanina Sorrenti
Untitled, 1998

153 | Sally Mann
Untitled, 1997

154 | Sophy Rickett
"Vauxhall Bridge (Pissing Women)", 1995

155 | Sarah Jones
"The Dining Room (Francis Place) I", 1997

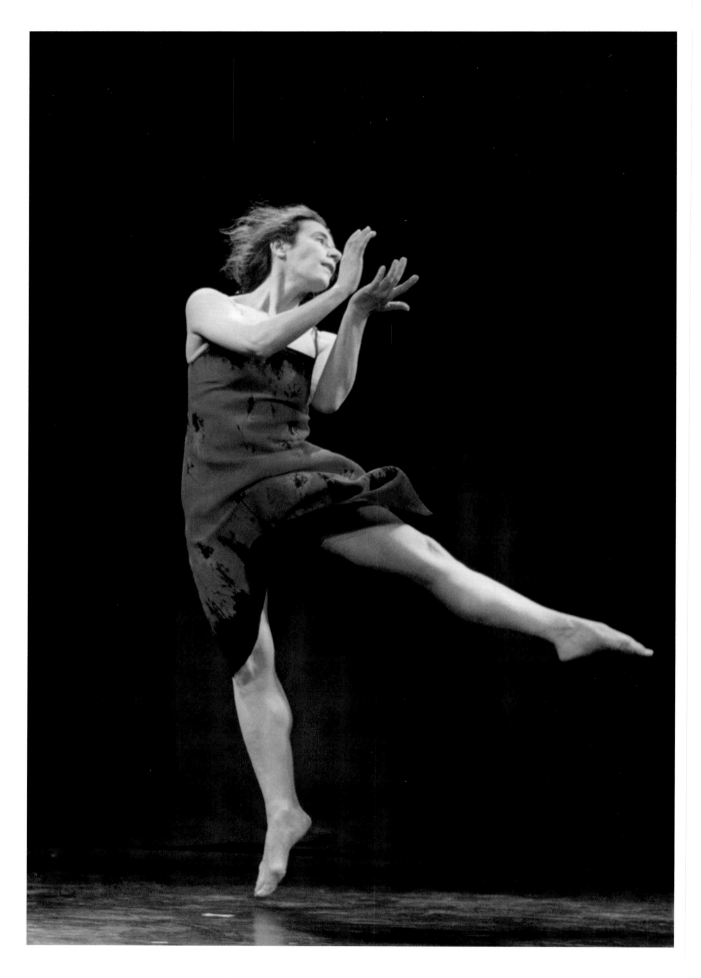

156| Ursula Kaufmann
"Solo", *Beatrice Libonati*, January, 2001

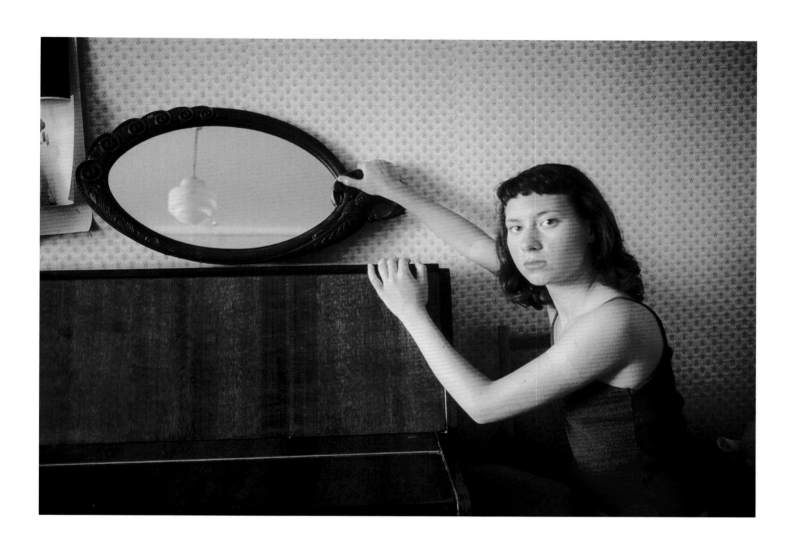

157 | Lise Sarfati
Julia, 20, St. Petersburg, 1999

158 | Nina Schmitz
Untitled, 1999

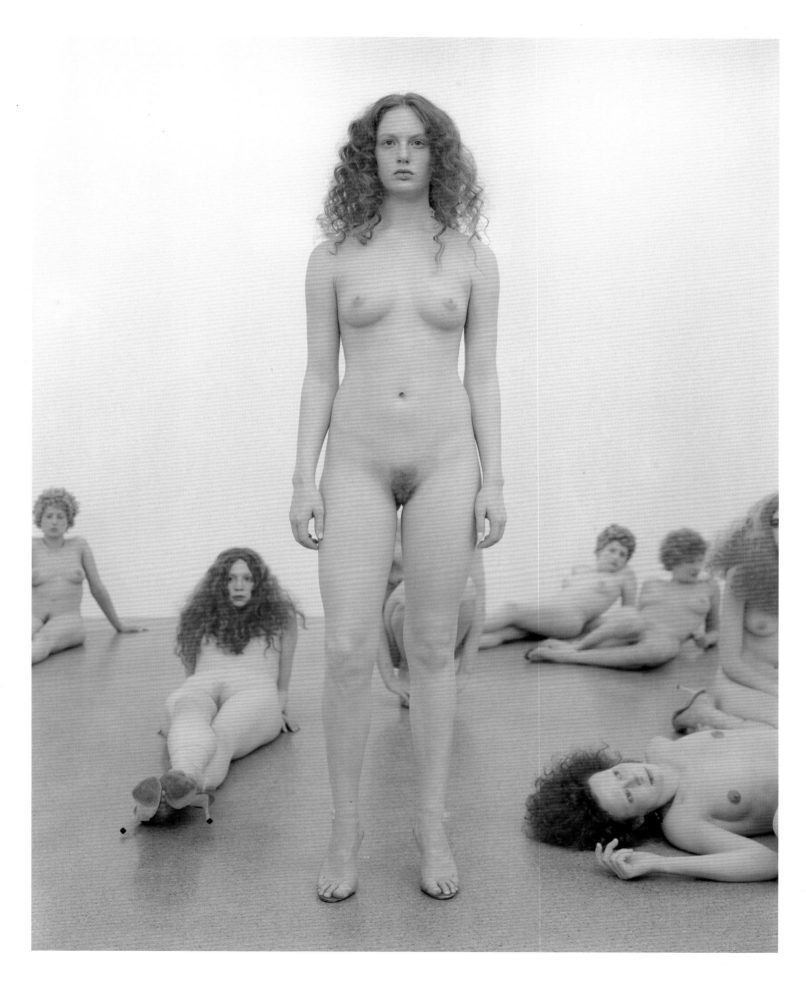

159 | Vanessa Beecroft
vb43.008.te

BIOGRAPHIES

OF THE PHOTOGRAPHERS

AND THEIR SUBJECTS

CONTRIBUTORS:
Michaela Angermair [M.A.]
Roana Brogsitter [R.B.]
Oliver Fischer [O.F.]
Simone Förster [S.F.]
Therese Hofbauer [T.H.]
Dorothee Rothfuss [D.R.]
Schirmer/Mosel editorial staff [S/M]
Esther Schlichting-Riedemann [E.S.-R.]
Franziska Schmidt [F.S.]

BERENICE ABBOTT
Plates 27, 29
1898/Springfield, Ohio
1991/Monson, Maine

After studying in Ohio, she spent some time in New York, where she became involved in the Greenwich Village art scene. In 1921, she went to Europe to study sculpture at the Grand Chaumière in Paris and in Brancusi's studio. From 1923 to 1925, she was assistant to Man Ray in his portrait studio. In 1926, she opened her own studio, creating portraits of leading figures of the artistic and literary avant-garde, among them James Joyce, Jean Cocteau, Peggy Guggenheim and Djuna Barnes (see Barnes). In 1927, she acquired part of the estate of Eugène Atget, the Paris photographer whose work had been rediscovered by the Surrealists. She had met Atget shortly before his death and went on to present his work in exhibitions and publications. On her return to New York in 1929, she set about creating a major documentation of New York, inspired by Atget's Paris project. It was shown at the Museum of the City of New York in 1937 under the title "Changing New York" and published in book form in 1939. From the 1950s onwards, she devoted herself primarily to visualising the processes of natural science. [S.F.]

ANNI ALBERS
Plate 34
1899/Berlin
1994/Orange, Connecticut

Born Anneliese Fleischmann, she enrolled at the Bauhaus in Weimar in 1922, and began training as a textile artist the following year. Given her outstanding creative and didactic abilities, she was appointed head of the weaving workshop in 1930. In 1925, she had married the artist Josef Albers, who also taught at the Bauhaus. After the Bauhaus closed in 1933, she immigrated to the USA and taught at the Black Mountain College in North Carolina until moving to New York in

1949. That same year, the Museum of Modern Art mounted an exhibition of her work – the first ever dedicated to a textile artist. In the 1960s, she focused increasingly on prints. [E.S.-R.]

ANITA ALBUS
Plate 122
1942/Munich

Painter and writer based in Munich and Burgundy, she studied at the Folkwangschule in Essen-Werden and has had solo exhibitions in Munich, Hanover, Salzburg, Paris and Dijon. Her publications, many of them translated into English, include *The Garden of Songs* (1974), *The Botanical Drama* (1987) and *The Art of Arts: Rediscovering Painting* (1997). [S/M]

LOLA ALVAREZ BRAVO
Plate 77
1907/Oaxaca, Mexico
1993/Mexico City

Married to the famous Latin American photographer Manuel Alvarez Bravo, her first photographs, some clearly influenced by Tina Modotti (see Modotti) and Edward Weston, were created in the 1930s. She was one of the favourite portrait photographers of Mexico's cultural and artistic elite. Her photographic oeuvre also has certain Surrealist traits. In her own way, she pursued the *objet trouvé* of surrealism. [F.S.]

ROGI ANDRÉ
Plate 55
1905/Budapest
1970/Paris

Created a remarkable series of portraits of painters, sculptors, architects and writers. Most of her works were created in Paris between 1933 and 1950. Born Rosa Klein, she studied at the School of Fine Arts in Budapest before moving to Paris around 1920. In the mid-1920s, she met André Kertész, and they lived and worked together until 1933. She liked to photograph people in their everyday setting, eliminating all that was superfluous in order to portray the essence of their lives. In 1950, she returned to Hungary and gave up photography for painting. [F.S.]

DIANE ARBUS
Plate 93
1923/New York
1971/New York

Born Diane Nemerov, she grew up in a wealthy New York family. In 1941, she married the photographer

Allan Arbus and began working with him as a fashion photographer. From 1955 to 1957, she studied under Lisette Model and then went on to work as a freelance photographer for such magazines as *Harper's Bazaar*, *Show*, *Glamour* and *The New York Times*. The focus of her work was on portraiture and portrayals of people on the margins of American society. In 1963, and in 1966, she received grants from the Guggenheim Foundation and, in 1967, an exhibition of her work at the Museum of Modern Art in New York caused a sensation, attracting considerable criticism. One year after her death by suicide, her remarkable portraits gained international acclaim at the Venice Biennale. [S.F.]

EVE ARNOLD
Plates 86, 97, 98, 117, 149
1913/Philadelphia

Daughter of Russian immigrants, she was largely self-taught, apart from a six-week course given by Alexey Brodovitch, the art director of *Harper's Bazaar*. In 1951, she became the first woman to work for the New York agency Magnum, becoming a regular member in 1957. Such famous figures as Joan Crawford, Marlene Dietrich, Richard Nixon, Joseph McCarthy and Malcolm X had her photograph them. By her own account, however, it was Marilyn Monroe who was her most important model. In the 1960s, she visited the Soviet Union several times and travelled widely in Afghanistan and Egypt, where she photographed veiled women. In 1973, this project was the basis of the documentary film *Behind the Veil*. In the late 1970s, she spent several months in China. Her resulting book *In China* won the National Book Award. Eve Arnold has lived in London since 1962. [R.B.]

ASSIA
Plate 51

Model and film actress in the 1930s. No further information known.

ATELIER ELVIRA
Plate 8
1887/Munich
1928/Munich

Set up by the photographers Anita Augspurg (1857-1943) and Sophia Goudstikker (1865-1924). Having met and fallen in love in Dresden in 1886, they decided to go into business together to earn their living. They trained for a few months in a studio in Munich and opened their own portrait studio, Atelier Elvira,

in July of the following year. Within a remarkably short space of time, the studio had become an economic and social success. Their clients included many figures of Munich's social and cultural elite, among them aristocrats, actors, artists, scientists and business people. Even royalty had their portraits taken at Atelier Elvira. In 1898, Sophia Goudstikker was appointed "Royal Bavarian Court Photographer", the first woman Court Photographer ever in Bavaria. A few years later a branch of the Munich studio was opened in Augsburg. In 1893, Anita Augspurg and Sophia separated and Anita went to Zurich to study law. In 1908, Sophia also retired from the studio, leasing it to the photographer Emma Uibeleisen. Although the studio continued to exist right up to the death of Emma Uibeleisen in 1928, its heyday had been in the Goudstikker era. [F.S.]

ELLEN AUERBACH
Plates 46, 78
1906/Karlsruhe
Born Ellen Rosenberg, of German-Jewish extraction, she initially studied sculpture before training as a photographer under the Bauhaus teacher Walter Peterhans in Berlin in 1929. In 1930, together with her fellow-student Grete Stern (see Stern), she set up the advertising and portrait studio "ringl + pit", which soon became renowned for its avant-garde photography, garnered numerous prizes and was represented at major international exhibitions. In 1933, she emigrated first to London, then to Tel Aviv, where she opened a children's portrait studio. She returned to London in 1935 and married the stage set designer Walter Auerbach in 1937. That same year they both immigrated to the USA. She worked as a freelance photographer in New York for *Time Magazine* and others, while at the same time experimenting with infrared and ultraviolet light and colour photography. From 1953 onwards she taught photography in New York and travelled extensively. At 60 she gradually abandoned photography and began to work in New York as an art therapist for children with behavioural disorders. [R.B.]

NADJA AUERMANN
Plate 137
1971/Berlin
Initially she intended to study architecture and furniture design, but in 1990, she was discovered as a

model and left Berlin for Paris. A photo-shoot with Ellen von Unwerth (see Unwerth) for British *Vogue* heralded her breakthrough on the international scene. Her work with such famous fashion photographers as Richard Avedon, Peter Lindbergh and Helmut Newton soon meant that she was in great demand as a top model. In the following years she continued to have significant commercial successes on the catwalks, in advertising and on the covers of major fashion magazines. She is married and has two children. [O.F.]

JOSEPHINE BAKER
Plate 22
1906/St. Louis
1975/Paris
By the age of 13 she was performing on the streets as a singer and dancer. Shortly afterwards she joined a vaudeville troupe and toured the United States. In 1924, she became a Broadway star, performing in *Chocolate Dandies*. She went to Paris in 1925 and caused a sensation in *La Revue Nègre* and gained her international reputation as the "Black Venus" and the "Girl with the Banana Belt". She maintained her unique position for more than a decade, also performing in solo shows. In 1937, she became a French citizen. During the war she was active in the resistance. After 1945, she performed only very rarely, devoting her efforts instead to the causes of minorities and to civil rights. She adopted several orphan children who lived with her at Château Les Milandes. [O.F.]

MARGARET BANNERMAN
Plate 17
1896/Toronto
1976
Born Margaret Le Grand in Toronto, she attended school in Halifax and began her career as an actress in Winnipeg. She became famous in England where she had her debut in the West End in 1915. She acted in many drawing-room comedies, usually playing haughty society ladies. Her repertoire included singing in cabaret, pantomime and opera. She went to the USA in 1937 and performed in New York and other large cities, taking the title role in Giraudoux's *The Mad Woman of Chaillot* (1958), touring as Mrs Higgins in *My Fair Lady* (1959-63) and appearing in several Hollywood films. [O.F.]

DJUNA BARNES
Plate 29
1892/Cornwall-on-Hudson, N.Y.
1982/New York
Grew up on a farm in New York State. As of 1912 she published reportages, interviews and illustrations in New York daily newspapers, plus one-act plays, short stories and poems. After a brief marriage she went to Paris in 1919, where she worked as a freelance journalist and became part of Gertrude Stein's circle of friends. From 1923 to 1931 she lived with the sculptor Thelma Wood. Her first novel, *Ryder*, was published in 1928. It was the dextrous prose of *Nightwood*, however, which caused a literary sensation in 1936. After that she published only sporadically. She returned to New York in 1940, where she eked out a living from social assistance until her death in 1982. [O.F.]

VICKI BAUM
Plate 38
1888/Vienna
1960/Hollywood
Born Hedwig Baum. Studied music and teaching in Vienna. In 1916, she assumed a position as a harp player in Darmstadt, which she abandoned the same year after her marriage to the conductor Richard Lert. She started writing in the 1920s and from 1926 to 1931 was an editor at the Ullstein publishing house. Her greatest literary success was in 1929 with the novel *People in a Hotel*, which was dramatised on Broadway and made into the film *Grand Hotel*, starring Greta Garbo. In 1931, she moved to Hollywood where she worked as a scriptwriter. Her books were banned in Germany after 1933. She became a US citizen in 1938 and successfully published in English. Her autobiography was published posthumously in 1962. [O.F.]

CLAIRE BAUROFF
Plate 18
Actually the Duchess Zichy, probably of Austro-Hungarian origin. Worked between 1923 and 1933 in Vienna and Berlin as a solo dancer in the modern, expressive, artistic nude dance and revue theatre sectors. No further details are known. [S/M]

RHODA MADGE BEASLEY
Plate 48
1909/Chelsea
1935/London
Much in demand as an artist's model in her time, in the 1930s, she was a favourite nude model of

the English photographer Dorothy Wilding (see Wilding). She died in 1935 at the age of 24 from injuries sustained in a car accident. [S/M]

SIMONE DE BEAUVOIR
Plate 85
1908/Paris
1986/Paris
Brought up in a strict Catholic family. Studied mathematics and philosophy. Met Jean-Paul Sartre in 1929. From 1931 to 1943 she was a teacher in Rouen, Paris and elsewhere. She then became a freelance writer of essays and novels. The radical theses on the role of women propounded in her 1949 book The Second Sex caused a sensation. In her autobiography, published between 1958 and 1972, she presents similarly rigorous analyses. Her open relationship with Sartre also encompassed joint travel and political activities. In 1974, she became president of the French League of Women's Rights. After Sartre's death, she adopted her friend of long-standing, Sylvie Le Bon, in 1980. [O.F.]

VANESSA BEECROFT
Plate 159
1969/Genoa
She is a performance artist who has chosen New York as her home. Regarded as a rising star on the international art scene, her similarly choreographed performances have been presented at the Venice Biennale (1997), the New York Guggenheim Museum (1998), the Vienna Kunsthalle (2001) and elsewhere. Flawless models dressed in bikinis or with transparent body make-up stand around the room; they may neither speak, react nor return the spectator's gaze. Beecroft alludes here provocatively to the 18th and 19th-century tableau vivant. Her body compositions, which she documents in photographs, carry her initials and a consecutive number, for example, VB 08-36, VB 42, VB 43 and so on. [D.R.]

ELISABETH BERGNER
Plate 19
1897/Galicia
1986/London
Born Ella Ettel in Austrian Galicia. Spent her youth in Vienna. Studied at the Academy of Music and Performing Arts from 1912 to 1915 and soon afterwards had initial engagements in Zurich, Munich and elsewhere. Her breakthrough came in 1922 in Berlin as Strindberg's

Queen Christine. Having made her first film in 1924, she became a film idol of the 1920s and 30s. After 1933 she lived in exile in England with her husband Paul Czinner, then in 1935 went to the United States. After a difficult phase in her career, she returned to London in 1950 and in 1954 performed in Germany again for the first time. She acted on stage for the last time in London in 1973. [O.F.]

RUTH BERNHARD
Plate 102, ill. p. 29
1905/Berlin
Brought up by her father, the graphic designer Lucian Bernhard. Studied at the Berlin Academy of Arts from 1925 to 1927 and then followed her father to New York. She first worked for the popular women's magazine Delineator, before becoming a freelance advertising, architecture and fashion photographer. In 1935, she met Edward Weston, who exerted a great influence on her. She then moved to California and worked from 1936 to 1953 as a freelance photographer specialising in still lifes and female nudes. After a lengthy illness in the 1960s and 70s, she began to teach, first at the Utah State University and the University of California, and as of 1971 at Columbia University, New York. [R.B.]

AENNE BIERMANN
Plate 30
1898/Goch on the Lower Rhine
1933/Gera
Born Anna Sibilla Sternfeld, she married the Jewish businessman Herbert Biermann in 1920 and moved with him to his hometown of Gera three years later. As a photographer she was self-taught, and the birth of her two children, Helga and Gershon, in 1920 and 1923, marked a defining moment in her life. She took detailed studies of stones and plants, before hitting on her main theme: everyday items, which she photographed with great clarity and precision in the style of New Objectivity. She gained public acclaim through her participation in important exhibitions and through the monograph by the famous art historian and photographer Franz Roh published in 1930 and containing 60 of her photographs. Today she is regarded as one of the most important representatives of Neues Sehen (New Vision). Her oeuvre included more than 3000 negatives, which were confiscated in 1939 when the fami-

ly immigrated to Palestine. Today most of her works are believed lost. In 1992, the city of Gera established the Aenne Biermann Prize for German contemporary photography. [F.S.]

LILLIAN BIRNBAUM
Plates 143, 146
1955/New York
An Austrian citizen, she grew up in Vienna and has been living in Paris since 1989. Her longer-term photographic projects have included several illustrated books: the volume Fahrende, 1984, and Die Künstler von Gugging, 1990. That year also saw the start of her book and exhibition project Vier Frauen (1993), undertaken in various places in Europe: portrait cycles of the actresses Hanna Schygulla (see Schygulla), Katharina Thalbach (see Thalbach), Barbara Sukowa and Sunnyi Melles. She also works for international magazines like the Sunday Times Magazine, Elle, Marie Claire and Stern. She took numerous portraits and fashion photos for the FAZ Magazin, which has been discontinued. She took photographs of the violinist Anne-Sophie Mutter for record covers and was also involved in the production of video clips and films. [D.R.]

MARGARET BOURKE-WHITE
Plates 67, 70, 74
1904/New York
1971/Stanford, Connecticut
Studied photography under Clarence H. White (no relation) and others, working from 1927 onwards as an architectural and industrial photographer. From 1929 she co-edited the magazine Fortune, for which she also took photographs. She had her own studio as of 1931 and worked for New York advertising agencies. In the mid-1930s she turned her attention to reportage photography, focusing on social and political themes; she joined the team of photo reporters at Life magazine in 1936. During the Second World War she photographed for the United States Air Force in England, North Africa and Italy. In spring 1945 she went to Germany with the American troops; her pictures and reports on the collapse of the Third Reich, including a harrowing series of pictures of the liberation of Buchenwald concentration camp, were published in book form the following year under the title Dear Fatherland, Rest Quietly. She gave up photography in 1957 for health reasons. [S.F.]

STEFFI BRANDL
Plate 14
1899/Vienna
1966/New York

Born Stephanie Olsen. Studied at the Graphische Lehr- und Versuchsanstalt in Vienna, where she then worked as an assistant to the photographer Trude Fleischmann (see Fleischmann). After her marriage to the architect Ernst Brandl she went to Berlin in 1926, working first in a photo studio in Schöneberg, then opening her own studio on the Kurfürstendamm. The great intensity and immediacy of her portraits – including those of Max Liebermann, Renée Sintenis, Emil Orlik, Otto Klemperer and the dollmaker Käthe Kruse – clearly distinguished them from the compositional principles of traditional studio photography. Some time between 1932 to 1938 she immigrated to New York where her trail disappears for a while. In 1980, the Berlinische Galerie bought a portfolio of her works containing almost 100 portraits and since then these have been shown in numerous group exhibitions. [S.M.]

MARIANNE BRESLAUER
Plates 42, 61
1909/Berlin
2001/Zurich

Photography apprenticeship from 1927 to 1929 at the Berlin Lette School, which had been co-founded by her grandfather, Julius Lessing. While still at school she exhibited works at the 1929 "Film und Foto" exhibition in Stuttgart. During a study visit to Paris she worked in Man Ray's studio, producing lyrical portraits and cityscapes, often from unusual angles. In 1930, she joined the Berlin studio of the Ullstein publishing house as a photoreporter; her photographs were published, among others, in the magazines Uhu and Der Querschnitt. When the press was "brought into line" with Party ideology in 1933, she was no longer able to publish. She immigrated to Holland in 1936, where she married the art dealer Walter Feilchenfeldt. In the years that followed she gave up photography and managed an art shop in Zurich with her husband. [S.F.]

LILY BRIK
Plate 104
1891/Moscow
1978/Moscow

Born Lilja Kagan into an intellectual family in Moscow. Her younger sister, Elsa Triolet, later married Louis Aragon. In 1912, she married the writer Osip Brik and her love for him was to last her whole life long. She is known to have had a liaison with Vladimir Mayakovsky, who lived with the Briks for several years. After Mayakovsky's death and her separation from Brik, she married General Vitali Primakov in 1931, and, following his execution in 1938, married the writer Vassili Katanjan with whom she lived until her suicide. Until 1945 Brik was again one of the family. A large number of letters in her estate document Lily Brik's constant exchange of ideas with artists and intellectuals from many countries. [O.F.]

CLAUDE CAHUN
Plates 20, 35, 53
1894/Nantes
1954/Jersey

Born Lucy Schwob, daughter of a wealthy publisher. Studied philosophy and literature at the Sorbonne in Paris and wrote lyrical texts, which she published under the pseudonym Claude Courlis. She began making self-portraits in 1912. In 1917, she changed her name to Claude Cahun. For almost 15 years, from 1922 onwards, she held her own artists' salon. Her friends included Henri Michaux, André Breton and the publishers Adrienne Monnier and Sylvia Beach. Apart from writing, she created highly staged self-portraits and tableaux that betray the influence of Surrealism. Together with her partner Suzanne Malherbe she made photomontages. From 1932 she was involved in communist and anti-fascist artists' associations and took part in the activities of the Surrealists. She became an active member of the Resistance in Jersey in 1940, was arrested in 1944 and condemned to death. Although she was pardoned in 1945, she never fully recovered from her incarceration. [S.F.]

MARIA CALLAS
Plate 82
1923/New York
1977/Paris

Born Maria Anna Sofia Cecilia Kalogeropoulos in New York, the daughter of Greek émigrés. Received her first singing lessons at the age of eight. When her parents divorced she moved with her mother to Athens in 1936, studied singing there at the conservatory and made her opera debut at the age of 15 in Cavalleria rusticana. In 1946, she returned to New York. During her Italian debut in La Gioconda in Verona she met her future husband, the brickwork owner Battista Meneghini, who became her manager. Between 1949 and 1959 Callas was the "primadonna assoluta" of all the world's opera stages; in 1951, she was permanently engaged by the La Scala opera house in Milan. Crises marked her life towards the late 1950s, privately owing to her romantic involvement with the shipping magnate Aristotle Onassis, professionally owing to problems with her voice. Callas performed for the last time in 1965 – as Tosca at Covent Garden, London. She then undertook concert tours, made recordings and gave master classes at the Julliard School in New York. [M.A.]

JULIA MARGARET CAMERON
Plates 3, 4, 5
1815/Calcutta
1879/Ceylon

She discovered the medium of photography at the relatively advanced age of 48, when she was given a camera. Born in Calcutta of an English father, she married Charles Hay Cameron in India in 1838, bore him five children and in 1848 went to England with her family. Through her close friendship with the poet Alfred Lord Tennyson she met many artists and writers, some of whom later sat for her. Her studio was in a former greenhouse, her darkroom in a coalhouse. There she developed her first portrait photographs, mainly of her family and friends. Her favourite model was her niece, Julia Prinsep Jackson (see Jackson), mother of Virginia Woolf. Cameron was known for her highly expressive portraits and her photographic tableaux based on biblical, mythological or literary models, such as the Arthurian saga or Shakespearean plays. Her works were shown at countless exhibitions; her oeuvre comprises almost 3000 photographic plates. [F.S.]

ELISABETTA CATALANO
Plate 106

Born in Rome. She is self-taught and began her career as a photographer with contributions to Il Mondo, L'Espresso and for the Condé Nast magazines in New York. In the 1970s she collaborated closely with concept and performance artists

such as Michelangelo Pistoletto, Vettor Pisani, Sandro Chia and Fabio Mauri. Since then she has devoted her energies entirely to artists' portraits. Her first solo exhibition "Uomini 1973" was held in Rome in 1973. Others followed, in Florence, Milan, Paris and other venues. In 1992, the Galleria Nazionale d'Arte Moderna in Rome mounted a retrospective exhibition of her works, which included 60 portraits, among them those of Joseph Beuys, Federico Fellini, Italo Calvino, Pasolini, Francesco Clemente, Alberto Moravia and Jean Baudrillard. She lives in Rome. [R.B.]

GABRIELLE "COCO" CHANEL
Plate 92
1883/Saumur
1971/Paris

Born in a poor-house at Saumur on the Loire. After her mother's death she was put in an orphanage at the age of 11. Later she went to boarding school, where she learned to sew. After training as a milliner she opened her first shop in Deauville in 1908; she moved to Paris in 1910. Her clean-cut, casual style contrasted starkly with the opulent fashions of the Belle Époque. She liberated women from corsets and wasp-like waistlines, dressing them in trousers and lots of costume jewellery, all rounded off with a touch of Chanel No. 5. Her revolutionary concept, to which she added the "little black dress" and the famous Chanel suit when her salon was reopened in 1954, made her the most successful fashion designer of the twentieth century. At the zenith of her fame in the 1930s she provided employment for more than 4000 people. [M.A.]

YVONNE CHEVALIER
Plates 41, 42
1899/Paris
1982/Paris

Took her first photographs – of cliffs and sea – at the age of ten. After meeting her future husband, a photography enthusiast, she abandoned drawing and painting in 1929 and devoted herself entirely to photography. A year later she opened a studio in Paris. During the 1930s her sitters included Max Jacob, Paul Claudel, Colette, Saint-Exupéry, Julien Green and Jean Arp. She also photographed dancers, musical instruments, still lifes, a series of nudes and French church architecture, and did photo reportages on Algeria and the

South of France. She gave up photography in 1970. Most of her works were lost in a fire in 1945. In 1980, she personally destroyed many of the prints that had survived until then. [F.S.]

EDITH CLEVER
Plate 121
1940/Wuppertal

On leaving school, she trained as an actress at the Otto Falckenberg School in Munich and went on to perform in Bremen, Munich and elsewhere, in various roles. In 1971, she joined the Berlin Schaubühne where she acted in plays by Botho Strauß, among others. She also appeared in a number of films under the direction of Volker Schlöndorff, Eric Rohmer and Peter Handke. In 1982, she began working with the director Hans Jürgen Syberberg and developed a preference for lengthy solo performances. She has received many awards. In the 1990s she turned her attentions to directing, primarily at the Schaubühne in Berlin. [O.F.]

HILLARY RODHAM CLINTON
Plate 141
1947/Chicago

Studied at Wellesley College and Yale Law School and worked as a lawyer for the Children's Defense Fund. Married Bill Clinton in 1975 and bore him a daughter. Both taught law at the University of Arkansas. During her husband's term of office as Governor of Arkansas, she campaigned for vocational and insurance programmes for children. When Bill Clinton was elected President in 1993, she headed the government's Task Force on National Health Care Reform and continued to promote the rights of women, equal vocational opportunities for girls and boys, and family planning. Her first book, It Takes a Village..., was published in 1996. She became Senator of New York State in November 2000. She is a member of the board of Wal-Mart and TCBY and is regarded as one of the United States' top 100 lawyers. [S/M]

SIDONIE GABRIELLE COLETTE
Plate 41
1873/St. Sauveur
1954/Paris

Born in Burgundy, she had a provincial youth. After moving to Paris at the height of the Belle Époque with her first husband, the author Gauthier-Villars, she

wrote the Claudine series of novels, which not only became international bestsellers, but also gave rise to a series of commodities: cigarettes, perfumes, hats, etc. After separating from her husband, she led a life that was remarkably liberal for the time, dancing in cabarets and having female lovers. She wrote for Le Matin, whose editor, Baron Henri de Jouvenel, became her second husband. Her literary success continued unabated. In the last ten years of her life, by now Mme Goudeket following her third marriage, she was confined to bed, but continued to write. As president of the Académie Goncourt and holder of the Grand Cross of the Legion of Honour, she was the first woman to receive a state funeral. [M.A.]

IMOGEN CUNNINGHAM
Plates 52, 90
1883/Portland, Oregon
1976/San Francisco

Studied chemistry at the university of Washington in Seattle. She began taking photographs in 1901 and worked in the studio of Edward S. Curtis from 1907. In 1909, she won a scholarship that enabled her to study at the Technische Hochschule in Dresden, one of the foremost schools of photo-technology and photo-chemistry at the time. On her return, she opened her own portrait studio in Seattle. In 1917, she and her family – she had three children – moved to San Francisco, and in 1920 to Oakland, where she took her famous plant studies in her own garden. She was a close friend of the photographer Edward Weston, and a founder member of the photography group f/64 around Ansel Adams. In the 1930s she worked for magazines such as Vanity Fair, photographing politicians and Hollywood stars, and, in the 1950s and 60s, the hippies in and around San Francisco. She taught at several Californian universities and was an active photographer right up until her death. [S.F.]

LOUISE DAHL-WOLFE
Plates 66, 69, 74, 76, 87, 92
1895/San Francisco
1989/Allendale, New Jersey

Though famous mainly for her fashion photographs, her extensive oeuvre also includes landscape, still-life and portrait photography. Initially she studied design, painting and architecture in San Francisco and New York. Inspired by

the work of the pictorialist photographer Anne W. Brigmann, she began to teach herself more about this medium in the early 1920s. It was another eight years before she began working as a professional photographer, first for an interior decor company, later for various magazines such as *Harper's Bazaar* and *Vogue*. The portrait of Mrs Ramsey taken in 1933 in the mountains of Tennessee, the state in which her husband Meyer Wolfe was born, was the first of her photographs to be published – in *Vanity Fair*. From 1933 to 1960 Louise Dahl-Wolfe ran her own studio in New York. [F.S.]

CLOTILDE DERP-SACHAROFF
Plate 10
1892/Berlin
1974/Rome
Née von Derp, she made her debut as a solo dancer in Munich in 1912. Widely regarded as an early proponent of expressive dance, she went on to achieve considerable success in London, Vienna and Berlin. In 1919, she married the dancer A. Sacharoff and from then on they usually performed together. After retiring from the stage, they opened a school of dance in Rome in 1953. [S/M]

FLORENCE DESHON
Plate 25
Biographical information unknown.

DIANA, PRINCESS OF WALES
Plate 128
1961/Sandringham
1997/Paris
Born Diana Frances Spencer in Park House near Sandringham, where, following her parents' divorce, she lived with her father until 1975. She attended school in England and Switzerland and began working as a nursery school teacher in London in 1979. In 1981, she married Charles, heir to the British throne, in a ceremony that was broadcast worldwide on television. She had two sons and assumed numerous official obligations. The separation of the couple was announced in 1992. They were divorced in 1996. Diana remained a member of the royal family and committed her energies to social issues that were of importance to her. Her sudden death in a car accident in Paris and the subsequent state funeral moved millions of people everywhere. [O.F.]

MARLENE DIETRICH
Plate 99
1901/Berlin
1992/Paris
Spent her youth in Weimar and Berlin, where she completed secondary studies and learned to play the violin. After training at the Max Reinhardt school she turned to stage and film in 1922. Her marriage to Rudolf Sieber and the birth of their daughter in 1925 led to a temporary retirement from public life. Her encounter with Josef von Sternberg in 1929 and the role of Lola-Lola in his film *Blue Angel* made her a star and laid the foundations for her later world fame. In the years that followed she starred in numerous successful films directed by Sternberg in Hollywood, including *Morocco*, *Blonde Venus* and *The Devil is a Woman*. From 1935 she also worked with other directors, including Lubitsch and Marshall. After Hitler came to power she refused offers from Germany. She became an American citizen in 1937. After the war Marlene Dietrich made a comeback in films by Hitchcock and Wilder. In 1953, she began a second career as a cabaret singer. She did not retire from the stage until 1975. [M.A.]

MINYA DIEZ-DÜHRKOOP
Plate 10
1873/Hamburg
1929/Hamburg
Born Minya Julie-Wilhelmine Dührkoop, she trained in her father Rudolf Dührkoop's portrait studio in Hamburg. In 1894, she married the Spanish photographer Louis Diez. After their divorce she opened a photo studio in Bremen, but one year later was working at her father's studio again; she became his business partner in 1907. At the time, both father and daughter were among Germany's leading portrait photographers. They travelled together to Paris, London and the United States. After the death of her father in 1918 she continued to run the studio. She was co-founder of the Gesellschaft Deutscher Lichtbildner [GDL] and one of its first female members. [F.S.]

RINEKE DIJKSTRA
Plate 132
1959/Sittard, Holland
Lives and works in Amsterdam and Berlin. She studied at the Rietveld Academie in Amsterdam from 1981 to 1986. She received photographic commissions for the magazines

Elle, Quote, Avenue and *Elegance*. Her intense photographs of teenagers and young adults soon brought her international recognition. She is known above all for her beach series featuring young people of different nationalities, her photographs of Bosnian refugee children and her portraits of young Israelis before and after joining the army. She received the 1987 Kodak Award Nederland, the 1991 Epica Award for Best European Advertising Photography and the 1999 Citibank Photography Prize. [R.B.]

ZOË DOMINIC
Plate 82
1920/London
A self-taught photographer who specialised in the theatrical arts and entertainment sectors early in her career. Initially she photographed ballet productions, then Laurence Olivier appointed her as the official photographer at the Royal National Theatre. She photographed the actors on stage, during rehearsals and at her London studio, and later made portraits of the stars of the Royal Opera House Covent Garden, including Maria Callas, Margot Fonteyn and Janet Baker. Her portraits appeared on countless record and CD covers and above all in books about stage artists. In 1970, for example, she illustrated a publication on the ballet choreographer Frederick Ashton, and, in 1982, the autobiography of Janet Baker. Her particular specialisation and her work for film companies involved lengthy spells in New York and California. She lives in London. [D.R.]

ELIZABETH II
Plate 83
1926/London
Born Princess Elizabeth Alexandra Mary in London. At the age of 12 her greatest wish was to live in the country with lots of horses and dogs. After the untimely death of her father, George VI, she was crowned Queen of Great Britain and Head of the Commonwealth in 1952. In 1947, she married Philip Mountbatten, a cousin of the fourth degree, known since their wedding day as the Duke of Edinburgh. They have four children. She is regarded as a model of conscientiousness in the performance of her duties and has made countless representative trips and public appearances at home and abroad. The frequently complicated mar-

riages of her children pose a serious challenge to her ideal of the Royal Family. Whatever leisure time she has at her disposal she still devotes mainly to breeding horses. [O.F.]

NUSCH ÉLUARD
Plate 57
1906/Mühlhausen, Alsace
1946/Paris
Born Maria Benz, she adopted the artist's name Nusch while working as an actress in Berlin. In the late 1920s she moved to Paris where she joined the Surrealist circle, became acquainted with the poet Paul Éluard and married him. She sat for Picasso and Man Ray, played at the Théâtre Grand Guignol and designed photomontages. During the Second World War she and her husband remained in Paris, joined the Resistance and in 1943 went into hiding for a few months in a psychiatric institute outside Paris. Weakened by the tribulations of war, she died at the early age of 40. [E.S.-R.]

JAYNE FINCHER
Plate 128
1958/London
Daughter of the owner of the Photographers International agency. She began working in her father's business as a darkroom assistant in 1975. Then she tried her hand at taking photographs with a borrowed camera. She accepted the occasional commission and in 1977 came into contact with members of the British Royal family. Once Diana appeared on the public stage in the late 1970s Fincher concentrated totally on the future Princess of Wales, whose official and private life she documented extensively over the following 17 years; her book, *Diana, Portrait of a Princess*, became an international bestseller. As the only woman among countless male colleagues specialised in the Royals, she has accompanied all the members of the Royal Family on numerous trips abroad and is also invited to private occasions. Jayne Fincher is currently working on a television film about the Royal Family. She has been a partner in her father's agency since 1980. [S/M]

TRUDE FLEISCHMANN
Plates 14, 18
1895/Vienna
1990/Brewster, N.Y.
Worked as a photographer specialising in portraiture, dance and nude studies in Vienna, London and New York. She was born and raised in Vienna. After spending

some time in Paris to study art she returned to Vienna and trained in photography for three years at the Graphische Lehr- und Versuchsanstalt. She then worked as an assistant at the studios of Madame d'Ora (see d'Ora) and Hermann Schieberth. She opened her own studio in Vienna in 1920. Until its closure in 1938, she created many portraits of key figures in the cultural life of Vienna, including Adolf Loos, Karl Kraus, Stefan Zweig, Alban Berg and Grete Wiesenthal. Fleischmann immigrated to London in 1938, and in 1939 to New York, where she opened a studio for fashion and portrait photography and began working for fashion magazines such as *Vogue*. She also photographed many émigrés in the world of theatre and music. Trude Fleischmann gave up photography in 1969 and settled in Switzerland. [F.S.]

LISA FONSSAGRIVES
Plate 84
1911/Uddevalla, Sweden
1992/New York
Born Lisa Bernstone, she grew up on the west coast of Sweden. In 1930, she moved to Stockholm to study design, art and dance, and in 1931 to Berlin, where she received dancing lessons from Mary Wigman. As a member of a ballet troupe she went to Paris in 1933, where she met Fernand Fonssagrives, her first husband. Willy Maywald, house photographer at Dior, introduced her to *Vogue*, initiating the meteoric rise to fame that over the following 20 years was to make her the most sought-after model in the history of fashion photography. In 1939, she went to New York, where she had her first child. In 1947, she met Irving Penn at a photo session and married him in 1950. After the birth of a son in 1952, she rarely posed for the camera any more, devoting herself instead to fashion design and her great passion, sculpture. [S/M]

JODIE FOSTER
Plate 145
1962/Los Angeles
The youngest of four children, her father was a real estate agent of German descent. She has been in front of the camera since she was three years old – first for advertisements, then from 1969 onwards in more than a dozen television series and finally in feature films. She achieved stardom through her

roles in Scorsese's films *Alice Doesn't Live Here Anymore* (1975) and *Taxi Driver* (1976), and then embarked on literary studies at Yale. Her breakthrough as a character actress came in 1988 with Kaplan's *Accused*, for which she received an Oscar; another Oscar followed in 1991 for *The Silence of the Lambs*. A doctor of philosophy with an IQ of 140, she has been directing and producing films since the early 1990s. She lives with her son, born in 1998, in the San Fernando Valley in Southern California. [M.A.]

MARTINE FRANCK
Plates 104, 116, 135
1938/Antwerp
A native of Belgium, she grew up in the USA and England and studied art history in Madrid and Paris. She started taking photographs in the early 1960s, became an assistant to Eliot Elisofon and Gjon Mili at *Life*, and in 1965 began working freelance for *Life*, *Fortune*, *Sports Illustrated* and *Vogue*. She married Henri Cartier-Bresson in 1970. Together with other dedicated photographers she founded the Viva agency in 1972, focusing on social reportage. She became a member of Magnum in 1980. Over the years she produced an impressive compendium of portraits, in particular of artists and scientists. She is the house photographer of the Théâtre du Soleil in Paris, where she lives. [D.R.]

GISÈLE FREUND
Plates 47, 62, 72, 85
1908/Berlin
2000/Paris
Born into a wealthy family in Berlin, she became interested in photography as a child. She studied sociology and art history at Freiburg and Frankfurt, where her teachers included Horkheimer and Adorno. A member of the socialist students' group, she fled Germany in 1933 to Paris, where she continued her studies at the Sorbonne, graduating with a paper on the theme of photography in nineteenth-century France. Her friendship with the publisher Adrienne Monnier made her familiar with the literary scene in Paris. In the years that followed she created the remarkable writers' portraits for which she is famous – among them Virginia Woolf, André Gide, Walter Benjamin, Simone de Beauvoir (see Beauvoir), Sartre, André Malraux and James Joyce. For some of these she used the recent innovation of colour film. She also worked as a

freelance photographer for various magazines, including *Life*. During the occupation of France she fled to Latin America. When she returned to Paris she worked as a photojournalist for the Magnum agency until 1954. Her photographs have been published and exhibited regularly since the 1960s. Gisèle Freund received numerous awards for her work. [F.S.]

INDIRA GANDHI
Plate 105
1917/Allahabad
1984/New Delhi
The only child of the Indian politician Nehru, she attended Indian and European schools. Influenced by her father, she joined the INC, India's largest political party, at the age of 21. Through her marriage in 1942 she assumed the politically important name of Gandhi, although she is no relation of Mahatma Gandhi. She had two sons. Initially she was her father's closest political adviser, later becoming a minister and, in 1966, Prime Minister. She promoted India's non-aligned status while cultivating relations with the USSR. Her authoritarian domestic policy lost her Congress Party the 1977 elections. Only three years later, however, her popularity swept her back to power. Following military action against Sikh radicals, she was murdered by two of her Sikh bodyguards in 1984. [O.F.]

GRETA GARBO
Plate 16
1905/Stockholm
1990/New York
Born Greta Lovisa Gustafsson in a poor quarter of Stockholm, she was discovered initially for advertising, then in 1922 debuted in her first feature film, *Luffar Peter*. In 1923, she completed training as an actress at the Stockholm Drama Theatre and adopted her artist's name. MGM mogul Louis B. Mayer brought her to Hollywood in 1926, where she garnered the legendary role of the noble and suffering beauty, which soon earned her the epithet The Divine. The transition from silent movies to talkies brought even greater success: from *Mata Hari* (1933) to *Anna Karenina* (1936) and *Ninotchka* (1939) her box-office popularity increased apace. Her first and only flop, with George Cukor's *Two-Faced Woman*, prompted her retirement in 1941. She spent her last years in seclusion in New York. [M.A.]

TRUDE GEIRINGER
Plate 19
1890/Vienna
1981/Larchemont, N.Y.
For Trude Geiringer, née Neumann, the daughter of a bourgeois Jewish family, photography was for many years merely a hobby. Around 1925/26 she met Dora Horovitz (see Horovitz), a trained photographer, and together they founded the Geiringer & Horovitz studio in Vienna in 1926, where very soon artists and prominent figures from Vienna's literary and cultural life had their portraits taken. In 1931, she left the studio partnership and in 1938, immigrated with her husband to New York via London. She then opened the unsuccessful Trude Geiringer Studio. From the mid-1940s until her death, she photographed only her family and friends. [F.S.]

MARTHA GRAHAM
Plate 79
1894/Pittsburg
1991/New York
Grew up near Pittsburgh and in California. She began her training as a dancer in 1916 with Ruth St Denis and Ted Shawn. Shortly after her first solo performance, in 1926, she founded her School of Contemporary Dance in New York, which is still in operation today, and also established her own dance company. Milestones in her career include her choreography of *Frontier* (1935), *Appalachian Spring* (1944) and *Clytemnestra* (1958). She collaborated on pioneering projects with composers. She received numerous awards, created more than 180 choreographies and ballets, and continued to work as a dancing teacher after her retirement in 1969. [O.F.]

JITKA HANZLOVÁ
Plate 151
1958/Náchod, Czechoslovakia
Worked for the state television station in Prague before going to Essen in the early 1980s to study communication design and in particular photography. Her first major series, *Rokytnik*, created between 1990 and 1994, was dedicated to the Czech village where she grew up. The *Inhabitants* cycle followed (published in book form in 1996) in which she engaged with her current urban surroundings, the anonymous cities of western Germany, and the long-term project *Female* (1997–2000), a portrait collection of anonymous women of

all ages in Europe and America. She has received numerous prizes for her work, including the 1993 Otto Steinert Prize, and has been exhibited internationally. She lives in New York and Essen. [D.R.]

CLEMENTINA, LADY HAWARDEN
Plates 1, 2
1822/Camberweald House, Glasgow
1865/London
Married Cornwallis Maude, 4th Viscount Hawarden, 1st Earl of Montalt. Began working as an amateur photographer around 1857, photographing her eight children almost exclusively in their town house in South Kensington and on their estate in Dudrum, Ireland. Her favourite models were her three eldest daughters, especially Clementina Maude and Isabella Grace. The intimate portraits of her children betray a clear influence of Pre-Raphaelite painting, yet have an astonishingly natural, unaffected appearance. Lewis Carroll, author of *Alice in Wonderland* and himself an amateur photographer, was one of her admirers. In 1863, she was the first woman to be elected a member of the Royal Photographic Society of Great Britain. In the years that followed she won numerous amateur awards. [T.H.]

FLORENCE HENRI
Plate 31
1893/New York
1963/Bélival, Compiègne
Regarded as the herald of New Photography in France. She studied music and painting in Rome and Berlin. In 1924, she married Karl Anton Koster in Switzerland in order to get a residence permit for France, where she began studying under Fernand Léger at the Académie moderne in 1925. In 1927, she studied at the Bauhaus, where she took her first photographs under the influence of László Moholy-Nagy. Having returned to Paris she opened a studio for advertising photography in 1929. Her compositions and self-portraits were influenced by Dadaism and Surrealism. They were published in numerous contemporary illustrated magazines and shown at the major exhibitions "Film und Foto" (Stuttgart 1929) and "Das Lichtbild" (Munich 1930). After the war she concentrated on taking portraits, until in 1963 she finally gave up photography altogether to devote herself to painting again. [T.H.]

HANNAH HÖCH
Plate 43
1889/Gotha
1978/Berlin-Heiligensee
Considered one of the most outstanding representatives of Dada in Germany. She studied glass design at the Kunstgewerbeschule in Berlin from 1912 to 1918 and graphic art at the Lehranstalt des Kunstgewerbemuseums. While she was there she had a relationship with Raoul Hausmann, who introduced her to the Dadaists and whose experiments with montage and collage inspired her to produce her first photomontages. In 1918, she was among the founders of the Dada Group in Berlin and one year later became a member of the November Group. She took part in the International Dada Fair in 1920. She subsequently participated in numerous exhibitions. From 1933 to 1945 her works were banned in Germany. A retrospective exhibition at the Musée d'art moderne in Paris in 1976 once again drew public attention to her and her main theme – the social conflicts between humans and machines and between man and woman. [F.S.]

ILSE HOCHHUTH
Plate 119
1905/Eschwege
1982/Eschwege
Born Holzapfel, married Walter Hochhuth, natural scientist and later industrialist. She had three sons, one of whom is the writer, playwright and essayist Rolf Hochhuth (born 1931). She edited several volumes of collected aphorisms, among others, by Jean Paul and George Bernard Shaw. Rolf Hochhuth called his theatre foundation after her maiden name, Ilse Holzapfel, claiming that he owed his love of literature to her. [S/M]

DORA HOROVITZ
Plate 19
1894/Brody, Galicia
Date and place of death unknown.
Born Deborah Lichtmann. First mentioned in 1926 in Vienna under her husband's name, Horovitz, in connection with the Geiringer & Horovitz studio. Very little information is available on her life. She is known to have had Polish nationality until 1938, and to have owned a perfume and soap shop. When Trude Geiringer (see Geiringer) left the joint studio, she continued to run it for a year or two. After being dispossessed, she fled via

Belgium to France in 1938 and lived in Montagnac until 1942. She was registered in Paris as a stateless person as of 1948. It is not known whether she worked there as a photographer, nor when she died. The last signs of life date from Paris 1959. [F.S.]

VERA ISLER-LEINER
Plate 142
1931/Berlin
Of Polish-Hungarian origins, she immigrated to Switzerland in 1936 with her two sisters; their parents both died in Auschwitz. She trained as a medical laboratory technician and worked initially in research, though she increasingly pursued her artistic interests, becoming actively involved in the theatre and film scene. She designed "textile pictures" and monochrome relief objects. During a prolonged stay in New York in 1980, she began taking photographs: photo-reportages, portraits, architecture. Her first book, *Kunst der Verweigerung*, about graffiti and the Swiss youth scene, was published in 1982, followed by *Schaut uns an* with portraits of old people (1986) and *Rollenwechsel – Fotografen vor der Kamera* (1992). *Face to face*, a cycle of artists' portraits published in 1994 was exhibited internationally. Her autobiography *Auch ich* appeared in 1998. Vera Isler's second husband is a journalist; she has two daughters. [D.R.]

DOMINIQUE ISSERMANN
Plate 118
1947/Paris
Spent her childhood in the country. Studied English language, literature and humanities. From 1969 to 1972 she lived in Rome. It was through contacts with film-makers there that she got involved in photography. On her return to Paris she wrote and photographed reportages on the filming of Fellini's *Casanova* and Bertolucci's *Novecento* for *Zoom*. She soon made a name for herself as a portrait photographer of actors and celebrities. Her many sitters have included Isabelle Adjani, Catherine Deneuve, Balthus, Gérard Depardieu and Isabella Rossellini. In 1974, she became drawn to fashion photography and since then has been successful as an advertising and fashion photographer in Paris. She has made video clips, for Leonard Cohen and others, as well as advertising films, and in 1987, she published her first book, *Anne Rohart* (see Rohart). That same year she received the Oscar

for fashion photography, and in 1992 the Niépce Prize. She was also awarded the Ordre des Arts et des Lettres. [S/M]

JULIA PRINSEP JACKSON
Plate 4
1846/Calcutta
1895/Kensington
Daughter of a highly respected doctor in India. At the age of two, she came to England with her mother and two older sisters; the father followed in 1855. A much admired beauty, she married the lawyer Herbert Duckworth in 1867 and had three children, but was widowed during her third pregnancy. In 1878, she married the author Sir Leslie Stephen with whom she had another four children; the third of these children was Virginia Woolf. The work of organising the everyday life of a large family gradually took its toll, resulting in states of constant exhaustion. Julia Stephen died in Kensington at the age of 49. [O.F]

LOTTE JACOBI
Plates 28, 38, 39, 44, 45
1896/Thorn, Western Prussia
1990/Concord, New Hampshire
The eldest daughter of the photographer Sigismund Jacobi, who carried on that profession in the third generation, she attended courses in art history and literature at the academy in Posen, married the wood merchant Siegbert F. Honig in 1916 and moved to Berlin in 1920. Having separated from her husband, she worked in her parents' studio in Berlin-Charlottenburg. In 1925, she began studying at the Staatliche Höhere Fachschule für Phototechnik in Munich. She returned to Berlin in 1927, worked for the illustrated press and as a freelance portrait photographer in the Jacobi studio. Thanks to her keen interest in art, theatre and literature, the history of photography possesses lively and expressive artists' portraits, among others, of Lil Dagover, Valeska Gert, Egon Erwin Kisch, Käthe Kollwitz, Lotte Lenya (see Lenya) and Kurt Weill. She was not permitted to publish her work under her own name after 1933. In 1934, she immigrated to New York via London, where she opened her own studio. In 1940, she married the Berlin émigré and publisher Erich Reiss and later became more and more involved with so-called photogenics, photographic experiments without a camera. In 1974,

an honorary doctorate was conferred upon her by the University of New Hampshire. [S.F.]

ELFRIEDE JELINEK
Plate 115
1946/Mürzzuschlag, Steiermark
She grew up in Vienna, where, by her own account, she was "trained" by an ambitious mother who sent her to ballet and music lessons at an early age. After leaving secondary school she studied not only piano and composition, but languages, dramatic arts and art history. She began to write after suffering a nervous breakdown. Her first volume of poetry, *Lisas Schatten*, was published in 1967. Her poetry, prose, theatre plays, radio plays and film scripts, some of which are partly autobiographical, contain mordant analyses of sexuality, violence and power. Although ignored for many years by the Austrian literary establishment, she quickly rose to fame in the Federal Republic of Germany. In 1996, she was awarded the Literature Prize of the City of Bremen and in 1998 the most prestigious German literary award, the Georg Büchner Prize. She has been married since 1974 to a computer scientist and for political reasons lives in Austria only intermittently. [M.A.]

SARAH JONES
Plate 155
1959/London
One of the younger generation of "realist" British photographers, she studied at Goldsmith's College, London, from 1978 to 1981 and since then has had numerous solo and group exhibitions: 1993 at the London Hales Gallery, 1996 at the Tate Gallery Liverpool, 1999 at the Museum Folkwang in Essen and the Museum Reina Sofia in Madrid, and in 2000 at the Huis Marseille, Amsterdam. Her photographs – mainly of young girls in meticulously arranged tableaux – have gained her many awards, including the BMW FSG Photographic Commission Prize in 1998. Sarah Jones lives and works in London. [R.B.]

JANIS JOPLIN
Plate 15
1943/Port Arthur, Texas
1970/Hollywood
Spent her childhood and youth in Texas. In the early 1960s she began singing folk music in cafés in Beaumont and Houston. She moved to San Francisco in 1966 and became a member of the Big Brother and

Holding Company. It was then that she cultivated her raw, bluesy vocal style that was enthusiastically received at the 1967 Monterey Pop Festival by critics and audience alike. A year later the Big Brother album *Cheap Thrills* topped the charts. She then left that group and founded two successive groups of her own. While recording *Pearl*, which for nine weeks was the best-selling rock album of 1971, she died of an overdose of heroin. In 1995, she was received into the Rock and Roll Hall of Fame. [S/M]

NORA JOYCE
Plate 27
1884/Galway, Ireland
1951/Zurich
Born Nora Barnacle, daughter of a baker and a seamstress, in Galway on the west coast of Ireland. She lived most of the time with her grandmother. Having left school at the age of 13, she worked as an attendant in a convent and as a laundry woman. She went to Dublin in 1903, where she earned her living as a chambermaid. On 10 June 1904 she made the acquaintance of James Joyce on Nassau Street, Dublin. In October of that year the unequal pair left Dublin and from then on lived for a time in difficult circumstances in Trieste, Paris and Zurich. Their son Giorgio was born in 1905, their daughter Anna Lucia in 1907. They did not marry until 1931. Nora Joyce died in Zurich in 1951, ten years after her husband. [O.F.]

FRIDA KAHLO
Plate 77
1907/Mexico City
1954/Mexico City
Daughter of a German-Hungarian immigrant and a Mexican woman, she was seriously injured in a traffic accident at the age of 18, which left her an invalid. Operations, hospitalisation and plaster corsets worn for months at a time were unable to alleviate the pain. While convalescing she turned her attention to painting. Her numerous self-portraits and other paintings are characterised by a symbolic, often surreal pictorial idiom. In 1929, she married the artist Diego Rivera, 20 years her senior, but left him in 1935 only to marry him a second time in 1940, one year after their divorce. She had solo exhibitions in New York and Paris in 1938 and 1939. From 1939 onwards she lived and worked at the Casa Azul, the house of her birth, where she

also held art classes, as a professor of the state academy. In 1953, though confined to bed, she attended the opening of her first solo exhibition in Mexico. [M.A.]

GERTRUDE KÄSEBIER
Plates 6, 7
1852/Fort Des Moines, Iowa
1934/New York
Born Gertrude Stanton, she moved with her family to Brooklyn and married the German émigré Eduard Käsebier in 1874. In the late 1880s, after the birth of their three children, she began to take photographs, at first of her family. In 1889, she attended courses in portrait painting at the Pratt Institute. She was assistant to the portrait photographer Samuel H. Lifshey and had her first solo exhibition in 1896. The following year she opened her own studio in Manhattan and quickly became successful and famous. Her portraits of children and society ladies, inspired by contemporary portrait painting and Asian art, won critical acclaim and the admiration of Alfred Stieglitz, who organised a solo exhibition of her work in 1899 at the Camera Club of New York and dedicated the first issue (1903) of *Camera Work* to her. She was among the first women members of the Linked Ring, was a co-founder of the American Photo Secession in 1902 and of The Pictorial Photographers of America in 1916. [S.F.]

URSULA KAUFMANN
Plate 156
1947/Essen
Born Ursula Badenberg, she trained in business economics and taught herself photography. Her special fields are dance and ballet, and since 1984 her photographs have been published in numerous German newspapers and magazines. For many years she accompanied the Pina Bausch ensemble, and her publications include a 1998 volume of photographs on the troupe. Ursula Kaufmann lives in Essen; her works have been widely exhibited and were included in the Hanover EXPO. [R.B.]

BARBARA KLEMM
Plates 107, 109, 113, 121, 147
1939/Münster
Daughter of the artist Fritz Klemm, she grew up in Karlsruhe, where she trained at a portrait studio. She has worked as a photojournalist for the German daily broadsheet *Frankfurter Allgemeine Zeitung* since 1959,

becoming their staff photographer in 1970, with special emphasis on the arts and politics. Until the fall of the Berlin Wall she photographed the two German states, documenting historical moments and everyday events, portraying Willy Brandt and Leonid Brezhnev, hip youth culture and pensioners. Her works have been widely published and shown in solo and group exhibitions in Germany and abroad. In 1989, she received the Dr Erich Salomon Prize of the Deutsche Gesellschaft für Photographie and the Hugo Erfurth Prize of the City of Leverkusen, in 1998, the Maria Sibylla Merian Prize for women artists in the State of Hesse and in 2001, the Konrad von Soest Prize. [R.B.]

UTE KLOPHAUS
Plate 101
1940/Wuppertal

After completing an apprenticeship in photography, she studied at the Staatliche Höhere Fachschule für Fotografie in Cologne. She has been working as a freelance photographer since 1963. During the "24-hour" happening at the Galerie Parnass in Wuppertal in 1965, in which she herself participated as an "Aktion" artist, she encountered not only such famous Fluxus artists as Nam June Paik, Charlotte Moorman (see Moorman) and Wolf Vostell, but also Joseph Beuys, whose oeuvre she was to photograph over the following 20 years. She documented his "Aktion" events and happenings, photographed his environments and sculptures and is widely regarded today as his most important photographer. In 1985, the two of them exhibited jointly for the first time in Madrid. After Beuys' death in 1986, her photographs of him and his works were shown in numerous solo exhibitions, often in connection with retrospectives of his oeuvre. Other focal points of her work are artists' portraits and cityscapes. Her most recent work, *Weimar: Ein Mythos* (1999), was published for an exhibition marking the 250th anniversary of Goethe's birth. [D.R.]

KÄTHE KOLLWITZ
Plate 44
1867/Königsberg
1945/Moritzburg, Dresden

Born Käthe Schmidt, her socially and morally aware parents gave her an upbringing that was very progressive by the standards of the time: she had a private drawing tutor and attended art schools in Berlin and Munich. In 1891, she married the physician Karl Kollwitz and had two sons. Throughout her life, her artistic work lent expression to her social dedication to the causes of the poor and needy; she supported the ideals of the social-democratic movement. After the death of one of her sons in the First World War, she advocated pacifism. She was the first woman to be accepted into the Prussian Academy of Arts, in 1919, after which she received the title of professor. In 1933, she was forced to resign from the Academy, and as of 1936 was unofficially prohibited from exhibiting. In the last years of the war she moved to Nordhausen, and later to Schloss Moritzburg near Dresden, where she died shortly before the war came to an end. [E.S.-R.]

ANNELISE KRETSCHMER
Plate 37
1903/Dortmund
1987/Dortmund

Became involved in photography more or less by chance. It was curiosity about the medium rather than a calling to the profession that prompted her to work for several years as an assistant to the photographers L.V. von Kaenel in Essen and Franz Fiedler in Dresden. While in Dresden she married the sculptor Sigmund Kretschmer, and in 1934, they moved to Dortmund, where she opened a photography studio specialising in portraiture. Around 1930 her photographs were included in such important exhibitions as "Film und Foto" in Stuttgart and "Das Lichtbild" in Munich. From 1943 to 1950 she lived with her husband and their four children in Freiburg im Breisgau. In the 1950s she re-opened her photography studio in Dortmund, running it jointly with her youngest daughter, Christiane, until 1978. [F.S.]

GERMAINE KRULL
Plates 11, 15, 40
1897/Wilda, Eastern Prussia
1986/Wetzlar

Her adventurous life took her throughout most of Europe, as well as to Russia, Brazil, Africa and South-East Asia. She studied photography at the Lehr- und Versuchsanstalt in Munich but was expelled from Bavaria in 1920 because of her political activities. After a brief spell in the Soviet Union, she opened a photography studio in Berlin. Soon afterwards she left for Holland with her future husband, Joris Ivens, then went on to Paris. In 1928, her book *Métal* appeared, making her the most important representative of Neues Sehen (New Vision) in France. In the 1930s she made a name for herself with photo reportages in the new illustrated media. In 1942, she fled, first to Brazil, then to Africa, where she worked for de Gaulle's "France Libre". She returned to France in 1944. Two years later, she went to Indochina as a war correspondent, travelled and photographed Asia, managed the Hotel Oriental in Bangkok for a while and in 1965 settled in Northern India among the Tibetan refugees. Two years before her death she returned to Germany on health grounds. [F.S.]

BRIGITTE LACOMBE
Plates 148, 149

Of French origins, she lives in New York. She left school and took up photography at the age of 17. As a photographer for *Elle*, she got to know Dustin Hoffman and Donald Sutherland at the film festival in Cannes in 1975 and through them gained access to the film world. The scriptwriter and dramatist David Memet attracted her to the theatre in 1983 with an invitation to photograph the premiere of his play *Glengarry Glen Ross*. For seven years she was staff photographer at the Lincoln Center Theater in New York. She was "behind the scenes" on a number of famous films, including *Close Encounters of the Third Kind*, *The English Patient* and the Scorsese film *Gangs of New York*. Her photographs, especially her portraits of actors, film stars, directors and authors, have been published in *The New Yorker*, *The New York Times Magazine*, *Paris Vogue*, *Vanity Fair*, *Interview* and *Condé Nast Traveler*. She was awarded the Eisenstaedt Prize for travel photography in 2000. [S/M]

INEZ VAN LAMSWEERDE
Plate 136
1963/Amsterdam

Studied at the Vogue Academy of Fashion and the Rietveld Academie in Amsterdam. Since her first exhibition, in Amsterdam in 1990, she has made a name for herself on the art scene as a producer of provocative photographic images: using digital image processing she lends children the features of adults, for example, or shop window mannequins real human form. On the

borderline between the world of art and of fashion she plays with gender stereotypes and clichés and with the aesthetic constraints of fashion and society photography in technically perfect and often deliberately shocking images. Together with her partner, the stylist and visagist Vinoodh Matadin, she has also undertaken fashion photography for Joop, Patrick Cox and Thierry Mugler since 1993. [D.R.]

ERGY LANDAU
Plate 56
1896/Budapest
1967/Paris
Of Hungarian origins. In 1918, she worked at the studio of Viennese photographer Franz Xaver Salzer. The following year she went to Berlin as assistant to Rudolf Dührkoop, and some time later opened her own studio in Budapest. In 1919, she met and photographed László Moholy-Nagy, with whom she became romantically involved. She left Hungary in 1923 and went to Paris where she opened her Studio Landau. She received French citizenship in 1925. Initially influenced by pictorialism, her style of photography changed as of 1928 under the influence of New Objectivity. She was represented at the major exhibitions of 1929 and 1930 in Stuttgart and Munich and her nude photographs in particular were published in various French journals. [F.S.]

DOROTHEA LANGE
Plate 68
1895/Hoboken, New Jersey
1965/San Francisco
In addition to training as a teacher, she studied photography in New York under Arnold Genthe and Clarence H. White. She opened a portrait studio in San Francisco in 1919 and one year later married the artist Maynard Dixon, with whom she had two sons. Struck by the increasing impoverishment of many social groups during the economic crisis, she abandoned art photography and began to document people on the street. With her second husband, Paul Tayler, she got involved in the Californian emergency agencies. From 1935 to 1942 she worked for the Farm Security Administration on a documentation and aid project initiated by the Roosevelt government. The resulting photo-reportages on rural life showed not only the bitter poverty, but also the pride and dignity of migrant workers. Her

photograph *Migrant Mother* came to symbolise the whole project and is today one of the most widely disseminated pictures in the history of photography. In the 1940s she photographed for the Office of War Information, among other institutions. She taught photography in San Francisco until 1962. [T.H.]

ANNIE LEIBOVITZ
Plates 103, 141, 142
1949/Westbury, Connecticut
Studied painting and photography at the San Francisco Art Institute. In the early 1970s she began photographing the American culture scene, initially for the magazine *Rolling Stone*, later for *Vanity Fair* and *Vogue*, establishing herself as a keen observer of American pop culture. Her photographs of musicians and actors, politicians and sports celebrities, dancers and artists have become icons of the zeitgeist; her portraits of John Lennon and Yoko Ono are now classics. With her 1984 portrait campaign for American Express she also set new standards in advertising photography. In 1991, the National Portrait Gallery in Washington, D.C., mounted a retrospective exhibition of her photographs. Her third book, *Women*, in collaboration with the writer and critic Susan Sontag, was published in 1999. Annie Leibovitz is one of the most successful and renowned photographers of our time. [D.R.]

MARILYN HEIT LEIBOVITZ
Plate 103
1926
Grew up in Brooklyn, New York. Her parents were Russian immigrants. She was awarded a scholarship to the Neighborhood Playhouse where Martha Graham (see Graham) taught dancing, and also studied at the Brooklyn College. She graduated in 1941 and the following year married Samuel Leibovitz. During his military career the family moved frequently. They had six children, including the photographer Annie Leibovitz (see above). Marilyn Leibovitz worked as a primary school teacher and a dance teacher. [S/M]

TAMARA DE LEMPICKA
Plate 23
1898/Warsaw
1980/Cuernavaca, Mexico
Born Gorska, in 1914 she went to live with an aunt in St Petersburg, where she cultivated a taste for the luxurious lifestyle represented by

the people she would later portray so successfully. At the age of 16 she met the lawyer Tadeusz de Lempicki, whom she married in 1916. The October Revolution put an end to their carefree life. The couple immigrated to Paris, where their daughter was born. Tutored in painting by Maurice Denis, André Lhote and others, Tamara de Lempicka was already exhibiting by 1923 and soon become the most celebrated and notorious portraitist of Parisian society. After separating from Lempicki, she married the Hungarian Baron Kuffner in 1933 and immigrated to America with him in 1939. In Hollywood she again made a career for herself as a society artist, although soon her style no longer suited prevailing tastes. Her oeuvre received renewed acknowledgement through a retrospective exhibition in Paris in 1972. [E.S.-R.]

LOTTE LENYA
Plate 39
1898/Vienna
1981/New York
Born Karoline Blamauer, she took ballet lessons at the Zurich Stadttheater and was a member of the ensemble until 1920. It was there that her acting talent was discovered. In the early 1920s she met the composer Kurt Weill in Berlin and married him in 1925. She gained fame in 1928 in the role of Jenny in the premiere of Weill/Brecht's *Threepenny Opera*. In 1933, the couple immigrated to America via Paris. It was only after Weill's death in 1950 that she made her breakthrough as an artist in the USA, again in the role of Jenny, which she played in more than 2,707 performances over a period of seven years. In Europe and America in the 1950s and 60s, her interpretations of the works of Weill and Brecht made a decisive contribution to their renaissance. She also starred in various films and was awarded an Oscar in 1961. [E.S.-R.]

HELEN LEVITT
Plates 71, 75, 80
1913/New York
Of Italian-Jewish origin, she has lived in New York since she was born. Instead of finishing school she went to work for a commercial portrait photographer for four years. Her meeting with Henri Cartier-Bresson in 1935 was crucial to her further development. In the 1930s and 40s she photographed

urban life in New York, especially in the ethnically mixed Brooklyn, Bronx and Harlem districts, her focus being mainly on immigrant children. The Museum of Modern Art in New York mounted a solo exhibition of her works as early as 1943. In the 1940s she turned her attentions more and more to cinema, working for Luis Bunuel, Janice Loeb and Sidney Myers, but she returned to photography in the early 1950s. Her photographs were shown in Germany at documenta X, in 1997. She has received numerous awards, including the 1997 Master of Photography Award presented by the International Centre of Photography. [R.B.]

BEATRICE LIBONATI
Plate 156

Born in Mons, Belgium, of a Belgian mother and an Italian father, she grew up in Italy and studied dance at the Accademia Nazionale di Danza in Rome. She worked with different experimental groups, was a guest solo dancer at the Spoleto festival and performed her own solo choreography at the festival in Nancy. She has been a member of Pina Bausch's Wuppertaler Tanztheater since 1978, but has continued to pursue her career as a solo dancer and choreographer outside that company. *Solo*, which she choreographed for herself, was premiered in 2001 in Wuppertal, where she also lives. [S/M]

ALICE PLEASANCE LIDDELL
Plate 5
1852/Oxford
1934/England

The second of the three daughters of Henry George Liddell, Dean of Christ Church College, Oxford, and his wife Lorina Reeve. She gained fame as the model for Alice in the stories by the mathematics professor Charles Lutwidge Dodgson, alias Lewis Carroll. In 1880, she married Reginald Hargreaves, with whom she had three sons and lived in a large house in Lyndhurst. After the death of her husband, she had the original manuscript of *Alice in Wonderland* auctioned for a record sum in 1925. On her 80th birthday she was invited to the USA to attend the celebrations in honour of the 100th anniversary of the birth of Lewis Carroll. She is a distant relative of Queen Elizabeth II through her great-grandfather. [O.F.]

ADRIANA LIMA
Plate 140

Born in Bahia, Brazil, of French, Portuguese, Indian and Caribbean ancestry, she worked as a model while still at school. At the age of 16 she joined the Elite agency in New York and was soon working with fashion photographers such as Peter Lindbergh, Steven Meisel, Patrick Demarchelier and Ellen von Unwerth (see Unwerth), for whose photography book *Wicked* (1998) she posed. As a result of poster and advertising campaigns for Ralph Lauren, Chanel, Christian Lacroix, Giorgio Armani and Yves Saint Laurent her face has become world famous. [D.R.]

RUTH HARRIET LOUISE
Plate 16
1906/Brooklyn, N.Y.
1944/presumably California

Began working as a professional photographer at the age of 17. In 1923, she opened a commercial photography studio in New York and another in Hollywood two years later. She was under contract to MGM Studios until 1930 and headed the MGM Portrait Gallery, the first and only woman in such a position at the time. Her style, an impressive blend of glamour, charisma and unpretentiousness, was highly regarded by such stars as Joan Crawford, Anna May Wong, Lon Chaney, Ramon Novarro and, most notably, Greta Garbo, who would not have her studio portraits taken by anyone else. In 1930, she married the film and later television director Leigh Jason, after which she worked mainly as a freelance portraitist of actors. [F.S.]

INGEBORG LUDOWICI
Plate 88
1930/Karlsruhe

Married name Samhaber. She attended the school of photography in Munich from 1951 to 1953, during which time she produced abstract still lifes, fashion photographs, stringently composed portraits and photographs of objects. Her self-portrait is regarded as the apex of her brief but creative career as a photographer. Soon after marrying she abandoned photography. She lives in Dorfen, Germany. [D.R.]

DORA MAAR
Plates 51, 55, 57, 60
1907/Paris
1997/Paris

Studied painting and photography in Paris. By the time she met Picas-

so in 1936, becoming his lover, muse and model, she was already an established artist whose photographs were acknowledged emblems of the Surrealist movement. Having photographed the genesis of his *Guernica* (1937), she abandoned photography to devote herself entirely to painting. When Picasso left her in 1946, she suffered a nervous breakdown from which she was slow to recover. She then lived a secluded life in Paris and in Provence, where Picasso had given her a house. She painted still lifes and landscapes, which have been exhibited frequently, most recently in Valencia in 1995. [T.H.]

LINDA MCCARTNEY
Plate 95
1941/Scarsdale, N.Y.
1998/London

Born Linda Eastman, she studied art history at Tucson, Arizona, where she discovered her interest in film and photography. In 1966, she was given the opportunity of combining her love of photography with her passion for rock music when she was admitted to a Rolling Stones press conference. During the 1960s she was photographer for the famous Fillmore East in New York and submitted shots of up and coming bands for *Rolling Stone* magazine: The Who, Doors, Beach Boys, Grateful Dead, Janis Joplin and many more besides. In 1967, at the press launch of the Beatles' *Sgt Pepper* album, she met and fell in love with Paul McCartney. They married two years later. In 1971, they founded the band Wings and went on a world tour from 1989 to 1993. [T.H.]

FRANCES MCLAUGHLIN-GILL
Plates 84, 129
1919/New York

She took up photography at the age of 18. She studied art, design and painting at Brooklyn and New York, won the Vogue Prix de Paris in 1941 and from 1944 to 1954 was a member of the photography team behind the Conde-Nast magazines *Vogue, Glamour* and *House & Garden.* Many of her elegantly stylish fashion shots appeared on the cover pages. For the editorial section, she photographed celebrities in the world of theatre, fashion and film, created travel reportages and beauty series. In 1948, she married the photographer Leslie Gill, with whom she had a daughter. From

1964 to 1973 she worked freelance, producing TV spots and advertising films, and from 1978 she taught photography at the School of Visual Arts, New York. It was not until 1985 that she gave up magazine photography. She lives in New York City. [D.R.]

MADAME D'ORA
Plates 9, 22, 23
1881/Vienna
1963/Frohnleiten, Steiermark
Born Dora Philippine Kallmus, she came from a respected family of Jewish lawyers. In 1905, she was the first woman to be admitted to theory courses at the Graphische Lehr- und Versuchsanstalt. That same year she became a member of the Viennese Photographic Society. She trained at Nicola Perscheid's Berlin studio and, together with Perscheid's assistant, Arthur Benda, she opened a photo studio in Vienna in 1907. The Benda – D'Ora studio was so successful that in 1924, they opened a branch in Paris. Three years later, Madame d'Ora herself went to Paris, where she continued to photograph famous artists and society people. She also concentrated increasingly on fashion photography, working for the magazine *Die Dame,* and others. When the Germans invaded France she fled to a convent. She did not return to Paris until 1946/47, when she reopened her studio. A serious traffic accident in 1959 left her an invalid. [F.S.]

MADAME YEVONDE
Plates 21, 49
1893/London
1975/England
Portrait and advertising photographer whose sitters were predominantly upper-class ladies posing as Roman or Greek goddesses. With her own portrait studio in London, she became a successful society photographer after the First World War. Her clients included Princess Marina of Kent and Lady Nancy Astor, as well as many actors and writers. In 1925, she began working for advertising agencies and turned to colour photography. On the outbreak of the Second World War she discontinued her work. In 1973, the Royal Photographic Society of Great Britain showed photographs by Madame Yevonde in the retrospective exhibition "Sixty Years a Portrait Photographer". [F.S.]

MADONNA
Plate 138
1958/Detroit
Born Madonna Louise Veronica Ciccone. She and her seven brothers and sisters were brought up by their strict Catholic father after the death of their mother in 1963. In 1977, she went to New York, making her living there as a singer and dancer. She gradually won acclaim, and in 1982, she signed her first recording contract. Her international breakthrough came in 1984 with *Like a Virgin.* Madonna forged her image skilfully through video clips and soon became a role model for teenage girls. Since 1985 she has also taken on acting roles, among others in the film *Evita,* 1996. She married for the second time in late 2000; she has two children and is regarded as the most successful female singer of all time. [O.F.]

SILVANA MANGANO
Plate 106
1930/Rome
1989/Madrid
Born in Rome, the daughter of a Sicilian father and an English mother. After school, she trained in ballet for several years. Having won the title of Miss Rome at the age of 16, she was discovered for cinema, making a name for herself in 1949 in Giuseppe de Santis' film *Bitter Rice.* That same year she married the film producer Dino de Laurentiis, with whom she had four children. In the 1960s and 70s she worked with Pasolini [*Oedipus Rex,* 1967; *Theorema,* 1968] and Visconti [*Death in Venice,* 1970; *Ludwig II,* 1972]. When her son was killed in an accident in 1981, she largely retired from the film world. Her last role was in *Black Eyes.* She died in Madrid, where she had spent her later years. [O.F.]

SALLY MANN
Plates 131, 153
1951/Lexington, Virginia
Born Munger. She trained at Anselm Adams' Yosemite Workshop, among others. She married in 1970, had three children, and concentrated increasingly on family scenes. Her photographs of her children in particular, candidly showing stages in their growth, unleashed highly controversial reactions. In 1992, she published *Immediate Family,* a series of family portraits. Numerous grants, awards and exhibitions, further book publications and acquisitions by large museums, among them the

Museum of Modern Art and the Metropolitan Museum, New York, have made her one of the most famous contemporary female photographers in the United States. Sally Mann lives with her family in Lexington, Virginia. [R.B.]

MARY ELLEN MARK
Plates 93, 108, 133, 145
1940/Philadelphia
Took up photography in 1963 after studying art, and gained a Master's degree in photojournalism at the University of Pennsylvania in 1964. She then went to Turkey for a year on a Fulbright scholarship. From 1968 onwards she travelled extensively throughout India, living with prostitutes in Bombay, accompanying snake-charmers and street acrobats and photographing Mother Teresa (see Mother Teresa) at work in the slums of Calcutta over a period of several weeks. The focus of her interest in the USA is also on groups at the margins of society. She has undertaken a number of long-term projects, photographing drug addicts, the mentally ill, transvestites and street children. A member of Magnum New York since 1977, her work has been published in many respected magazines and periodicals and several books of her photographs have appeared since the mid-1970s. Her work has been widely exhibited and she has won many awards. Mary Ellen Mark teaches photography and holds photography workshops. She is married to film-maker Martin Bell and lives in New York. [R.B.]

MARY MARTZ
Plate 111
Sitter for Deborah Turbeville (see Turbeville)

MARGARETHE MATHER
Plate 25
1885/Salt Lake City
1952/Glendale, California
Grew up in an orphanage, ran away from her adoptive family as an adolescent and earned her living as a prostitute in San Francisco. After meeting Edward Weston in 1912, she worked with him for a while in a small but renowned studio in Glendale. She worked as a commercial photographer in the fields of portraiture and interior design until well into the 1930s. From 1919 onwards she successfully exhibited her creative work, which included unconventional still lifes and nudes as well as portraits, in various photographic salons. In the last year

and a half of her life she reduced her photography to occasional portraits of friends. Margarethe Mather died of multiple sclerosis. [F.S.]

SUSAN MEISELAS
Plate 150
1948/Baltimore

She took a Master's degree in Education at Harvard University in 1971 and went on to develop concepts for the use of film and photography in the school curriculum. She later became a freelance photographer. In 1977, she joined Magnum, gaining full membership in 1980 and becoming vice president of the agency in 1987. In the 1970s, South and Central America became the focus of her photographic work. She was in Chile in 1973 at the time of Pinochet's putsch, photographed in El Salvador and created a number of famous photo reportages on the war in Nicaragua in 1978-80. She travelled extensively in Cuba, India and Chad. Her works have been published in the *New York Times Magazine* as well as in *Geo, Paris Match, Life* and several books. Her most recent work has focused primarily on Kurdistan. Susan Meiselas has been awarded many prizes, including the Photojournalist of the Year award in 1982. She lives in New York. [R.B.]

LEE MILLER
Plates 54, 58, 59
1907/Poughkeepsie, N.Y.
1977/Chiddingly, Sussex

She was trained in photography by her father, an inventor and amateur photographer. She studied painting and stage design and, as a student, sat as model for Edward Steichen and Arnold Genthe, later for Horst P. Horst and George Hoyningen-Huene. In 1929, she went to Paris, where she became part of the circle of Surrealists around André Breton and Max Ernst, and began working with Man Ray, with whom she was also romantically involved. In 1932, she returned to the USA and set up a studio for fashion and portrait photography in New York. In 1934, she married the Egyptian businessman Aziz Eloui Bey. Her second marriage, in 1947, was to the art historian and writer Roland Penrose, with whom she had been living since the late 1930s in England. Between 1939 and 1947 she was a war correspondent, initially for *Vogue* London and from 1940 onwards as an official war correspondent for the US Forces. She

worked until 1954 as a freelance journalist and photographer for the British, French and American issues of *Vogue*. [T.H.]

LISETTE MODEL
Plates 64, 65, 73, 81
1901/Vienna
1983/New York

Born Elise Amelie Felicie Stern, she studied singing and composition under Arnold Schoenberg before going to France in 1926, where she devoted herself to painting and photography. It was in Nice that she made her famous series about wealthy holidaymakers on the Promenade des Anglais. In 1938, she and her future husband, the Russian painter Evsa Model, immigrated to New York, where she soon made the acquaintance of America's leading art photographers and took part in a group exhibition at the Museum of Modern Art. In the years that followed, she created her frequently tongue-in-cheek portrayals of Coney Island day-trippers, people on the Lower East Side and life in the bars, restaurants and hotels of Manhattan. Her photographs were published in *P.M.* magazine and *Harper's Bazaar*, for which she was a regular contributor up to 1953. From 1947 onwards she taught at the San Francisco Art Institute and from 1951 at the New York School for Social Research in New York, where her students included Diane Arbus (see Arbus). [T.H.]

TINA MODOTTI
Plates 24, 26, 33
1896/Udine
1942/Mexico City

Born in Italy, she followed her father to California in 1913 and worked in a San Francisco textile factory. From 1917 onwards she became a stage actress, married the American writer and painter Roubaix de l'Abrie Richey (who died in 1922) and had some small roles in Hollywood silent films. In 1923, she immigrated to Mexico with Edward Weston, for whom she was model, muse, lover, student and business partner. In Mexico, she joined the Communist Party, met Pablo Neruda, Diego Rivera and Manuel Alvarez Bravo, and took her first photographs. The murder of a Mexican trade union leader who was her lover, and her implication in an assassination attempt on the president, led to her deportation. She went to Berlin and then to Moscow, where she gave up

photography to work for the communist cause in Poland, France and the Spanish Civil War. In 1939, she returned to Mexico, where she died in mysterious circumstances in Mexico City at the age of 45. [F.S.]

LUCIA MOHOLY
Plates 31, 32, 34, 63
1894/Prague
1989/Zurich

Best known for her portrayals of life and work at the Bauhaus and Bauhaus architecture. Born Lucia Schulz, she studied art history and philosophy in Prague and worked as an editor and copy editor for publishers in Berlin. She wrote reviews and published her own Expressionist texts under the pseudonym Ulrich Steffen. In 1920, she met the Hungarian artist László Moholy-Nagy, whom she married the following year. With him, she began her first experiments in photography. When he was appointed to teach at the Bauhaus, she went with him to Weimar, where she began photographing the work and products of the Bauhaus. In 1925-26, after the Bauhaus moved to Dessau, she created a major series of photographs documenting the new buildings, which brought fame to the architecture and the photographer alike. She also photographed many of the teachers, friends and students of the Bauhaus. In 1929, she and her husband separated and she began teaching at the Itten School in Berlin. In 1933, via Prague, Vienna and Paris, she immigrated to London, where she became a portrait photographer and devoted much of her energy to microfilm techniques. She settled in Zurich in 1959. [S.F.]

MARILYN MONROE
Plates 86, 98
1926/Los Angeles
1962/Los Angeles

Born Norma Jean Baker or Mortenson (her mother's maiden name). After a difficult childhood, she worked as a pin-up model and became a film actress in the late 1940s, drawing attention in 1950 for minor roles in such films as John Houston's *The Asphalt Jungle*. By 1953 at the latest she had become a star thanks to her roles in *How to Marry a Millionaire* and *Gentlemen Prefer Blondes*, followed by even greater fame in the Billy Wilder films *The Seven Year Itch* (1955) and *Some Like it Hot* (1959). Her high-profile marriages to baseball star Joe DiMaggio

(1954) and playwright Arthur Miller (1956-61) both failed. *The Misfits* (1961) was her last film. Her mysterious death the following year made her a legend and an eternally young sex goddess. [O.F.]

SARAH MOON
Plates 139, 144
1940/England
Born Marielle Hadenague, of French descent, she taught herself photography. She studied drawing at art school and had a successful career as a photo model in Paris before deciding to take up photography herself in the late 1960s. Since then, she has worked as a fashion and advertising photographer. Her impressionistically romantic style with a surreal undertone was highly esteemed in the 1970s and 80s in particular. She has photographed for such magazines as *Marie-Claire, Harper's Bazaar, Vogue, Elle* and *Stern*, and has created advertising campaigns and films for Cacharel, Revlon, TWA, Bally and Dupont. She has made a television portrait of Henri Cartier-Bresson and in 1990, she made her first feature film, *Mississippi One*. Her many awards and accolades include a Lion d'Or at Cannes for her Cacharel campaign in 1979, the Fashion Award of the International Centre of Photography in 1983 and the Grand Prix de la Photographie in 1999. [R.B.]

CHARLOTTE MOORMAN
Plate 101
1933/Little Rock, Arkansas
1991/New York
A single child, she was fascinated by the "masculine voice" of the cello, which she began to play at the age of 12, going on to play in various orchestras and ensembles until 1966. From 1963 onwards she organised the annual New York Avant-Garde Festival, inviting the action and video artist Nam June Paik to take part in 1964. Their mutual inspiration led to a number of performances together in the following years, including a 24-hour happening with Joseph Beuys, Wolf Vostell and other Fluxus artists, in Wuppertal in 1965, various projects, world tours and minor scandals. Although she became seriously ill in 1979, her continued efforts to promote exchanges between avant-garde artists made her something of an institution in the New York art world. [O.F.]

INGE MORATH
Plate 100
1923/Graz
2002/New York
Studied languages and literature in Berlin and went on to work as editor and translator for the United States Information Service. She also wrote for the Austrian radio station Rot-Weiss-Rot and the literary magazine *Der Optimist* and was Austrian editor of the periodical *Heute*. In the early 1950s, she moved to London and trained as a photojournalist with Simon Guttmann. In 1953-54, she was Henri Cartier-Bresson's assistant in Paris. In 1955, she became a full member of Magnum. In the 1950s, she travelled extensively in Spain, Tunisia and Iran, and from 1964 in the Soviet Union, South-East Asia, Africa, South America, the Middle East, Cambodia and China. In 1962, she married the American playwright Arthur Miller, with whom she has a daughter. She received the Gold Medal of the National Arts Club, New York, in 1999, the Austrian State Prize for Photography in 1992, and an honorary doctorate from the University of Harvard in 1984. She has published many books, some of them in collaboration with Arthur Miller. Her photographs have been published and exhibited throughout the world. [R.B.]

JEANNE MOREAU
Plate 148
1928/Paris
Her father was a hotelier and her British mother was a dancer. She trained as an actress at the Paris Conservatory and in 1948 became the youngest member ever of the Comédie Française. By the mid-1950s she was hailed as the best stage actress of her generation. Her international breakthrough came in 1957 with her role in Louis Malle's nouvelle vague film *Ascenseur pour l'Echafaud*. "La Moreau" went on to inspire internationally renowned directors to create such masterpieces of film history as Antonioni's *La Notte* (1960), Peter Brook's *Moderato Cantabile* (1960), Truffaut's *Jules et Jim* (1961) and Bunuel's *Le Journal d'une Femme de Chambre* (1964). In 1977, she married her second husband, the American director William Friedkin, and interrupted her film career to concentrate on directing, but returned to stage and screen after their divorce in 1979. At the 50th Berlin Film Festival in 2000,

she was awarded the Golden Bear for her life's work and became the first woman to be elected to the Académie des Beaux-Arts in Paris. [M.A.]

BARBARA MORGAN
Plate 79
1900/Buffalo, Kansas
1992/North Tarrytown, N.Y.
Born Barbara Brooks Johnson, she grew up in Southern California, studied art at the University of Los Angeles and devoted her energies to painting and printmaking. In 1925, she married the photographer and writer Willard D. Morgan. Having met Edward Weston that same year, she turned her attention to photography as an artistic medium and began to create portraits, landscapes, dance photographs and experimental photomontages and light abstractions. She was particularly interested in capturing movement of any kind, as in dance or gesture. In 1935, she met Martha Graham (see Graham) and photographed her regularly from then on. Her book *Martha Graham: Sixteen Dances in Photographs* was published in 1941. In the 1940s she also worked with other dancers, including Merce Cunningham and Jose Limon. [F.S.]

NELLY
Plates 13, 36
1899/Aidini, Anatolia
1998/Athens
Born Elli Souyoutzoglou, the daughter of a wealthy Greek merchant family. In 1920, together with her brother Nikos, she went to Dresden, where she studied painting, changing two years later to photography and training with Hugo Erfurth and later with Franz Fiedler. In Dresden she met her future husband, the pianist Angelos Seraidaris. Having completed her studies, she opened a photographic studio in Athens. Apart from portraits of Athens society, she was commissioned by the Ministry of Tourism to document the sights of Greece. She became known for her nude studies of the dancers Mona Paiva and Jelizaveta Nikolska (see Nikolska) in front of the Parthenon, which scandalised her more conservative contemporaries. At the outbreak of the Second World War, Nelly was presenting her work in New York. She chose to stay in the USA and did not return to Greece until 1966. [T.H.]

JELIZAVETA NIKOLSKA
Plate 36
1904/Russia
1955/Caracas
Trained as a dancer in Russia. In the 1920s she danced as a guest of the National Theatre in Prague before becoming prima ballerina there and eventually director of the ballet. Under her influence, ballet at Czechoslovakia's leading theatre moved away from the Italian style to embrace the classical Russian school of dance. She also ran her own ballet school in Prague. [O.F.]

JESSYE NORMAN
Plate 123
1945/Augusta, Georgia
One of seven children in a family of music lovers, she trained as a soprano at Howard University, Baltimore and Michigan. Her first success in Europe came when she won the 1968 broadcasting companies' music competition in Munich, leading to a contract at the Deutsche Oper Berlin, where she gave her debut as Elisabeth in *Tannhaeuser*. She went on to sing in Milan, London, Salzburg and Hamburg, but it was not until 1982 that she performed in the USA, appearing at the Met the following year. In the 1990s she shifted her focus from opera, in which she is now only rarely seen in Wagner roles, to specialise instead in "Lieder". She is unmarried and lives in London. She gives master classes in France and the USA. [M.A.]

ISOLDE OHLBAUM
Plates 115, 119, 122
1947/Moosburg
Known especially for her portraits of international writers. From 1970 to 1972 she studied at the Bavarian State School of Photography and has worked as a freelance photographer for various publishers, newspapers and periodicals since then. Having initially worked in the field of photojournalism, she soon began to focus entirely on portraiture. Her sitters include almost all the leading writers in the German-speaking world. Another focal point in the 1980s was erotic funerary sculpture in European cemeteries. Her work has been shown in many exhibitions and she has published several books. For her 1994 *Autorenporträts* she was awarded the Kodak Photo Calender Prize. She lives in Munich. [R.B.]

MERET OPPENHEIM
Plate 94
1913/Berlin
1985/Basle
Arriving in Paris at the age of 18 to study painting, she soon became part of the circle around André Breton. Her friends included Hans Arp, Man Ray and Alberto Giacometti. She had a relationship with Max Ernst. Her works were included in all the Surrealist group exhibitions. In 1938, for reasons both political and personal, she had to return to Basle, where she studied painting and earned her living as a restorer. Together with her husband, Wolfgang LaRoche, she moved to Berne in 1948 and in the 1950s she dedicated herself once more to painting, sculpture and writing. Her rediscovery as an artist was consolidated by a major retrospective exhibition in Stockholm in 1967, and she became an icon of the feminist movement, in which she had been actively involved in the 1970s. In 1975, Meret Oppenheim was awarded the Art Prize of the City of Basle. [F.S.]

GRET PALUCCA
Plate 12
1902/Munich
1993/Dresden
As a young dancer, she was trained by Heinrich Kroeller in Dresden and Munich. In 1919, she joined the Mary Wigman ensemble. Her first successes came as a solo dancer in the 1920s, when she developed her own expressive style that was to make her one of the most famous representatives of expressive dance. In 1924, she founded her first school of dance in Dresden. Branches in other German cities followed. In 1939, the Nazis closed her school. After the war, she began performing and teaching again. She ended her career as a solo dancer in 1950 and from then on earned her living entirely as a teacher. In spite of the cultural restrictions of the East German regime, she managed to establish herself and gain recognition and accolades beyond the borders of the GDR. [E.S.-R.]

ANNA PAVLOVA
Plate 9
1881/St Petersburg
1931/The Hauge
Born Anna Matvejevna, she began her training at the age of ten with the Imperial St Petersburg Ballet School, graduating in 1899 and

going on to rise swiftly through the hierarchy of the Mariijinskiy Theatre. In 1906, she was declared a ballerina. Michel Foukin choreographed several pieces for her, including the "Dying Swan", which she danced thousands of times in the course of her career. From 1907/8 she performed in Northern and Central Europe, dancing with Sergei Diaghilev's Ballet Russes, with Nijinsky as partner. In 1910, she had her debut in New York. In 1913, she left the Imperial Russian Ballet and founded her own ballet troupe, with which she travelled the world. She died in 1931 on a tour to The Hague. [E.S.-R.]

OMARA PORTUONDO
Plate 130
1930/Havana
Havana's most expressive Bolero singer, she sang with the Aida Diestro Quartet for 13 years. Having worked with Nat King Cole and Edith Piaf, she was among the legendary members of the Buena Vista Social Club in Havana, immortalised by Wim Wenders in his film of the same name. [S/M]

JEANNE REMARQUE
Plate 61
1901/Hildesheim
1975/Monte Carlo
Born Ilse Jutta Zambona, she was married for the second time in 1925 to Erich Maria Remarque, who was then a sports journalist. By 1930, this marriage, difficult from the start, was dissolved. Two years later, she followed Remarque to Switzerland, fearing Nazi persecution. When her visa ran out, Remarque married her again to enable her to stay out of Germany. In 1939, she immigrated to the USA with him and became a US citizen in 1947. Although Remarque divorced her in 1957 to marry Paulette Goddard, he continued to support her. [O.F.]

BETTINA RHEIMS
Plates 123, 126, 138
1952/Paris
She experimented with various artistic media before choosing photography in the late 1970s. In 1980, she published her first series – a cycle of nude studies of striptease dancers and travelling acrobats – in the magazine *Egoiste*. Just one year later, she had an exhibition at the Centre Georges Pompidou in Paris. This was followed by advertising and fashion shoots, as

well as portraits of actors and famous faces for CD covers and film posters. In 1989, she published her first book, *Female Trouble*, featuring portraits of famous and unknown women in latently erotic situations. Further publications followed. Video clips and advertising films are other aspects of her diverse range of work, and she is the official portrait photographer of French President Jacques Chirac. [D.R.]

SOPHY RICKETT
Plate 154
1970/London

One of the Young British Artists who captivated the public imagination in the 1990s with their provocative brand of wit and exuberance, she studied at the London College of Printing and the Royal College of Art and, from an early stage, specialised in night scenes, using technical means to make them even darker. Her colour and black-and-white photos are mainly taken in abandoned places, where the occasional figure emerging from the darkness is illuminated by car headlights. Since 1994, her work has been shown in group exhibitions in London, New York, Berlin and elsewhere. She lives and works in London. [D.R.]

LENI RIEFENSTAHL
Plate 147
1902/Berlin

Having trained as a dancer and painter, she took up acting in 1926 and starred in several films, including *The White Hell of Pitz Palü* (1929) before making her first film, *The Blue Light* (1932), which she directed, produced and starred in. Impressed by her film, Hitler commissioned her to make the propaganda films of the Nuremberg Party Rally in 1933 and 1934. In 1936, she made a two-part documentary of the Olympic Games in Berlin. At the end of the war, she was imprisoned by the Allies for collaboration with the Nazis. She was rehabilitated in 1952 and turned her attention once more to photography in the 1960s. She travelled extensively, photographing tribal peoples in Africa. In 1974, she developed an interest in underwater photography and went on a number of diving expeditions. Leni Riefenstahl lives in Munich. [T.H.]

RINGL + PIT
Plate 46

See Auerbach and Stern.

ANNE ROHART
Plate 46
1959/Angers

Between 1980 and 1990, she was an internationally renowned photo model who worked with Richard Avedon and Peter Lindbergh and frequently graced the front covers of *Vogue France*, *Elle*, *Marie Claire* and *Egoiste*. In 1987, she was the model for Dominique Issermann's (see Issermann) first book, *Anne Rohart*. While she was still a model, she used a super-8 camera to document her photo sessions. In 1991, she made her first commissioned film about stylist Christophe Lemaire. A portrait of Dominique Issermann for Arte (1993), documentations with Isabella Rossellini (1994) and Sophie Marceau (1996) and advertising films followed. [D.R.]

CHARLOTTE RUDOLPH
Plate 12
1896/Dresden
1983/Hamburg

Worked as a photographer primarily in her hometown of Dresden and in Berlin in the 1920s to the 1940s. Specialising in modern dance, she photographed Mary Wigman and, in 1942, created studies of Gret Palucca (see Palucca) and Ted Shawn. In 1938, she took over the studio of the Jewish photographer Genja Jenny Jonas in Dresden. The studio and archives were destroyed by bombing in 1945. After the war she moved to Hamburg, where she stayed until her death. In the late 1920s, her photographs, dedicated in particular to image and movement, were included in the major exhibitions "Fotografie der Gegenwart" in Essen and "Das Lichtbild" in Munich. [F.S.]

LISE SARFATI
Plate 157
1958/Oran, Algeria

A French citizen by birth, she has been taking photographs since she was 15 years old. She studied Russian at the Sorbonne in Paris and taught at a number of private schools before devoting herself entirely to documentary photography. She has been a member of Magnum since 1997. Her award-winning photo-reportages and individual photographs have been published in the *New York Times Magazine*, the *FAZ Magazin* and *NZZ Folio*.

Since the fall of the Iron Curtain, she has travelled extensively in Russia, as documented in her analytical description of the former Soviet Union, *Acta Est*, published in Paris in 2000. [D.R.]

NINA SCHMITZ
Plate 158
1968/Geseke

She studied at the Kunstakademie Düsseldorf from 1990 to 1996 and was a master student in the photography class of Bernd Becher. In her early work, she photographed people in her circle of acquaintances. From 1997 onwards, she has concentrated on group portraits of young women, often including herself in the group with an automatic shutter release. Photographed in the wide open outdoors, the women step out of their passive role as objects of observation and take an almost offensively confident stance. In 2000, Nina Schmitz was awarded the Place of Life European Award for Women Photographers. In 1999, she received a scholarship from the North Rhine Westphalian ministry of culture and in 1995, she won the European Architecture Photography Prize. She lives and works in Düsseldorf. [R.B.]

ROMY SCHNEIDER
Plate 114
1938/Vienna
1982/Paris

The daughter of actors Wolf Albach-Retty and Magda Schneider, she grew up with her mother following her parents' divorce and had her first film role by the age of 15. In the 1950s she became one of Germany's favourite film stars, but always remained associated with her leading role in the *Sissi* series of films about the Austro-Hungarian monarchy, which was highly popular in German-speaking countries. In 1959, she moved to Paris, where she began a second career working alongside her fiancé Alain Delon. She was directed by Luchino Visconti both on stage and in front of the camera and worked with many other renowned directors, among them Orson Welles, Joseph Losey and Claude Sautet. She became very popular in France, winning the César in 1976 and 1979. Her private life was marred by her split with Delon, two failed marriages and the accidental death of her son in 1981. [M.A.]

RENATE SCHOTTELIUS
Plate 78
1921/Flensburg
1998/Buenos Aires

At the age of seven, she enrolled at the ballet school of the Berlin Opera and was an early admirer of the Wigman school of modern dance. As a Jew, she was barred from studying in the Third Reich and immigrated in 1936 to Argentina, where she became a soloist and an assistant to the Miriam Winslow ensemble from 1942 to 1947. In 1953, she studied dance in New York, where her teachers included Martha Graham (see Graham). On her return to Buenos Aires she founded a modern dance company at the Teatro San Martin, where she worked as artistic adviser until her death. As a solo dancer, choreographer and internationally renowned teacher who trained several generations of dancers, her work was seminal to the development of modern dance in South America. [S/M]

HANNA SCHYGULLA
Plate 146
1943/Kattowitz

Born in Upper Silesia, she grew up in Munich, where she studied German and Romance languages and literature and also took acting lessons in her spare time. It was her friendship with Rainer Werner Fassbinder that brought her to the stage, playing many roles directed by him in Action Theatre and Anti-Theatre. Her film debut was also under his direction, in *Love is Colder than Death* (1969). They worked together on many film projects right up to Fassbinder's death in 1982, including *The Marriage of Maria Braun* (1978), for which she received the Silver Bear, and *Lili Marleen* (1981). In the years that followed she worked with internationally renowned directors, such as Schlöndorff, Godard and Saura, but still remained loyal to the theatre, directing her first play in 1994 in Berlin and later launching a career as a chanson singer. She lives in France. [M.A.]

EVA SERENY
Plate 114

Born in 1948 to Hungarian parents, she grew up in England. She has lived in Rome since the 1960s and taught herself photography in the early 1970s. Soon she began to specialise in the photographic documentation of film shoots and worked with such directors as Ste-

ven Spielberg, François Truffaut, Federico Fellini, Roman Polanski and Luchino Visconti. She had a good rapport with the actors on set and was able to build up a vast collection of portraits and snapshots of them, some of which were published on the covers of *Life*, *The Sunday Times Magazine*, *Paris Match*, *Vanity Fair* and *Newsweek*. She also makes documentary and feature films. She is married with two children. [D.R.]

CINDY SHERMAN
1954/Glen Ridge, New Jersey

Even as an art student in Buffalo, she experimented with theatrically staged self-portraits. In 1977, she moved to New York and soon drew attention in the art world with her black and white series of *Untitled Film Stills*, published in book form in 1990. Her international breakthrough came in the early 1980s with her cycles of large-format colour photographs in which, disguised beyond recognition, she played the main figure, ironically undermining female role patterns and clichés. In 1985, she started working with the material of fairy-tales, later exploring the field of art history to create a series published in book form in 1991 as *History Portraits*. In her *Civil War* and *Sex Pictures* series, she is no longer the model: plastic dolls and prosthetics arranged in complex tableaux create scenes that suggest impending violence and doom. Cindy Sherman lives in New York City. [S/M]

MARILYN SILVERSTONE
Plates 96, 105, 112
1929/London
1999/India

Born in England as the daughter of Eastern European immigrants, she studied at Wellesley College, worked as an editor and co-produced a film series, before launching her career as a freelance photographer. From 1959 to 1973 she lived and worked in Bombay and New Delhi, photographing everyday life and customs there for *Paris Match*, *Cosmopolitan* and the *New York Times*. She also documented the floods, famines and wars of the subcontinent, as well as the arrival of the Dalai Lama in India and the funeral of Nehru. A full member of Magnum from 1967 onwards, she travelled extensively for the agency throughout Europe, Africa, Central America and the Soviet Union. In 1973, she became a Buddhist nun

and lived from then on in a convent in Nepal. [R.B.]

EDITH SITWELL
Plate 87
1887/Scarborough
1964/London

Daughter of an eccentric Baron, she became a writer like her younger brothers Osbert and Sacheverell. In 1916-21, she became the editor and main author of *Wheels*, a radical forum for new poetry. In 1922, she published her experimental cycle of poems, *Façade*, which was set to music and performed with considerable success. She went on to publish prose, essays and biographical novels, often under considerable financial pressure. After two successful US tours in 1948/50, she finally gained recognition and fame in her own country. In 1954, she was made a Dame of the Order of the British Empire. [O.F.]

VANINA SORRENTI
Plate 152
1973/Naples

Lives and works in New York and is widely regarded as a major new talent in fashion photography. She started working as a professional photographer in 1998, for such magazines as *i-D*, *Icon* and *surface*. That same year, she made a short film for the Run collection by fashion designer Susan Cinaciolo. [R.B.]

GRETE STERN
Plate 46
1904/Wuppertal-Elberfeld
1999/Buenos Aires

Studied graphic arts at the Kunstgewerbeschule Stuttgart and worked as a freelance graphic artist in advertising before moving to Berlin in 1927 to train as a photographer at the studio of Walter Peterhans. It was here that she met Ellen Rosenberg, later Auerbach (see Auerbach). Together, they founded the advertising and portrait studio "ringl + pit" the same year, and it soon became famous in avant-garde circles. From 1931 to 1933 she attended the photography class at the Bauhaus, where Walter Peterhans was now teaching. She immigrated to London with her future husband, the photographer and Bauhaus student Horacio Coppola, and from there they went on to Argentina. In Buenos Aires, they founded a studio for advertising photography and graphic arts. They had two children. When they separated, she worked as a photographer and commercial artist, pub-

lished her photomontages in various women's magazines and taught photography at the Resistencia University. [S/M]

LISELOTTE STRELOW
Plates 89, 91, 99
1908/Redel near Polzin, East Pomerania
1981/Hamburg
The daughter of a land-owning family, she initially trained in agriculture before moving to Berlin in 1930 to study photography at the Lette Society. She worked for Kodak in Berlin and opened her own studio on Kurfürstendamm in 1938. In 1943, she married the philologist Guido Guiard, who died the following year. When her studio was bombed she continued to work in an attic in Detmold, specialising in portraits of people from the world of theatre, music, politics and finance. From 1950 onwards she ran a successful studio on Düsseldorf's Königsallee. Under Gustav Gründgens she was the official photographer at the Schauspielhaus in Düsseldorf and at the Deutsches Schauspielhaus in Hamburg, and from 1925 to 1955 she was commissioned photographer at the Richard Wagner Festival in Bayreuth. [T.H.]

KARIN SZÉKESSY
Plate 127
1939/Essen
Born in Germany, she grew up in Hertfordshire and studied at the Institut für Photojournalismus in Munich. Until 1966, she worked as a photojournalist in Hamburg, where she also taught at the Werkkunstschule (school of applied arts). In 1970, she went freelance. In 1972, she married the painter Paul Wunderlich, with whom she had three children. They also worked closely together. Apart from her journalistic work for newspapers, including *Die Zeit*, *Die Welt*, *FAZ* and others, she published her unconventional, surreally alienated nude studies and portraits of artists such as Joseph Beuys, Meret Oppenheim (see Oppenheim), James Baldwin, Siegfried Lenz in a variety of magazines and periodicals, from *Twen* to *Playboy* and *Avantgarde*. Her photographs, created using an old printing process, have been shown in more than 60 exhibitions at home and abroad, have won such prestigious awards as the Kodak Prize and have been published in several books. She lives with her family in Hamburg and in Provence. [D.R.]

JOYCE TENNESON
Plate 134
1945/Boston
Known for her ethereally mystic portraits of women. Her 1978 book *In-Sights: Self-portraits by Women* attracted considerable attention. Largely self-taught, she has worked as a photographer since 1969, turning increasingly to fashion photography in the mid-1980s and founding her reputation primarily on her portraits of stars. Her work has been shown internationally in more than 150 exhibitions and has won many awards. She has published a number of books, photographed the 1989 Pirelli Calendar and her work has been published in magazines such as *Vogue*, *Time*, *Life*, *Premiere*, *Esquire* and *The New York Times Magazine*. [R.B.]

MOTHER TERESA
Plate 112
1910/Skopje
1997/Calcutta
Born Agnes Gonxha Bojaxhio, she was the youngest of three children of an Albanian building contractor. At the age of 18 she joined the Irish Sisters of Loreto and left to teach in Calcutta the following year. In 1946, during a bout of illness, she realised her spiritual vocation and thereupon dedicated her energies to caring for the poor in the slums of Calcutta. She left the sisterhood and in 1950 founded the Order of the Missionaries of Charity devoted to caring for the sick and orphaned. From 1962 onwards she received many awards, among them the 1979 Nobel Peace Prize. In spite of her failing health from 1989 onwards, she remained indefatigable and did not give up her position as the head of the order until just before her death. [O.F.]

KATHARINA THALBACH
Plate 143
1954/Berlin
Born in East Berlin, the daughter of actress Sabine Thalbach and director Benno Besson. At the age of four, she had her first performance on stage and in front of the camera. At 15 she had her debut with the Berlin Ensemble in the *Threepenny Opera*. In 1976, she moved to West Berlin with her husband Thomas Brasch. In 1980, she was elected Performer of the Year. Her acting talents have been proven in her roles as Ophelia, Mother Courage and in Doris Dörrie's *Paradise*. Since the late 1980s she has also been

working as a stage director. Her awards include the Deutscher Filmpreis (1987) and the Adolf Grimme Prize (1997). [O.F.]

MARGARET THATCHER
Plate 120
1925/Grantham, Lincolnshire
Born Margaret Hilda Roberts, she studied chemistry and law at Oxford. Drawn to the world of politics, she won a safe seat for the Conservative party, making her an MP at the age of 34. In the course of her meteoric career, she became Minister of Education and Science in 1970 and in 1975 she won the party leadership, becoming Prime Minister in 1979. Her style of government earned her the epithet Iron Lady. She advocated the free market economy and the "special relationship" between Britain and the UK and has always been regarded as a Eurosceptic. During her term as Prime Minister, the Falklands War was fought in 1982. In 1990 she resigned in the face of increasing opposition within her own party. Since 1992 she has sat in the House of Lords as Baroness Thatcher of Kesteven. [O.F.]

DEBORAH TURBEVILLE
Plates 111, 124, 125
1937/Boston
This enfant terrible of fashion photography moved to New York in 1956 and attended photographic seminars by Richard Avedon and Marvin Israel. After an initial stint as an editorial assistant on the *Ladies' Home Journal*, she became a fashion editor for *Harper's Bazaar* and *Mademoiselle* in 1960. In 1972, she changed to photography, working freelance in Paris and New York for *Vogue*, *Marie Claire* and *Nova*. Her distinctive, somewhat morbid scenarios, sometimes set in dilapidated houses, abandoned swimming pools or gloomy landscapes, instigated a new stylistic direction in young American fashion photography. Several book publications and solo exhibitions, including a show at the Centre Georges Pompidou in Paris in 1986, bear witness to her international success. [R.B.]

ELLEN VON UNWERTH
Plates 137, 140
1954/Frankfurt am Main
At the age of 15 she moved into a commune in southern Germany and after leaving school worked for the Circus Roncalli. From 1975 onwards she modelled in Paris for the Elite agency and stood behind

224

the camera professionally from 1986. Her photographs of the young Claudia Schiffer launched both their careers. Since then she has worked with the major figures of the fashion and showbiz scene, including Naomi Campbell, Madonna, Vanessa Paradis and Annie Lennox. In the 1990s her refreshingly unconventional fashion and nude shots made her a shooting star in the fashion world. Her work has been published in all the major international fashion and trend magazines. She has created advertising campaigns for leading designers, shot videos for Duran Duran and Salt 'n Pepper, and has published three photo books to date: *Snaps* (1994), *Wicked* (1998) and *Couples* (also 1998). [S/M]

DINA VIERNY
Plate 89
1919/Russia

Her real name was Dina Aibinder, and for more than ten years she was the favourite model of sculptor Aristide Maillol. She came to France at the age of seven, following her social democrat father who was deported under the reign of the Csar. As a student of art, she was involved with the association of revolutionary writers and artists, became an active member of the Young Socialists and worked as a teacher. After the war she ran an international art gallery. A leading connoisseur of Maillol's work, she was a driving force behind the realisation of a Maillol museum, establishing a foundation for that purpose and compiling a catalogue raisonné of his oeuvre. She is married to sculptor Manfred von Diepold. [E.S.-R.]

HELENE WEIGEL
Plate 91
1900/Vienna
1971/Berlin

Daughter of a wealthy Jewish family. After school she trained as an actress, then moved to Frankfurt am Main and later to Berlin, where she studied under Max Reinhardt, established her career as an actress and met her future husband, Bert Brecht. In 1933, she went into exile, spending the next 16 years in Prague, Vienna, Paris, Switzerland, Scandinavia and the USA. In 1949, directed by Brecht, she played the role of Mother Courage at the Deutsches Theater in East Berlin, and immediately resumed her former stage success. She and her husband founded the Berliner

Ensemble in the eastern sector of the city and she remained manager of the ensemble until her death. After Brecht's death in 1956, she was executor of his estate and held the performance rights to his plays. [M.A.]

DONATA WENDERS
Plate 130
1965/Berlin

As a student in Berlin, her main interest was photography and camerawork. Later, she enrolled at the Stuttgart drama school, where she studied directing and was camera assistant for a wide variety of student films. In 1993, she married Wim Wenders and since then she has been involved in his film projects and has documented them in her photographs. The box office success of *Buena Vista Social Club* (1999) and *The Million Dollar Hotel* (2000) are documented in publications which include portraits of the actors that she took during shooting. Wim and Donata Wenders live in Los Angeles and Berlin. [S/M]

DOROTHY WILDING
Plates 7, 48, 83
1893/Longford, England
1976/London

From the 1920s to the 1950s she was probably the best-known portrait photographer in England. Her career began in 1914, at the age of 21, when she opened her first portrait studio in London, and ended in 1958 with her withdrawal from public life. She was the first woman to be appointed official court photographer. Her coronation portrait of Queen Elizabeth II (1952) hung in every British embassy and was the model for coins and stamps. From 1932 onwards her work was exhibited at all the major photo galleries in Britain and continental Europe. In 1937, she opened a branch in New York. Although she had an excellent reputation as a portrait photographer and had enjoyed a remarkable career, for a long time her name was all but forgotten. [F.S.]

FRANCESCA WOODMAN
Plate 110
1958/Denver, Colorado
1981/New York

Born into a family of artists, she took up photography at the age of 14. She attended one of the very few American high schools to offer art courses and in 1975, she

enrolled at the Rhode Island School of Design in Providence, where she studied the work of Man Ray, Weegee and Duane Michals. She spent some time in Rome in 1977/78 on an exchange programme. After graduating, she went to New York, where she worked for a while as a model and photographic assistant and participated in various group exhibitions. Her first publication, *Some Disordered Interior Geometries*, was issued in January 1981. That same month, at the age of 22, she committed suicide. Her photography was almost exclusively about her self and her body, often appearing as a fragment or transient apparition in her work. [F.S.]

VIRGINIA WOOLF
Plate 47
1882/London
1941/Lewes, Sussex

She grew up with her three siblings and four half-siblings in an intellectual but psychologically complex Victorian household. In 1895, she experienced her first major crisis on the death of her mother. Without attending school, she made use of her father's library and expressed an early desire to become a writer. In 1904, she started writing literary reviews and essays. In 1912, she married the author and publisher Leonard Woolf. Although she had been writing novels since 1908, her first experimental texts were written from 1922, including *Mrs Dalloway* (1925) and *To the Lighthouse* (1927). Psychologically unstable all her life, she drowned herself in the River Ouse in 1941. [O.F.]

WANDA WULZ
Plate 50
1903/Trieste
1980/Trieste

Born into a family of photographers. Like her father, she photographed the intellectuals and artists of Trieste. She and her sister Marion took over their father's studio in 1928 and ran it together until Wanda's death. During the 1930s, under the influence of the Italian Futurists, she turned her attention to experimental photography. The first public exhibition of work by Wanda Wulz outside Trieste was in 1930, when she participated in the Biennale Internazionale d'Arte Fortografica in Rome. [F.S.]

CLARA ZETKIN
Plate 32
1857/Wiederau
1933/Moscow

Born Clara Eissner in Saxony. In 1878, she met a young teacher, Osip Zetkin, and became involved in the social democratic movement. From 1882 to 1990 the legislation against socialist political activity forced her into exile in Zurich and Paris. She took the name Zetkin in 1883. As her Marxist views became increasingly radical, she successively joined the SPD, the Spartakusbund, the USPD and the KPD. From 1892 to 1917 she edited the socialist women's periodical *Die Gleichheit*. She was jailed for several months in 1915 for her anti-war stance. From 1919 onwards she was actively involved in the communist women's movement, and was elected to the Reichstag as a communist party member from 1920 to 1933. In her capacity as a member of parliament, she warned against the Nazis as early as 1932. She died at Archangelskoje near Moscow. [O.F.]

ACKNOWLEDGMENTS

We wish to thank the photographers, institutions and private collectors involved in this project for their kind support. Without their assistance, and that of those who undertook picture research and helped in other ways, this book would not have been possible. In particular, we would like to mention:

Ellen Auerbach; Vanessa Beecroft; Ruth Bernhard; Lillian Birnbaum; Elisabetta Catalano; Zoë Dominic; Rineke Dijkstra; Jayne Fincher; Jitka Hanzlová; Vera Isler-Leiner; Dominique Issermann; Sarah Jones; Ursula Kaufmann; Barbara Klemm; Ute Klophaus; Brigitte Lacombe; Inez van Lamsweerde; Annie Leibovitz; Helen Levitt; Ingeborg Ludowici; Sally Mann; Mary Ellen Mark; Frances McLaughlin-Gill; Sarah Moon; Isolde Ohlbaum; Bettina Rheims; Sophy Rickett; Nina Schmitz; Eva Sereny; Vanina Sorrenti; Karin Székessy; Joyce Tenneson; Deborah Turbeville; Ellen von Unwerth; Donata Wenders

Kathryn & Thomas Abbe, Glen Head, NY; Heike Ander, Dirk Snauwaert, Kunstverein München, Munich; Nicola Atchley, Dominic Photography, London; Malin Barth, Kraige Block, Skye McGiness, Throckmorton Fine Art, Inc., New York; Marion de Beaupré, Galérie 213, Paris; Caroline Bouchard, Galérie Baudoin Lebon, Paris; Christian Bouqueret, Paris; Dr Christian Brandstätter, Austrian Archives, Vienna; Stephan Braun, InterTopics, Hamburg; Ann Cain, Debra Bosniak, Robert Mann Gallery, New York; Jennifer B. Calder, Commerce Graphics Ltd, Inc., NJ; Carol Callow, Arabella Hayes, Lee Miller Archives, Chiddingly, England; Jean Pierre Cap, Paris; Rosa Casanova, Fototeca del I.N.A.H., Pachuca; Donna Cerutti, Tanya, Marek & Associates, New York; Eric Cez, Editions Marval, Paris; Michèle Charton, Collections Mnam – Centre Georges Pompidou, Paris; Fani Constantinou, Benaki Museum, Athens; Alessandra Corti, Archivi Alinari, Florence; Lydia Cresswell-Jones, Dr Juliet H. Hacking, Sotheby's London; Prof. Dr Sibylle Dahms, Derra de Moroda Dance Archives, Universität Salzburg; Anne Dary, PIASA, Paris; Helen Dobson, Nicole Mendelsohn, V&A Picture Library, London; Bettina Erlenkamp, Elke Kilian, Sächsische Landesbibliothek – Staats- und Universitätsbibliothek Dresden / Deutsche Fotothek; Dr Ute Eskildsen, Robert Knodt, Museum Folkwang, Essen; Prof. Dr Konrad Feilchenfeldt; Janos Frecot and his colleagues in the photographic collection of the Berlinische Galerie / Landesmuseum für Moderne Kunst, Photographie und Architektur, Berlin; Dr Monika Faber, Albertina, Vienna; Gesellschaft Photo-Archiv im Rheinischen Landesmuseum, Bonn; Vicki Harris, Lawrence Miller Gallery, New York; Sabine Hartmann, Bauhaus-Archiv, Berlin; Mary Ann Helmholtz, Burlingame, CA; Rolf Hochhuth; Jenni Holder, Edwynn Houk Gallery, New York; Lawrence Hole, Yevonde Portrait Archive, Compton, Winchester; Janet Johnson, Lacombe Inc., New York; Samantha Johnson, Sarah Bentley, The Royal Photographic Society, Bath; Martina Kaup, Barbara Stampnik, Frankfurter Allgemeine Zeitung, Frankfurt am Main; Thorsten Krause, Frau Roth, Rheinisches Landesmuseum, Bonn; Frau Kutschke, Deutsches Tanzarchiv, Cologne;

James Lavender, Interim Art Gallery, London; Nicole LePage, Michael Fisher, Leibovitz Studio, Inc., New York; Meredith Lue, Falkland Road, Inc., New York; Bill McMorris, The Dorothea Lange Collection, Oakland Museum of California, Oakland, CA; Janice Madhu, George Eastman House, Rochester, NY; Ann Mahi, Time-Life Syndication, New York; Lloyd Morgan, Barbara Morgan Archives, Hastings-on-Hudson, NY; Robert Montgomery, Robert Montgomery & Partners, London; Val Nelson, Jersey Museum, St Helier, Jersey; Dianne Nilsen, Center for Creative Photography, The University of Arizona, Tucson, AZ; Mr and Mrs Adrien and Lucette Ostier-Barbier; Paola, Agency Nina Beskow, Paris; Elizabeth Partridge, The Imogen Cunningham Trust, Berkeley, CA; Pascale, L'office, Paris; Terence Pepper, James Kilvington, National Portrait Gallery, London; Sally Drinkwater, Photographers International; Valérie Philippe, Rapho, Paris; Dr Ulrich Pohlmann, Monika Gallasch, Fotomuseum im Münchner Stadtmuseum, Munich; David L. Prince, Syracuse University Art Collection, Syracuse, NY; Naomi Pritchard, Thames & Hudson, London; Margot Klingsporn, Frau Clasen, Thomas Witzke, Photo- und Presseagentur Focus, Hamburg; Stefan Ratibor, Gagosian Gallery, London; Rebecca Sheir, Parker Stephenson, Gallery 292, New York; Gary Samson and his colleagues at the Lotte Jacobi Archives, Instructional Services, Dimond Library, University of New Hampshire, Durham, NH; Dr Rolf Sachsse; Sammlung Schreiber, Vienna; Dietmar Siegert, Munich; Jeffrey D. Smith, Contact Press Images, New York; Marla Ulrich, Los Angeles, CA; Ann und Jürgen Wilde, Cologne/Zülpich; Betty and George Woodman, New York; Regula Zbinden, Kunstmuseum Bern, Berne.

Lothar Schirmer

PICTURE CREDITS